REMEMBER US

My Journey from the Shtetl
through the Holocaust

Martin Small and Vic Shayne
Foreword by Milton J. Nieuwsma

Skyhorse Publishing

Great care has been taken to ensure that the places, people, groups, and events in this story are historically accurate. In cases where facts cannot be verified, the author has relied upon the memory of those interviewed.

The views expressed in this work are solely those of the author and do not necessarily reflect the views of the publisher, and the publisher hereby disclaims any responsibility for them.

Some of the names in this book may have been changed to protect the privacy of certain individuals.

Skyhorse Publishing books may be purchased in bulk at special discounts for sales promotion, corporate gifts, fund-raising, or educational purposes. Special editions can also be created to specifications. For details, contact the Special Sales Department, Skyhorse Publishing, 307 West 36th Street, 11th Floor, New York, NY 10018 or info@skyhorsepublishing.com.

Skyhorse® and Skyhorse Publishing® are registered trademarks of Skyhorse Publishing, Inc.®, a Delaware corporation.

Visit our website at www.skyhorsepublishing.com.

10 9 8 7 6 5 4 3 2 1

Paperback ISBN: 978-1-5107-1862-3

Library of Congress Cataloging-in-Publication Data
Small, Martin, 1916-2008.
 Remember us : my journey from the shtetl through the Holocaust / Martin Small & Vic Shayne.
 p. cm.
 ISBN 978-1-60239-723-1 (hardcover : alk. paper)
 1. Small, Martin, 1916-2008. 2. Jews--Belarus--Mouchadz'--Biography.
3. Holocaust, Jewish (1939-1945)--Belarus--Personal narratives. 4. Mauthausen (Concentration camp) 5. Mouchadz' (Belarus)--Biography. 6. Baranowicze (Poland)--Biography. I. Shayne, Vic, 1956- II. Title.
 DS135.B383S677 2009
 940.53'18092--dc22
 [B]
 2009024775

Printed in the United States of America

Contents

To my mother and father,
Esther and Shlomo, and my two little sisters, Elka and Peshia.
May you always be remembered.

Foreword

I am probably the least likely person to write a foreword to this book. For one thing, I am not a Jew but a gentile. For another, I am not a historian but a journalist. For still another, I am not a Holocaust survivor but a Dutch Reformed preacher's kid who grew up in the Midwest. Nothing in my background comes remotely close to what Martin Small experienced in his journey from Maitchet, the shtetl in eastern Poland where he came from, to Mauthausen, the concentration camp in Austria where he ended up.

So why did I accept this assignment? The first reason has to do with my journalist's view of the world: What I see is a world in disarray, a world where nationalism is on the rise and globalism is on the decline, where cooperation and coexistence have given way to confrontation and conflict, where populism—a word we once associated with Thomas Jefferson—has become a euphemism for mob rule. The second reason has to do with Martin Small's book: His story is a stark reminder that if we forget the past, we are condemned to repeat it.

The omens are everywhere. In 2016, Great Britain voted to withdraw from the European Union. More recently, we have

seen the rise of the far-right NPD (National Democratic Party of Germany), and the rise of Marine Le Pen in France and Donald Trump in the United States. As I write this, Trump has been in office less than two months. During this time, he has issued two executive orders banning travel to the United States from several Muslim-majority countries, has deported thousands of undocumented Mexicans, and has pledged to make good on his campaign promise to build a wall along the Mexican border. Meanwhile, bomb threats on Jewish schools and community centers have become everyday occurrences. We're not talking Germany in the 1930s, but the United States in 2017.

So when Martin Small describes an *Aktion* against the Jews of Baranowicze (a nearby town where he worked as slave laborer), I have to ask myself: *Is this really any different than an illegal immigrant mother from Mexico being picked up and deported by ICE (US Immigration and Customs Enforcement) in the middle of the night and separated from her six (US-born) children? Is the "Night of Broken Glass" that ravaged Jewish businesses and synagogues across Germany on the night of November 9, 1938, really any different than thugs vandalizing a Chicago synagogue or desecrating a Jewish cemetery in St. Louis or Philadelphia?*

One may argue that while Hitler's targets were mainly Jews, Trump's targets are mainly Muslims and Mexicans. But where bigotry runs amok, any minority can be a target. I learned that when I experienced, vicariously, the ordeal of three young Jewish girls from Tomaszów Mazowiecki, a predominantly Catholic town in central Poland. The children, along with their parents, were herded into a ghetto and later deported to labor camps and finally to Auschwitz where, against all odds, they survived.

Like Vic Shayne, who had the daunting task of documenting Martin Small's story for a mostly adult audience—and for posterity—I had the somewhat less daunting task of documenting the children's stories for younger readers and then for public television. But while two of the children I interviewed were too young to remember many details of their lives before the war (they were six, seven, and ten when they were liberated from Auschwitz in January 1945), Martin Small's story is largely the story of his life before the war—the lost world of the shtetl, a mournful elegy to a way of life gone forever.

In a way, Maitchet reminds me of the town my father came from—Strasburg, North Dakota. It is as far away from Maitchet as you can get, geographically and in every other way. But there are a few similarities. Until the Great Depression, it boasted a population of a thousand people. Even into the 1950s, it was a thriving farming community. It had two grain elevators, a Gambles store, a freight train, and two churches—a big Catholic church at one end of town and a little Dutch Reformed church at the other end. Every summer, I looked forward to visiting my grandparents and cousins at the family farm. For a preacher's kid who moved around a lot, Strasburg was the closest thing I had to a hometown. Today, only a few hundred remain.

That's where the comparison ends. It wasn't the war that decimated the town; it was the lack of economic opportunity. Eventually, most of my cousins and their contemporaries sought their fortunes elsewhere. Most have prospered; some have extended the family tree beyond the United States to different parts of the world. But theirs was a different kind of diaspora than what the

Jews experienced. For the children of Strasburg, it was an escape from the farm. For Martin Small and the children of Maitchet, it was an escape from death.

So why is his story important to us? History is immutable. We can't change it, but we can change what we do with it. A few months before Martin Small passed away at age ninety-one, a reporter from the *Denver Post* interviewed him about his life in Broomfield, Colorado, where he and his wife had gone to be near their daughter and her family. "People here listen to me," he said. "The Holocaust changed one word, love to hate. People here changed hate to love."

Martin Small's story inspires us. We see how through sheer power of will he rose from trauma to rebirth, how he became an integral part of his community, and how he transcended hardship and heartbreak to find his Promised Land in a country that, at least until now, welcomed the weary and worn in search of a better life. His story is a compelling one, and it is relevant to our time.

Milton J. Nieuwsma
March 16, 2017

Author's Note

When I began writing this book in Martin Small's name, he was a sprightly eighty-seven-year-old. He was lucid, quick-witted, and light on his feet. He enjoyed a good joke, an occasional shot of his favorite Russian vodka, challenging his rabbi in the middle of Shabbos services, and creating works of art in his basement. He had a wonderful intellectual curiosity, a gift for languages, and a love of music. However, both he and I were somewhat concerned that this book—Martin's life story—would not see the light of day until after his passing. For this reason, I worked around the clock and, for nearly four years, spoke with Martin at least once a day. I was in awe of his memory, especially as I checked, to the best of my ability, his recollections against historical facts and events. By the age of ninety-one, after more than eight decades had passed, Martin was still remembering the names of the children in his neighborhood, conversations with his grandfather, and the layout of his shtetl. The summer before Martin's ninety-second birthday, the first printing of this book came out. He was thrilled not merely to see his story in print, but to be able to physically hold it in his hands. He realized a life-long dream of memorializing, in permanent form, the family that was taken from him so that he could connect them to the new family that he and his wife, Doris, created here in America. He passed on an invaluable legacy. Shortly after Martin and I celebrated the release of this book, he was diagnosed with terminal pancreatic cancer and passed away in Doris's loving arms in his home on a cold November morning just weeks before his ninety-second birthday. Days before, I visited him on his death bed and he reiterated the solemn words that he had spoken throughout his sojourn during the Holocaust: "Jerusalem, if I forget thee, may I lose my right arm." In doing so, he cast his eyes upward and they filled with tears. His love for his people, his religion, and his family were inseparable and forever in his heart. It is my hope that this love shall grant you cause for reflection as you read his story and consider what has forever been lost.

Vic Shayne

Preface

I was twenty-five years old in the beginning of spring, 1942. I stood at the wooden counter in my mother's kitchen looking for something to eat. There was a slight chill in the air. I rubbed my arms with my hands. There was no fire burning anywhere in the house. My entire family was in the living room, along with some guests, huddled together waiting. Once in a while, my father would stand up and look out the window then go back to the sofa beside my mother. It was the middle of the day. Nobody was working. My stomach growled. I was growing hungrier by the moment. What was I looking for in the cupboard? Anything. There was nothing left. I stood staring at an empty plate, my thoughts drifting far away. It was too quiet. I looked out the window. The street was deserted. I turned around and sat down on a chair and crossed my legs. This kitchen that I helped my father build was, for once, quiet. It wasn't natural. My little sisters and my mother weren't baking or cooking. It was a foreign feeling. No pots and pans and baking dishes were clanging. The laughter was gone. The stoves were cold to the touch. It was deathly quiet. Then I heard a boom coming from the living room. *What was that?* It sounded like a log smashing into the front

door. It jolted me. Everyone in the living room had jumped from the shock.

Boom, boom, boom! Fists were pounding on the door and a young, familiar voice was shouting. Demanding. *Open this door! Open or I'll smash it in.* I ran to the door. Everyone was wide-eyed. My father stood with his fists clenched at his sides as I opened our front door. In front of me stood my boyhood friend, Stach Lango. His seething expression, his twisted mouth, and sick gaze belonged to somebody else. What happened to him? He pointed a pistol to my face, grabbed me by the collar, and said, "If you fight me, I'll shoot your mother, your father, and your two sisters right in front of you." What was I to do? It was hopeless. Stach pulled me by the shoulder and yanked me out of my house. My family watched helplessly as I was dragged into the empty street and pushed all the way to the police station and into a room with a wooden table in the center and a glowing fireplace by the wall.

A small stack of wood and some iron pokers leaned against the dirty, paint-peeling wall. Once inside, still with a pistol pointed at my head, I was forced to undress. *Hurry up, goddammit, Jew!* Then Stach tied me to a table in the middle of the room. I couldn't move. My wrists were tearing from the ropes. My eyes followed him as he tucked his gun inside his waistband. He picked up one of the iron pokers and angrily shoved the end of it into the embers. He knew I was watching and relished his power over me. The iron grew hotter and hotter until the tip of it pulsated in red and white. "I'm going to kill you, Jew," he said. His voice was monstrous. He brought the iron toward me and I could hardly bear the heat even from several inches away. Smoke was rising from the glowing tip.

"I'm going to kill you slowly. I want to hear you scream."
My heart raced and I felt sick. The poker was pushed slowly and
torturously toward my face, and all I could think was, "God, take
me quickly." I called out for God—God my rescuer and confidant;
the God I knew as a Yeshiva student; the God of our Torah. Where
was God in all of this? I braced myself for the worst as Stach came
toward my eyes with the iron. Then the door flew open and Stach
turned to face his friend, who was exhaling puffs of steam and trying
to catch his breath. He whispered something in Stach Lango's ear.
I couldn't hear what was being said, but without a word spoken to
me, I was untied and set free. I don't know why. I don't know to this
day why they let me go. I ran out the door and ran and ran until I
came back to my house in a pool of sweat and called for my mother
as I burst through the front door. I saw her face through my tears,
and she opened her arms. I held her tightly and felt every fiber of
her dress in my hands. I breathed in her hair and laid my head in my
own perspiration and in the tears running down her neck, soaking
her collar. I couldn't let go, and she held me; I was her baby and she
held me. She sat down and held my head on her lap and stroked my
face. I sobbed and she tried to console me.

How did this happen? How did things get to be this way?
How did my friends—whom I played with—turn into murderers
and rapists? The world was turning inside out in my little town in
Poland. The clouds had darkened our world almost overnight. And
still, the worst was yet to come.

I Live to Remember

For many years I have wanted to write this book. Many Holocaust survivors have written books, and I wasn't sure how this one would be any different. My biggest concern was trying to understand for myself why I wanted this to be written. Maybe the point of writing is, if nothing else, an expression. I am not trying to prove anything to anyone. I am not trying to get people to believe that the Holocaust was real or that it was literally an unbelievable period of history. I am not looking for sympathy or any worldly gain.

I want you to understand that the Holocaust was, and is, a very personal event. Historians, psychologists, and other well-meaning experts tend to present the Holocaust through an impersonal story of facts, figures, political landscapes, economic downturns, and loss of culture. But this is not what the Holocaust means. The Holocaust was, above all else, a deep and traumatic occurrence that cannot be comprehended by the loving mind and heart. It was a personal event for each and every one of us who suffered through it and managed to survive. We are talking about human beings here, family

and friends. We are talking as well about an entire culture, a Yiddish civilization born and nurtured in the shtetls of Eastern Europe. Ours was a rich culture with real people who had real feelings, hopes, dreams, aspirations, ideas, personalities, and creative impulses. Regular people; extraordinary people.

Can I hold back the tide and keep people from thinking about the Holocaust as a generalized event in which six million Jews died? This is my hope. I want you to understand a little about the world from which I came, a world that is no longer alive—a world of ghosts where a murdered language cries out from the past. I want you to realize that my family and friends were not "lost" in the Holocaust. They were murdered and tortured but not lost. I want you to think about your own mother, father, sisters, brothers, aunts, uncles, and cousins. I want you to think of those who are closest to you and how you could not bear to lose them to unthinkable, shameless, mindless, purposeless, and hateful acts. When we forget that these were real, close, vibrant, feeling people—individuals— who were murdered, then we cannot ever hope to find the deeper impact and grief associated with the loss and suffering.

I am offering this book to the world not as a historical, psychological work but rather as a remembrance. This is a strange paradox for me because, since the terrible years of the Holocaust, I have been haunted by my memories. I have been tortured by my own mind, just trying to understand what happened and why. I reach out blindly through the darkness for my mother whose hand I cannot grasp. I sense that she is there but cannot feel her. I can find no good answers for any of what has happened. I must rely on dreams, memories, and nightmares. Yet the human mind does

not always allow for selective impressions. I cannot remember only the good and forget the bad. Here is the paradox. To forget the Holocaust would mean forgetting my family. This I have decided never to do. Nor will my mind indulge me in remembering the good and forgetting the horrible.

The story I have to tell is true, but I am leaving out the great many details and occurrences that include gruesomeness and the depths of dehumanization that I, my family, my friends, and my fellow Jews suffered. I shall not dwell on the hell I witnessed in Mauthausen concentration camp. I want to spare you the ghastly details of what went on. Photographs, films, and testimonies of survivors, victims, and soldiers abound to offer you some idea of the ugliness of what transpired during the Holocaust years. Instead, I am choosing to make this book a commemoration. I want to remember the goodness from which I came. I am recalling the special people who shaped my life and the lives of others. Without such a memory, there is nothing with which to compare the extent of the loss and tragedy.

In the pages to follow, I remember my wonderful childhood, my loving family, my nurturing shtetl, and everything else I had to leave behind—everything else that was taken from me. I remember a world that no longer exists—the world of the shtetl—so that you can understand the calamity of cultural extinction. But most of all, I remember the people who made our shtetl civilization unique and prosperous. We must think of the value of human lives—real people with real faces. They had voices, sang songs, danced, worked hard, laughed, prayed to God, basked in the sun, performed in theaters, worked the farms, ran aimlessly in open fields, and worried about

the safety and welfare of their children. I remember what is all gone. I alone, as a survivor, am left to remember.

To remember is to be faithful to the teachings on which I was brought up. We remember to pay tribute, to honor, to learn, and to share with others. We light the candles for Shabbos and Chanukah to remember our connection to God and to one another. Each year we light a Yahrzeit candle to remember our loved ones who died. We remember to validate the experiences of others. When I stand in my synagogue and say kaddish for my mother, my father, my sisters, my grandparents, my uncles and aunts, my cousins, and for those who died beside me in the concentration camps, I am simply remembering and honoring them. There in the synagogue, I am transported to another time and place. I cannot forget them; I don't want the world to forget them. I want to see their faces and hold them close. I want to remember, even if it forever robs me of my sanity and sentences me to unexpected visions and sleepless nights. I must remember because I am a part of it all.

My name is Martin Small, and I am a Holocaust survivor.

My Little Shtetl, Maitchet

Once I was a Yeshiva *bocher*, a religious scholar, in a little town—a shtetl—called Molczadz, in Poland, before World War II. Molczadz was a *miasteczko*, a small city, surrounded by scores of little villages nestled along rivers running beside thick forests, winding in and out of the Russian borderlands. The nearest seat of government was in Nowogrudek, a town that would later gain a reputation as a very different kind of village—one where Jewish partisans hid from Nazis and their collaborators and lived as a subculture of people with death at their heels. These people were to become the last vestiges of Jewish life along the Polish–Soviet border. But this was to come later.

Molczadz, which would change hands from the Russians to the Poles a few years after my birth—following World War I—had an electric power station, a tannery, a pitch factory, and mills. We weren't by any means modernized when I grew up in the 1920s. We had no motorized traffic, and the only ones with a telephone were the police, the postal worker, and the richest merchant in town, a man named Mr. Lieberman. There was no electricity available to the homes, and to get around we would either walk or take a horse-

drawn wagon from here to there. Venturing out of town was a rare and big adventure. Automobiles were as foreign to us as asphalt roads, airplanes, or indoor plumbing. Without the amenities that, today, are so familiar to modern people, to survive in our lost world we had to know every one of our neighbors and to rely on them. As a small town, this mutual dependence was taken in stride, because generations before us discovered how to work hand-in-hand to meet life's basic needs. This guy would help you load your wagon and that guy would take your flour to the mill for you. Cooperation wasn't a luxury.

Politics shaped our part of the world more than any other area on the continent. The maps of Eastern Europe were redrawn every now and again so that once we were Russian and now we were Polish. Over the past five hundred or six hundred years, Molczadz had seen its share of tyrants, monarchs, feudal lords, and communist bureaucrats. But despite who was in charge, we were always relatively poor—not really wanting, just poor. To be a Jew in this region was to be a second-class citizen whose future was always uncertain and whose safety was never secure. We had every disadvantage of our Gentile Polish neighbors, and then some.

Molczadz is a Russian word that means "to keep quiet." I don't know whether the town founders wanted to enjoy peace and quiet in this corner of the world or whether it already was quiet and they wanted to keep it that way. Historically speaking, Molczadz didn't exactly enjoy much quiet, though. Russians, Belarusians, Lithuanians, Slavic tribes, Poles, and Tartars fought over the region for reasons that are hard to understand. All of these conquering people left a part of themselves behind in buildings, languages,

fortresses, and customs. Left standing were the tall pine trees lining the forests that drew health-seeking visitors from all around and, of course, the Jews. The area was never without its Jews.

How did I come to Molczadz? I was born there along with the rest of the people in my family. I was born into a world that was the last of its kind: a world that would become as extinct as the dinosaur. Our world was the world of the shtetl, where time stood still and life was all about people, family, relationships, and learning.

I come from the seat of Yiddish civilization, where life was guided by Jewish teachings and customs. I come from a place and time where you lived life to the fullest, worked very hard, but always made a point to stop and drink in the richness of family life. Those who are old enough to remember shtetl life, before the Holocaust, frequently use the word "rich" to describe their culture. For people without money, means, connections, or power, we were the richest people on earth.

I didn't come from a big town. A census from the mid-1800s says that Molczadz had only 350 people or so. Fifty years later, there were more than 1,700 residents, most of whom were Jews. By the time I was born, in 1916, there were a few more. It was a place of little industrial action but plenty of very busy people. By today's standards, Molczadz was tiny.

We Jews called our town by its Yiddish name, Maitchet. This is the name I wish to remember in connection with my childhood and my family. Molczadz was a town; Maitchet was my home. I guess the Jews a few hundred years before us figured that if our government was bent on forcing us into poverty, discrimination, and oppression, the least we could do was give our town our own name.

were said th
ences melte(
 The Mc
summer, as a
of ice. The i
to be used
after year n
the marketpl
containers fi
ice as we col
salt, chocolat
cream machi
result was w
refreshment a
 In late s
began to roll
was a steady
until it reach(
dam was ere
wheels of tw
were owned
them from t
bring wagon
into a fine po
market day. T
could be squ(
 I am rem
fields, chop (

Molczadz was a Polish (sometimes Russian) village, but Maitchet was our own little shtetl of Jews trying to live according to the law of the Torah and in harmony with our Christian neighbors and friends. We were always fighting a losing battle in this respect. In the years to come, we were all to learn the difference between tolerance and acceptance. For the time being, we Jews were tolerated by our Christian neighbors—who secretly despised our way of life, our religion, our schools, our customs, and our language.

Although we lived in a Christian country, like many other shtetl dwellers in Poland, half the people of Maitchet were Jewish. But if you looked down at us all from heaven, you'd hardly see the differences. All you would see was a community of men, women, and children who scurried about doing this and that—all the things that had to be accomplished from sunup to sundown—plowing fields, chopping wood, making deliveries, repairing roofs, feeding the chickens, shoeing horses, chasing geese, building coffins, sewing clothes, and planting seeds for the future. We were all children of God, even though it wasn't always clear that we shared the same God; the Poles had their churches and we had our synagogues.

But on the street we were neighbors, friends. This is the way it had been for centuries—people just trying to live in peace and quiet, to eke out a livelihood, raise a family, and breathe the fresh air right up until it froze in the Siberian winter wind.

Maitchet was familiar, colorful, vibrant, and the center of my life. That's how I remember it. It was home. This is how I want to remember Maitchet. My little shtetl always lives with me, as do the warm, expression-filled faces of my family. This warmth is suspended in time. My Maitchet meant green, warm summers,

rainy spri
shadowy f

Once
or later. T
and sheets
melt only
on your *tu*
a little mo

Even
the winter
neverendir
cold and th
river turne
the gray-w

As chil
ka with ma
ing our luc
at any min
when fate t
into the ic
running at
ments, a to
down the b
water. Jews
hands and
blankets, an
the river. B
the death o

wagon, and haul it off to our great big barn. It still makes me smile to picture myself sitting on our wagon, driving our horse as my Zayde—my grandfather, Avraham Shmulewicz—was right there with me, always walking a few paces behind my wagon to catch the corn that fell onto the ground. "Nothing should be wasted," he used to say. While I bounced around on the long and bumpy ride, Zayde trudged along, bending over, picking up the corn, and throwing it back onto the wagon. When we reached the barn, I went to work unloading the whole wagon before bringing the corn and wheat inside. We had a technique for knocking off the grain of the wheat from the rest of the plant before sweeping it into a big pile. From the pile, we'd take a large shovel and toss the grain several feet away so that it would separate from the lighter plant fibers that fell to the floor. We'd collect the edible parts of our harvest, let them dry, put them back onto the wagon, and head off to Moshe Aaron Boretsky's flour mill. Inside the mill was a series of large, flat stones used for crushing grain into flour, employing the current of the river to power the mill. When the grain was pulverized, we poured it into our sacks and took it away to be made into the best bread, bagels, rolls, and cakes.

The Molczadaka River not only drove the mills but was our "river of life" in other ways as well. It gave us water when we were thirsty, and on its muddy banks we washed away our sins for Rosh Hashanah, our New Year. On Rosh Hashanah, we made quite the spectacle. In hordes we made our way to the river—mothers, fathers, grandparents, and children of all ages. While the adults stood facing the water, singing, praying, holding their open palms to the sky, and pulling their pockets inside out to empty them before

the warmth of my mothe
family.

And then there was tl
contemplation. People to
was lucky enough to be in
the Molczadaka River to
filled fields to wide-open
appreciated a simple life. I
spring snow recedes into th
and God reveals a canvas
Flowers of pink, yellow, an
shtetl from grassy rooftop
I remember how, suddenly
waves through the fields, n
from the black, rich earth o
and sprouts that would turn
Maitchet transformed itself
nights to the clicking of lea

On rainy days I rememb
looking skyward, as I tried to
my eyes and gazing up at h
mustache and beard, then dr
in a miniature, funny little w
his books—his holy books—

When we stepped into o
background but we knew it
feet and backs swayed to th
melded with the rhythm of

God, the children ran around screaming and playing. After hours of this pilgrimage to the river and the outpouring of faith, hope, and expressions of love for God, the Jews of Maitchet trekked back home and returned the river to its peaceful solitude.

For the children of Maitchet, the river was often a place to have fun or to get into trouble. On the hottest of days, with a running start, we jumped into the water and splashed around. The best swimmer in town was a boy named Moishe Volkomirsky who never lost a race. He was strong and fast and loved to show off as he dove in the water and swam along with no effort while the others tried, but failed, to keep up. If someone came into town and wanted to swim, Moishe would end up challenging him to a race. In all the excitement, while the rest of us cupped our hands over our mouths and screamed words of encouragement for our local hero, Moishe pulled far into the lead. He always came out ahead and won the race.

All the mothers and daughters in Maitchet came to the Molczadaka to do their laundry, rubbing and twisting the family's clothing with handmade soap against big, flat rocks and wooden scrub boards. I can still see my mother and my two little sisters washing our clothes and losing themselves in conversation with other mothers and daughters along the Molczadaka. And if fire ever broke out, a procession formed from the river to the blaze in a bucket brigade. We had a squeaky old water pump in the middle of town, but the river provided more water for less effort.

Maitchet was paradise and it was not paradise. For certain, our life in Maitchet was not "the easy life." Like anywhere else in Eastern Europe, as far as people were concerned, there were good

and bad. But all had the
Gentiles and Jews alike. V
and never tempt the har
were far more justified. H
We knew that we had to
year-old fear of the Jew ;
we worked and played an
Maitchet was Jewish—the
tradition of thinking of us ;
believed urban legends th
of Christian children as ar
or how we were all evil ;
generations, watching our
us bake matzohs, and pee
still not enough to keep ou
were being kept from then
would some day find out. V
different; they didn't under
they didn't know; and their
businesspeople, merchants,
assets were held against us v
side by side, but we were s
invisible wall that we had to

So how can I remember
eyes open you couldn't miss
childhood in this place that
conveniences. I was blessed
hills, aromatic pine trees th

synagogue. God was talking back to us. I could hear Him tapping on the roof. We sang to God, we questioned God, we pleaded to God, and we demanded His help and guidance. For a couple of hours in shul, we were protected from a ceaseless, steady course of rain and thunder.

Yiddish Culture

In the days of my youth, and even to this day, there were famous shtetls that everyone had heard of, like Vilna, Bialystok, Chelm, Mezritch, and Belz. These towns were made famous by the rabbis and the intensity of Jewish study. But few people today realize that Maitchet was also famous, at least to the most scholarly of all Yeshiva students and rabbis. Our little shtetl still remains connected to one of the brightest, most influential Jewish scholars, Shlomo Pelachek, and his life began like most others in eastern Poland.

Years before I came into this world, Shlomo was living far out in the country, tending cows and chickens. But soon it became apparent that Shlomo Pelachek was no ordinary boy. Even though he spent his whole life on a farm, he managed to learn Hebrew, the Torah, the Talmud, and any other teaching he could get his hands on. He was mostly self-taught, yet his hunger for knowledge brought him into prominence in all of Eastern Europe's Jewish quarters—and eventually in America and throughout the rest of the world.

Shlomo Pelachek, born in 1877, was my grandmother's cousin. By the age of twelve, he was recognized as a genius, a prodigy of

tremendous rarity. A Yeshiva student from Volozhin, named Aaron
Rabinowitz, happened upon Shlomo on a farm near Maitchet and
after speaking with him for a short while convinced the bashful boy
to go to Volozhin and meet Rabbi Berlin, the Rosh Yeshiva (head
of the Yeshiva). It was suggested by Aaron Rabinowitz that Shlomo
Pelachek be considered for enrollment in the Yeshiva without
delay. Of course, this was no small order, because most Yeshiva
candidates, if accepted at all, were not admitted until they reached
seventeen years of age or older. Rabbi Berlin was taken aback at the
mere suggestion of such a young boy joining his famous Yeshiva
and mockingly asked Rabinowitz, "Why didn't you bring his
crib along?"

Aaron Rabinowitz thumbed his nose at this insult but knew
what he had in this prodigy. He confidently said to the rabbi, "Let
the Rosh Yeshiva test him and decide what crib he needs." At this,
Rabbi Berlin began to quiz Shlomo on the Torah and very quickly
Shlomo proved his genius. He answered questions as if he were a
sage, and his recall of the Torah was so precise that at times the rabbis
had to pause, run their fingers through their long gray beards, stare
blankly at one another, and check the facts for themselves. When
Rabbi Soloveichik asked Shlomo Pelachek where he was from, the
boy answered, "From Maitchet." And this is how my grandmother's
cousin became known throughout all of Jewish Eastern Europe as
the "Maitcheter Iluy," the "Hiddushei Ha'iluy Mimaitchet," which
means the "prodigy from Maitchet."

Once Shlomo Pelachek was accepted to the Yeshiva, he was
given the task of covering ten pages of the Gemara daily, and his
roommates were assigned to keep an eye on him, engage him in

conversation on what he studied, and make sure he completed his homework. Every Friday night, Rabbi Soloveichik tested Shlomo on his newfound knowledge and always parted in a state of amazement. Nobody else at the Yeshiva could keep pace with him. When at last Shlomo turned thirteen and became a bar mitzvah, the head rabbi made a special breakfast in his honor, which, according to the rabbi's son, was possibly the first time the Volozhin Yeshiva ever celebrated the bar mitzvah of a student.

In the winter of 1892, the Volozhin Yeshiva closed down and Shlomo spent time on his own studying in Minsk. Not long afterward, Rabbi Soloveichik, the rabbi of the shtetl Brisk, invited Shlomo to come join him.

Shlomo continued to gain a reputation as the preeminent scholar of his day while at the same time gaining the respect of everyone due to his kindness, humility, and charity. It is said that when Shlomo was in Volozhin, he would bring several shirts with him at the beginning of each semester but never returned home with more than one: he had given the other shirts away to students needier than himself. The chief rabbi spoke highly of our Maitcheter's power to grasp the deeper meaning of the Jewish teachings and said in later years that, in all his life, he had never met as extraordinary an *iluy*—genius—as Shlomo Pelachek.

In 1896, when Shlomo was eighteen years old, he was convinced by a fellow student to leave the Yeshiva Brisk where he was then studying and to join a more advanced Yeshiva; and shortly after that he headed to Vilna—the most famous center for Jewish learning in the world at the time.

By 1905, eleven years before I was born, Shlomo Pelachek, now a rabbi of great fame, married a wealthy young woman from the town of Ivenitz. Unsuccessful in the business world, he went back to learning and teaching in the Lida Yeshiva until World War I broke out. To avoid the war, Shlomo fled deep into Russia where he wandered from place to place until the war's end.

In 1921, Rabbi Shlomo Pelachek returned to Poland and settled in Bialystok. There, his lectures became famous, though he never wrote down what he said, and one of his associates filled a thousand pages with Shlomo's teachings and gave them to him in a bulging leather briefcase.

My distant cousin, Shlomo Pelachek, the Maitcheter Iluy, was only fifty years old when he died. In memoriam, the scholarly Jewish community published a special paper called "Aidainu," Our Tragedy, paying tribute to Shlomo, his work, and the sadness left at his passing. It has been said that nobody could meet Shlomo Pelachek and not be overwhelmed by his genius, though he was the only one who did not comprehend his own brilliance. To this day, his reputation as a scholar, a prodigy, and a man of virtue and charity among the most learned Jews of the world lives on. If you go to Israel, you will find a street named after Shlomo Pelachek in Jerusalem.

After the Holocaust, when I had just moved to New York City, I went looking for a synagogue to join. One day I walked into a shul in midtown Manhattan and introduced myself to the rabbi. He asked me where I was from and I told him Maitchet. The first words out of his mouth were, "Did you ever hear of the Maitcheter Iluy, Shlomo Pelachek?" I said, "Are you kidding? He was my grandmother's cousin!" and I joined the synagogue on the spot.

Answering Questions with Questions

We Jews had three places of worship in Maitchet. We had our old synagogue that had been built years and years ago that we affectionately called the "cold synagogue" (*kalte shul*) because it had no heat. In the winter it was so cold that a steady cloud of steam came out of our mouths as we talked and prayed.

When you stepped inside the cold synagogue, after kissing the mezuzah on the old, weathered door frame, there was an anteroom, a lobby of sorts, with tables and chairs. Passing through the anteroom there were two large, sturdy wooden doors that opened onto a stairway going down below ground level. At the bottom of the stairs was the entrance to the floor of the synagogue made of well-polished, dark, wooden planks that ran beneath rows of seats. Our family always occupied the same spot in the cold synagogue—in the front row. To our left, and upstairs, opposite the entrance, was where, in traditional style, the women sat. And in the center of the room was the bimah.

When we entered the cold synagogue, we entered another world. Here we found ourselves in a special, holy place, and for this reason alone we wore our finest clothes as a show of our respect

and reverence. We respected the fact that our synagogue was the home of the Torah, the sacred teachings of our people, housed in a hand-carved wooden Ark of the Covenant.

Our Torah was more than just a gift from God. It was a symbol of who we were and where we were going. Like other Jewish boys, I began to learn Hebrew at around age four. I was eager to read. Something about languages always intrigued me. My heart filled with joy at the thought of picking up a pen, dipping it in a well of black ink, and forming Hebrew letters onto scraps of paper in Zayde's home office. Sometimes, Momma used to keep me from getting to my lesson quickly. I so wanted to go—to be like a grown-up, like Papa and Zayde. Looking back now, I was honored to feel the warm comfort of Zayde's hand holding mine, to help direct my pen, as I carefully drew each letter of the alphabet like it was a piece of art. "Beautiful, Motel," Zayde would say. He would clap his hands and I'd beam with a smile. Zayde filled me with a kind of joy that I cannot describe.

Nine years from the time I began to learn Hebrew, I became a bar mitzvah and earned the right to take my place among the other men and read from the Torah in shul. I cannot begin to tell you what a great honor it was for me to ascend the steps in the center of the synagogue and stand beside my father, grandfather, and uncles. I was a proud part of something so much greater than myself; I was a part of a special history of learning and respect for knowledge; I was a part of a proud family; I was a part of the richest Jewish culture that ever existed; I was carrying on the tradition, and the eyes of my entire family were on me as I sang from the Torah in shul.

When the Torah was opened in the kalte shul, not one person failed to understand that this old scroll with its yellowed edges and coiled pages was a treasure beyond words. Our old, handwritten Torah held within its pages a treasury of prose, poetry, and metaphor wrapped around the history of our people and brought to this point by blood and suffering. The Torah spoke to us of Abraham and his covenant with God and of the exodus of the Jews from Egypt when the nation of Israel was formed. All of our past, present, and future were wrapped up beneath the velvet cloth and the brass breastplate. This was our Torah. We alone, as a People, treasured it and brought it with us from place to place, through fires and floods, through pogroms and exiles, to this place, to this cold, old synagogue in Maitchet. Not a one of us would dare forget this. I remember it still.

Each Shabbos we opened the Torah, read a portion of it, then paraded it around for all to kiss—a kiss of respect and love of the word of God. To the non-Jews it may have looked as if we worshipped the Torah, but this couldn't be farther from the truth. The Torah inspired us to sing and dance, to think and celebrate, and to hold our heads high with pride and bow them low in humility. Our Torah was the sea and we were the tide, ebbing and flowing, rising and falling, moaning and davening in cascades of minor notes flooding every corner of the synagogue.

Our music was the kind of music you could not find anywhere else. Sometimes it sounded like crying, wailing; other times it lulled you into a deep well of contemplation or was light enough to lift your heart and prayers to heaven.

Each time our service was finished, the Torah would be dressed again and returned to the Ark until the rebirth of Shabbos when we would read the next portion of our people's history. The sounds of our synagogue still resonate in my ears. I hear the music, yet the voices are gone. Forever lost in silence are the voices of the kalte shul of Maitchet. I stand in my synagogue now, across the world from Maitchet, but behind my closed eyes I am there in the kalte shul drowning in the music.

Our cold synagogue was certainly a special, holy place for us, but it was not the sole center of Jewish life in our town. Our *stiebl* (little community synagogue) was a smaller building used for intense study, where we sat crowded in a minyan around big tables and pored over the meanings and the subtleties of the Talmud. I used to go to the stiebl with Zayde who taught me the Gemara, a text that poses a variety of questions on issues that still have relevance in today's world.

Through the Gemara, Zayde taught me that life is full of unanswered questions. The law is never concrete—even the law of God has to be discussed and interpreted. The Gemara made us think about some of the more difficult questions of law. Many times, the answer would be, "This cannot be answered until the Moshiach comes!" Wait for the Messiah? I'd think. How can a problem be so big that you need outside help to solve it? This is a question whose answer I would one day discover the hard way.

The law, we learned, was not simple; it made you think about the far-reaching effects of your actions: be careful, be considerate, think ahead, watch your step. The Gentiles always complained about how we had our heads in the books and that we were too clever.

How could we not be when all we thought about was the law? But this jealousy was a very insidious thing, growing into a hate and fear that would soon prove unimaginably destructive.

For three thousand years we learned to examine the law under a magnifying glass. I recall one conversation in particular about brotherhood. The rabbi in our stiebl posed this scenario, one that would be all-too real for me later in life: A man has to cross the desert and it will take him ten days, and so he takes enough water and bread for that time. He is walking and sees a man coming the other way. The man has no bread or water. Now the question: If he shares the bread and water, they will both continue for another five days and then die. But if he gives the man nothing, he will cross the desert but he will leave his fellow man to die. It is not his fault, but he will violate Jewish law. How can you make a decision about this kind of dilemma?

One day in the not-so-distant future, I would find myself in just this situation with hardly enough bread to survive on my own. Yet, how could I deny a share of my bread with the shivering living skeleton starving next to me in Mauthausen concentration camp? Thinking back on this, I feel as though our Jewish teachings prepared us for difficult situations, for impossible, choiceless choices.

In Hebrew, Jewish law is called Halacha and to the Jews, the law is a living and breathing thing. This is how we see all of our teachings. You study these things your entire life, as did my father, my grandfather, and so many of the others from my world, but you find out that it is more of an exercise in thinking and reasoning than it is in finding concrete solutions. You get an idea but rarely a

concrete solution. This is why it is said so often that when you have a room with ten Jews, you get eleven opinions.

In our Yeshivas we learned to read between the lines. That's the way life is, and that's the way we were trained as religious scholars. The old stories of the Torah were not just some literal explanation of history; they were metaphors giving us insight into how people think and act. The story of Abraham wasn't just about a man who blindly followed the voice of God. It was a story of man's struggle with himself, his commitment to ideals, and the power of his love for both his God and his son. The story of Moses in the desert with the nation of Israel was about doubt, questioning, and the fear of the unknown, moving from generations of hardships in Egypt into a dark void of uncertainty.

The specific, carefully chosen words that are used in our teachings are sometimes as important as the sentences. We used to study the words themselves, why certain words were chosen instead of others, words with double meanings.

Zayde taught me that the Gemara began with questions—clever, thought-provoking questions. And questions lead to other questions. In this way we live in an eternal discussion.

In the Yeshiva I learned that the Jewish Sanhedrin (a council of seventy-one people) was set up to tackle these questions and to mete out justice in ancient Jerusalem. This led to Jewish scholars all over the world attempting to find conclusions to ethical questions. This promoted competition in shul, with each person trying to make a valid argument based on his understanding of the law. While the competition only made us think harder, nothing could fully prepare us for the senseless times to come.

Dreaming of a New World

Yeshivas dotted the landscape all over Eastern Europe, so when we Yeshiva bochers traveled around, we always had a place where we could stop and study the law.

Maitchet had its own Yeshiva, but so did shtetls near and far. There were Yeshivas all over Poland, Lithuania, and Russia, in the towns of Baranowicze, Slonim, Nowogrudek, Malaat, and Mir. When I went to another town to study at the Yeshiva, some nice family would take me in for a couple of days. Somebody's momma would feed me and give me a bed so I could study the law with the men of the shtetl. When you did this enough, you found out whose mother was the best cook, so the next time you came to town you knew where you wanted to stay.

An hour before the sun rose, I was standing by my bed, loading my books in my knapsack. When I was dressed, I made my way into the kitchen. Momma was already awake and had my breakfast ready. I sat down at the table as she set a bowl of hot cereal in front of me, gave me a spoon, and kissed me on the forehead. "Did you have a good sleep?" Momma would ask me. Sleep? I couldn't sleep for the anticipation of traveling. I loved it. Momma was worried about

me but hardly voiced her concerns. I could just see it in her eyes. I, on the other hand, couldn't wait to hit the road. My little sisters, rubbing their eyes, wandered into the kitchen and nestled up to Momma. As soon as I finished my breakfast, I kissed them all good-bye and flew out the front door. I couldn't wait to get started.

The experience of being a Yeshiva bocher meant more than just studying Torah and Talmud—it was about all the different people I met along the way. I came to know students and their families from many miles around Maitchet. I got to know the lay of the land, the major roads, back roads, the forests, and the fields. It was one big, welcomed adventure.

Once in a while, as I began to get older, I would hear stories of impending pogroms and of the stirring political situation to the west. Many times I would arrive at a stranger's house and, over dinner, we would end up in a discussion about growing hatred toward the Jews in Germany, Poland, and Russia. Wherever I went, people were worried about the future of Jews in Europe. All over, including at home in Maitchet, groups were forming to discuss leaving Eastern Europe altogether. We all knew it was never safe for Jews and never would be. With each passing year of my youth, discussions of Palestine entered conversations more and more frequently. This was reinforced by our teachings, reminding us of our goal to return to our homeland. Zionism was a train picking up steam.

When I was a teenager, I joined two Zionist groups. I came to understand that there were a lot of young Jews who strongly believed that there was no future for us where anti-Semitism was tolerated by the Church, the government, and the general

population. Zionist leaders were actively manifesting an ancient dream and we were all getting caught up in the excitement. Even during brief periods when there were no wars, the Zionists would tell us that we still had never found peace and had always lived with an uncertain future. Further, we were never allowed full freedom or equality, were always cringing when our borders were redrawn, and were dreading that a more powerful country would send us an even more belligerent landlord. We were constantly bracing for the next pogrom.

One of the Zionist groups I joined was called Shomer Hatzair. Later I joined another Zionist organization known as Betar. I'll never forget one of my first experiences at a Betar gathering. It was in Baranowicze and I was there with my father. There was excitement in the air. My father stood next to me with his arms crossed and his eyes glued to the speakers. There was a young man, Vladimir (Zev) Jabotinsky, standing on a makeshift wooden platform in front of the crowd who was giving an impassioned speech about how Jews needed to return to their own homeland. He said, "For thousands of years we have been mistreated, murdered, and given no rights as human beings; we must find our way to our own land or we will die as victims of hate." Also giving talks around Poland during this time was a young man who would one day become not only my close friend but also the prime minister of Israel. His name was Menachem Begin.

The most striking memory I have of Jabotinsky's speech still haunts me. He said to a crowd of Polish Jews, "You will not build Israel with money, but with your blood." These words brought tears to my eyes. His impassioned words rang in my ears over and over as

they brought to mind death and tragedy—a sacrifice to be made at the altar of the world. Jabotinsky's talk of a place where Jews could be free from random murders, raping, and pillaging, and where we would have a chance to be Jews without fear, struck me to the core. Building a Jewish homeland would not be easy, but what was ever easy for the Jews? One way or another, Jewish blood will be shed, Jabotinsky preached. A lot of people thought he was a radical, an alarmist, but he turned out to be a prophet, of sorts.

The Zionist youth group Betar was born in Latvia in 1923 after the First World War, when I was almost seven years old. It took root as more and more hate, pushed to the front by political changes, grew for the European Jews. The Zionist groups were responding to the growing nationalism and ethnic pride of Germans and other European people. Nationalism and ethnic pride needs an enemy to succeed; the Jewish people would one day soon openly be declared that enemy.

Unlike other Zionist groups, Betar was concerned with life and death. Our group concerns seemed to have so much more gravity. We weren't talking about recreation, camping, staring at the stars or hiking. Our concerns were with life and death. The work of every Zionist organization was tied to an ancient longing to return to the land of milk and honey. This yearning has been in our prayers for thousands of years. To this day, not a Shabbos goes by when we do not speak of our dream to return. Week after week, in shuls all across Europe, Jews would cry out the words, "Jerusalem, if I forget thee, may I lose my right arm." It had been thousands of years, but in Maitchet and every other shtetl, we clung to this dream.

Practically speaking, Betar had us thinking about leaving the evils of Europe and settling in Palestine. The ideology of Betar included creating a formal Jewish state in the territory of Mandatory Palestine, providing a new home for exiles, embracing Zionism without a socialist component, founding a just society, engaging in military training for self-defense, and developing a pioneering spirit. These were no lofty ideas; people like Menachem Begin and Zev Jabotinsky were serious about them. They had plans, not dreams. I was inspired. In the middle of snowstorms, we dreamt about raking a garden hoe across the desert sand in a kibbutz somewhere near Jerusalem or maybe on the frontier.

Convinced of the need to leave Poland, I once had a long conversation with my father, trying to get him to move to Palestine and start a new life. As soon as I started talking, though, Papa made it clear that he would have no part in this. He told me that Maitchet was where his family was; he couldn't think about leaving his mother, father, cousins, brothers, aunts, and uncles. For generations we had built a life here. Papa learned from his own father that family was more important than anything; without a family, life had no purpose. So that was that. Over the next few years, I found myself saying good-bye to most of my friends as they kissed their crying parents and little brothers and sisters and left for Palestine.

Many who traveled out of their shtetls and eventually made it to Palestine arrived virtually without any money and no place to live. Yet they stayed and began to work the land and find a new home in a kibbutz far from the troubles of Eastern Europe. Of course, these emigrants had no idea that the Holocaust was coming, but they were among the few who escaped with their lives. After the war,

I was lucky enough to reconnect with many of my friends who had moved to Palestine and to reminisce about Maitchet, which remained, in their minds, unchanged.

There was a wide range of opinions about the Palestine issue in those days. People remained in Maitchet for all kinds of reasons. Some didn't want to leave older relatives behind. Others, like the Jews out of Egypt in the olden days, were afraid of the unknown. There were also many Jews who felt that the trip to Palestine was just a dream and not really a possibility. Some even thought that there was no need for a Jewish homeland—our home was safe and sound in Eastern Europe. Life presents some bumps and bruises now and then, they'd argue, but you can't run from your problems. And then there were some who stood around waiting for a sign that the time was right. "How will we know when to go to Palestine?" some of the older rabbis would pose. Then they'd answer their own question, "We'll know because God will send Moshiach."

I was in the middle, with the Zionist groups tugging on me on one side and my family and tradition pulling on the other. Countless times I thought of heading out on my own for Palestine, but I always thought of my father's sentiments and could not bring myself to leave my entire family behind. My life, my soul, was in Maitchet.

Shabbat Shalom

I was torn. As a restless youth, part of me longed for Eretz Yisroel and the other part felt that home was here in Maitchet. This was my life; these were my people. Time with my family, endless hours spent with Zayde discussing Jewish law, my mother's cooking, the smiles on the faces of my little sisters, and my father's love, as well as my studies in the Yeshivas and shul, won out. All of these precious things made life worth living. And I kept asking myself: In Palestine, would I find scholars stuffed into shtiebls heatedly debating the subtlest shades of the law? What would Sukkot, Passover, Yom Kippur, or Shevuot be like in the desert? What about Shabbos?

In Maitchet, Shabbos was the greatest of all holidays—the most important and the most celebrated. Shabbos was a time to make a departure from the ordinary. You didn't work, you didn't clean, and you didn't do any other chores. It was a break from the normal, daily routines of life.

How I miss the Shabbos of my youth. I thank God for giving me these memories of Shabbos candles in the windows, bright tablecloths, and the radiant faces of relatives and guests who laughed and cried at my Bubbie's table. My childhood memories

are treasures within treasures, better than gold, and I was richer than anyone could dream possible as my ears soaked up the sounds of my cousins playing around the table, the voices of my little sisters preparing the Shabbos bread and kugel, and the sweet music filling me to the soul in shul, rocking me back and forth before Torah, God, and a room full of scholars. My mouth still waters for the taste of cholent on my lips.

Cholent. What is cholent? We used to have a joke about cholent. People ask what cholent is. Cholent is what the father puts into the oven on Friday and the mother takes out on Saturday. Maybe the joke loses something from the original Yiddish. Anyway, cholent is a stew that we only ate on Shabbos day. Momma, Bubbie, and my aunts had cholent simmering on their stoves for hours and hours until the flavors of potatoes, carrots, garlic, mushrooms, onions, beef, and other ingredients just melded into one wonderful experience. I haven't had cholent since my childhood.

My memory of Shabbos in Maitchet is not complete without Sorah Henya, a young woman who worked for Bielski the baker. Sorah would stand in Bielski's little bakery and load up a *koshik*—a big basket—overflowing with kugel, challah, and *bulkas* (rolls). When Sorah's basket was full, she left Bielski's house that sat right near the market square, near Zayde's house, and set out on foot into the neighborhood. She was a welcomed sight every Shabbos evening—this sweet young lady with a pleasant smile and happy eyes. She approached every house with warm expectation, selling the breads from her basket.

Every Shabbos in Maitchet began with our Jewish town crier, Moishe, hurriedly shuffling from one side of Maitchet to the other

singing out, "Shabbos! It's Shabbos! Time to light the Shabbos candles!" Moishe encouraged everyone to go home and be with family. "Go home and eat; go home and celebrate." As the sun began to set, businesses were closed and locked, vendors banged and clanged while they piled their wares onto their pushcarts, and Gentiles and Jews parted ways. Many a Gentile would pat us on the back and utter the phrase, "*Gut Shabbos.*"

By the time Shabbos came, my mother, Esther, and my two little sisters, Peshia and Elka, had been working feverishly in the kitchen, cooking, cleaning, baking challah, making soup, baking kugel, taking down special serving dishes, setting the Shabbos candles on the table, and sweeping the floor and washing it spotless. All of this had to be done before sundown, according to Jewish law.

Then, at last, it was Shabbos and the pots and pans stopped clanging. No more cooking; no more cleaning. Any dishes that had piled up would wait until late the next day before they were taken care of. As I walked down the street, I could see the lighting of Shabbos candles through the windows of every house. Mothers dressed in pretty shawls draped over their heads brought their hands to their closed eyes in prayer as the candles were lit. Throughout Maitchet, the voice of each momma was heard softly singing the prayer, "Blessed are You, our God, who has trusted us to celebrate and know your Shabbos. Grant us peace, protect our children and our families, and allow us to fulfill your commandments." And so the Shabbos candles burned brightly in Maitchet as they had for thousands of years in the homes of Jews throughout the world. The holiday had begun. This memory of Shabbos, our most sacred event, even now brings me joy and tears.

Clean, crisp tablecloths, carefully embroidered and handed down through the generations, caressed dining room tables, and special dishes used only for Shabbos were standing in front of a feast fit for a king.

For me, my sisters, and my mother and father, Shabbos was almost always spent at my father's parents' house. Bubbie and Zayde were the Shabbos hosts for the whole extended family. My grandmother's heavy wooden table was very large, and her kitchen was so big that twenty or more people could sit down to eat together. My uncles (my father's four brothers) and their wives would each bring food to the house and soon the walls were shaking from the commotion. All my cousins were there, including Chonyeh, the one closest to me. Chonyeh was more like a friend than a relative; when we went out to play, I kept my eye on him so he wouldn't get picked on. His brother, Moishe, usually sat beside him at the table. Across from me was my cousin Yossel, who one day would become the head of the fire department. Sometimes after dinner, Yossel would entertain us with his clarinet—the same clarinet he would become known for playing at many weddings in Maitchet over the coming years.

No Shabbos would have been complete without strangers. There were always visitors passing through, people on vacation and *maggids*—religious scholars on a teaching tour. We were never without strangers at our table. Zayde taught us all about the value of sharing with others. "We'll invite them to eat with us, share the Shabbos, and then they won't be strangers anymore." That's how Zayde thought. "Anyway, did you ever think, Motel, that maybe to

others we are the strangers? If you were tired and hungry, think of how much you would appreciate such generosity."

Shabbos was a celebration beyond imagination: forks brought to hungry lips; red wine sipped from special Shabbos glasses; my aunts feeding their little children from their plates; the eyes of my family, now smiling, dancing, sparkling. We would talk about Palestine. We'd talk about my Aunt Frieda, my mother's sister, in New York with her family. We'd laugh at silly jokes and riddles. We'd gossip about the next town play and who was making the costumes and the props. The sounds of the voices and commotion would rise and fall like a musical concert. And somewhere in between, inevitably and without fail, we would raise our glasses and toast, "*L'Chaim*, to life!" To life.

I have to ask myself now, what kind of God could give us such a wonderful occasion? This weekly gift. What kind of ingenious idea is this that sets apart one day of the week to honor life and family and friends? If I close my eyes, I hear their voices; I breathe in the sweetness of challah and red wine. We were safe and happy and free in our Shabbos, sitting and talking and laughing as a family, with my Zayde at the head of the table kvelling over his children and his grandchildren.

All of these memories are alive within me. I close my eyes and there's my grandmother, my Bubbie, sitting at the other end of the table, across from Zayde. She watches me. I look up at her and smile because I happen to spot one of her cakes sitting on the counter. She knows how much I love her cakes. Just a few days before, I snuck up to the window of Bubbie's kitchen where a cake was sitting by itself on the ledge. Quietly moving along the wall of the

house like a spy in the night, I popped my head up to look inside the kitchen. Bubbie was nowhere in sight, so I reached out and grabbed a piece of the cake then ran off to eat it. It was a sort of game between Bubbie and me. She knew I was the thief, but she never said a word; and she never stopped leaving her cakes alone on the window sill.

Dinner at Bubbie's lasted for hours. We made *b'ruchas* (blessings) over bread, wine, dinner, and one another. We ate until we couldn't take another bite. Some of my cousins fell asleep on the floor by the fire. Our guests would excuse themselves then throw themselves on the bed as we stragglers listened to them snoring all the way into the kitchen. Then my mother and father would stand up, walk over to Bubbie and Zayde, give them a kiss, and take us home. It was a short trip home from my grandparents' house at the edge of the market square to ours at the other end of the street. In his strong arms, my father carried Elka and Peshia, half asleep, past the darkened homes and in through our front door. Papa laid my sisters into their beds and Momma carefully tucked them in. Then my parents would stare at their sleeping jewels for a while before saying good night to me.

The next day, Shabbos morning, we would all dress in our special Shabbos clothes and walk to the kalte shul. We were a proud family, all walking together with Papa in the lead.

Once again, as we entered the kalte shul, the world outside no longer existed. In minutes we were swaying to and fro, singing, bowing, bending, standing. We sang to God; and we sang with God. I closed my eyes and listened and became lost in the heavenly music. All of my senses willfully absorbed the deep, melodic, hypnotic

voices forming a symphony that shattered into a rumbling murmur before falling to absolute silence. It was instinctual and all at once the voices would rise again in musical prayer. This is a sound like no other. Ancient and moving, touching the heart and cleansing the soul and body. Sometimes I heard nobody else but Zayde. Then, like a switch being turned on, I would hear a rabbi from far across the room, then another from the back. Each voice was different. Each voice swelled in harmony. It was Shabbos and there was no room for inhibition. If you want God to hear you, you've got to give it all you've got.

I watched intently as an old man with his prayer shawl covering all but his face stood stooped over the Torah to sing the Haftorah. People were still filing into the synagogue. Their friends were greeting them with hugs and handshakes, while at the same time the old man's voice rose up, then down, then drifted, then moaned and cried.

We who spoke Polish, Russian, and Yiddish outside the walls of the shul spoke our own language inside. This was the language of our fathers and their fathers, the language of our homeland, Eretz Yisroel. Led by the main rabbi, in Hebrew we thanked God for taking us out of Egypt and bringing us to Israel and we prayed that we might return one day. We were in exile in Europe. Our real home was a warm place where the wall of the Second Temple still stood in the desert to remind us where we came from and where we dreamed to return.

In shul I always found myself ecstatic, enveloped in a world a million miles away from the chilly air, muddy streets, and damp morning that lay beyond the walls. Shul transported me back into

the history of my people. Our thoughts were with Moses as he carried the weight of a new nation under the blistering sun and across vast, parched, and sandy lands to lead our people out of Egypt. Each Shabbos we yearned to return to this other world of our dreams. The rabbi called it the land of milk and honey, and we sang to it, turning to the southeast. Outside it would begin to drizzle, but my mind had settled on the warm soil of Eretz Yisroel.

When our service had finally ended, and maybe the rain had stopped, the sun would peak through the clouds and take the chill out of the air all the way home. I would more times than not leave the kalte shul filled with questions that I could finally ask Zayde: How did the Jews cross the Red Sea? Where is the Red Sea? Have you ever seen it, Zayde? How did this happen? What did this mean? Have you been to Eretz Yisroel? Where is God? What does He sound like?

Zayde would think for a minute then say, "God led the children of Israel out of the land of the Egyptians, Motel Leib. And do you know what they discovered as soon as they parted?"

"Freedom?" I asked. I was proud of my answer.

"Danger," Zayde answered. His smile had disappeared and his eyebrows lowered in seriousness. "We discovered a world of danger, and we've been living in that world ever since."

I think about my Zayde every day. In my head I hear his words of wisdom and I hear him singing in shul. I close my eyes and I am with him. I close my eyes and see it all: my entire childhood and all those who are still so dear to me. Then I think of the danger that we were all in as I walked with Zayde down the road, the heels of our shoes clacking against the cobblestones. Jews were always

living on the edge of danger. It was on Zayde's mind, and now it would always be on mine. It had been this way for all Jews since our people left Egypt.

Yearning to Touch the Past

Not a day goes by when I don't think of Maitchet. Over the years I have reunited with a few remaining friends who once lived in our faraway home. I have painted paintings and drawn pictures of it. I have pored over my books and family photographs. And I have even written poems:

Greetings to my little town, in a faraway land.
Greetings to my little house; I'd like to touch you with my
 hands.
You have changed by now. I love you so.
You, Maitchet, are so dear to me, with pain in my heart.
Now, so far away and so many years behind, I stop to ask Why.
I know the world is stormy now.
There are broken-down, old trees.
Overflowing riverbanks, and blood up to my knees.
There was beauty once up there; I wonder where all this has
 gone.
There was life; there were children playing from morning to
 dawn.

All has gone, just memories.

In Silence, from far away, I greet you; I touch you and I
 cry.

Today my memories meld with the present: inseparable and inconsolable. What I remember of Maitchet is not enough to bring me closer to what I have lost, but I have no choice. Memories will have to do. My little hometown is gone. All the Jews are gone. I am here so far away. My memories hold onto a place that can no longer be touched with the five senses. My memory alone holds the Shabbos voices, the village marketplace, Zayde's house, and the gentle wind blowing the leaves on the summer trees. I hear the slow current of the river and the ladies' singsong voices as they wash their laundry at the water's edge. I dream that I can touch the past. My memories form a foggy, well-worn bridge to this other world from which I came.

It is October 2007. I have made it to the ripe old age of ninety—almost ninety-one—and I hold in my hand a letter. The envelope still bears two twenty-five groszy stamps from Poland. A rubber-stamped indicia bears the name Molczadz. I stare at this remnant. It is real. The ink from Zayde's pen is real. His handwriting survives, as do his words. Perhaps with scientific instrumentation we would discover hairs from Zayde's beard on this letter, or maybe oil stains from his loving fingers. Zayde wrote this letter in 1928. His handwriting is on it, in Yiddish, as clear and crisp as if he just laid it into my hands. "Here, Motel Leib, I want you to read this letter. I wrote it eighty years ago while you were a ten-year-old boy play-

ing outside my window. Here, Grandson, read my words, hold this letter in your hands, and you will be able to touch me once again."

Zayde's letter brings the news of the old country to the new. Zayde's letter crossed the Atlantic and was delivered to my Aunt Frieda, my mother's sister, who had been living in New York since 1922. My grandfather was asking for money. Things were not going entirely well, financially speaking, and American dollars would go a long way in our corner of the world. Zayde writes to Aunt Frieda that my great-grandmother died. He tells her nothing about Nazis or atrocities; these things are of the future and do not yet exist.

When this four-page letter, on lined paper, in blue ink, was written in cursive Hebrew from Zayde's pen, the problems of life in Maitchet were still small—trivial by most standards. Outside his window, from his writing desk, he watched as his grandchildren ran across the market square kicking a soccer ball. And from the other direction, ten minutes later, he watched one of his sons riding an old hay wagon into town from the fields. These sights made him smile and filled him with happiness. Maybe if I hold Zayde's letter to my ear I can hear his laughter. Maybe I can hear him call Bubbie, "Come here, come watch out the window. There goes Shlomo. What's he carrying all by himself? And look at Zimmel pushing that cart. Shhh. Here comes Motel sneaking around the back of the house. He thinks we don't see him. Did you leave a cake for him on the window sill?" Zayde's smiling eyes still gaze upon his words that I now cradle in my hands.

I cling to Zayde's letter of no great significance because it is so very important and meaningful—a contradiction of terms, I am

sure. But you see, with this letter I can have my grandfather once again. I can feel his hand, the hand that used to hold my hand along the snow-packed roads of Maitchet on the way to shul. Now I am left with Zayde's letter and a dozen photographs to remember my family.

From time to time I sit at my kitchen table, take out my pictures, and stare at my mother's face. I have to thank her for thinking ahead. She was as aware as anyone that Jews were never safe in our corner of the world, and the next pogrom was always around the corner. In her wisdom, my mother sent copies of family photographs to her sister, Frieda, for safekeeping. These are wonderful photographs, some more than a hundred years old. I'm looking at one now. I am on the right and beside me, on the edge of my grandfather's forest, are my two little sisters, Elka and Peshia. I'm a strong, healthy young man in the photograph, and my sisters are girls without a care in the world. They're wearing dresses Momma made for them and they're smiling into the camera. I can almost hear them giggling. "Take the picture already," Peshia tells Momma. "We want to go pick flowers before supper." I have the photograph still, but my beautiful sisters, like the flowers, are all gone.

Visiting Baranowicze

Before daylight, my mother would pack my father and me provisions for our daylong trip to Baranowicze. It was a slow, twenty-mile ride by horse and wagon. Momma made us cheese sandwiches and kugel and put them in a sack along with some fruit that was grown in our family's little orchard. Heading southeast by horse-drawn wagon, my father and I would first travel through a little shtetl called Mush. Baranowicze was only a couple more miles down the road.

As a teenager, a trip to Baranowicze was a great adventure—a place far from home with a thousand exotic sights and sounds. It was a big, busy, industrial city that by today's standards would hardly be noteworthy. But in the days before the war, Baranowicze was the center of our world.

Baranowicze was first a village owned by a Polish family named Rozwadowski in 1706. By the end of the 1700s the town became part of the Russian Empire. A hundred years after this, Baranowicze was "on the map" because it became an important railway junction of the Warsaw-to-Moscow and Vilna-to-Lviv lines. By the late 1800s, more than five thousand people lived in Baranowicze and

half were Jews. In the center of town were wide roads paved with round fieldstones. Hundreds of people were walking here and there.

At the time of my first visit, in the early 1930s, about twenty thousand people were living in the city.

Baranowicze was a trading post for every kind of product you could think of—from pillows to jewelry. The thick forests around Baranowicze made the area a lumber capital, where trees were milled, stacked in warehouses and yards, sold, loaded on trains, and shipped to the four corners of the country. As we rolled along in our wagon, we'd see lumber piled twenty feet high, with workers hauling it off to trains waiting to take it to Germany or some other far-off place. Since Baranowicze was also home to a large Polish army base, much of the town's industry was geared to supplying the military with basic needs, including food, uniforms, leather belts, and hats.

Baranowicze had every kind of store you could think of. While my father conducted business, I took the opportunity to walk all over the city, poking my head into shops and warehouses. Workers were making and selling shoes, foods, candies, baked goods, metal wares, kitchen appliances, sewing machines, wagon parts, picture frames, glass wares, furniture, cooking utensils, and clothing. One of my uncles in Baranowicze had a big, popular hardware store that sold tools and equipment for farmers, homeowners, and the local industry. Another uncle owned a lumber store. We visited my uncles whenever we came to town.

Many of the Jews of Baranowicze—close to ten thousand by the late 1930s—did very well for themselves. The Jewish community not

only contributed to the prosperity of the city but also met its own needs with Yeshivas, hostels, an orphanage, charitable organizations, homes for the aged, soup kitchens, a Hebrew-language high school, and ten synagogues. Jewish theater, restaurants, inns, and bakeries also thrived. There were so many Jewish merchants in Baranowicze that on Shabbos the downtown area became deserted.

Though my father sometimes traveled to Baranowicze with other businessmen, I was thrilled when he invited me along as his travel companion. It was so exciting that sometimes I had trouble falling asleep the night before our trip. Taking our wagon, the journey was a day's travel, and we'd stay overnight, taking our time to pick up all of the kinds of goods and supplies you couldn't find in Maitchet. One thing I remember very clearly was the Swiss cheese we bought in one of the stores; a delicacy not found at home. And in a chocolate shop you could buy Swiss, German, Dutch, and Belgian varieties. My father used to buy chocolates and candies to bring back to Maitchet and sell. This was my favorite part of the trip, because the biggest treat would be to have a meal of chocolate and bread.

I also remember my grandfather's sister's son Nechemia Bitensky, who sold material for suits, pants, women's clothes, and draperies. He was a rich merchant with a thriving business. His big factory was popular among clothes makers from all around because of the variety of materials he offered from England, China, and other places. Bitensky's friend in Baranowicze was a famous beer brewer named Pupko. Pupko was a member of Poland's most popular brewery family. The company was founded in 1876 by Nissan Pupko, then passed to his sons Meilach and Simon Pupko.

The main brewery in Lida (in Belarus, northwest of Baranowicze) had electric motors with a total power of eighty-seven horsepower and included a steam mill and a sawmill. There were branches of the firm (at least bottling plants) in Baranowicze, Nowogrudek, Grodno, Vilna, and other towns across eastern Poland, Lithuania, and western Russia.

Two large Yeshivas made Baranowicze, among other things, a Jewish cultural center that attracted boys from many other shtetls to study the scriptures. While we were in town, we could pick up any one of six weekly Jewish newspapers published in Baranowicze and read about the Polish Jewish community and about what was going on in Palestine and the rest of the world. No matter where the papers came from, we could always read them as they were printed in Yiddish. And because Baranowicze was such a center for business, there were many wealthy families living there. On our way in and out of town we would admire their fancy homes with gleaming fences and well-manicured flowering gardens with tulips, narcissuses, and sword lilies.

Even though I had well-to-do uncles down south in the Baranowicze garment industry, most of my family's clothing was still made at home by my mother. However, once a year my mother's parents, Sheyna and Eliyahu Bielous, who lived up north in a shtetl called Morozovichi, presented me with a new store-bought suit and hat. My grandmother and grandfather in Morozovichi loved to spoil me with new clothes. In these days now, when you hop in your car and run to the mall, the excitement and novelty of store-bought clothing is lost. But in those days, it was a special occasion to bring home to Maitchet and try on a suit of clothes stitched by

machine operators and made of fine materials from the big city. My whole family would all pile in our wagon and drive until we reached my grandparents' home, which sat on the edge of a lake and stream. My grandfather Eliyahu owned a mill, so we never left without at least a sack of freshly ground flour to take back home with us. Once in a while we would stay for the weekend, and when Shabbos came around, my grandfather stopped talking. He never spoke on Shabbos—his way of resting, I suppose.

Baranowicze was a happy place for me. It was full of energy and excitement, where the Jewish community was respected and thrived. The wide-open spaces, broad streets teeming with people coming and going, and the surrounding neighborhoods created a wonderful mixture of peace and excitement. When at last we drove out of town, we left with satisfaction, our wagon loaded down with goods and supplies for us and our relatives back in Maitchet. On the sandy road out of town, back toward Mush, people waved to us from their yards until the pretty houses with their flower and vegetable gardens disappeared behind us.

The Wrong Kind of Excitement

I have many fond memories of Maitchet and my childhood. But life wasn't without its dangers.

As I look back into the past, I remember a time when the sun was setting as I headed home for dinner one early spring day. I was nearly nineteen years old. The last of the snow was melting on the roadside; puddles made the roads muddy, the air was chilly, and the lights were just going on inside the homes. On this particular evening, it was all peaceful and quiet, except for the sounds of a few distant voices, or maybe a horse neighing as his owner led him into the barn for the night. My stomach began to growl as I made my way home, imagining what my mother was cooking for dinner. There was a dreamy, beautiful feeling about Maitchet, a feeling that I sometimes get just sitting down in my backyard now and studying my ripening tomatoes on the vine.

Momma was an amazing cook. She and my sisters would spend an entire day in the kitchen preparing dinner until the unforgettable aroma seeped through windows and doors and eventually wafted out onto the street before melding with the smells of scores of

other meals from other homes—beef stew, cooked carrots, boiled potatoes, fresh greens, soup, and baked bread.

I picked up my pace as the shadows grew longer behind me. The sky had turned orange-yellow and thick gray clouds sat low over Maitchet. Fires were being lit in the homes, and puffs of smoke filled the air from chimneys. Few people were out on the street except for stragglers like me. The neighborhood stood in silence as I approached my house. At the far end of our street, after finishing his work, Zayde had seated himself down for dinner and Bubbie brought him a bowl of hot chicken soup. Meanwhile, my father was locking our horse in the barn behind our house. He walked into the house and closed the door behind him. I was about to unbutton my coat and take the last few steps toward our front door when I heard a low rumbling noise, like thunder. But it wasn't thunder. My heartbeat quickened and my ears perked up. It wasn't my imagination. The sound of galloping horses grew louder and soon I spotted a gang of riders off in the distance. I could barely make out how many there were—close to twenty, I guessed.

A warning rang out. In the quiet of the neighborhood it was loud and clear. I heard someone from some corner or behind a fence scream "Cossacks!" In a panicked, high-pitched voice, he yelled the warning over and over. Maybe he was running from the horsemen, I couldn't see. Now, out from the Jewish homes poured dozens of strong boys with wooden sticks, iron bars, knives, and farm tools. "Cossacks!" the voice screamed. And then I saw him, a teenager running toward me, holding his hat in one hand and racing along with a tree limb in his other. He was pointing back toward the horsemen as he tripped and fell in the street. He got back up, hands

scraped and his pant leg torn at the knee, and he continued to run. All around me I heard mothers locking their doors and windows as the sky grew darker. I grabbed a stick or a club that was near me and rushed into the street where the others had now gathered. We fanned out across the road and waited anxiously. In no time the Cossacks were completely in view, just a hundred meters away, then fifty. I saw their faces. I watched them rushing toward us with black eyes and bushy mustaches, dressed in dark grays and blacks with long coats flapping wildly alongside their saddles. Clumps of dirt flew off hooves in every direction, spotting the riders' faces in mud as they brandished their swords in the air, screaming at us: "Death to the Jews!" Several of them waved flaming torches in the air. Then they were on our cobblestone street and the sound of the horses was deafening.

They came to kill us and to burn our homes to the ground, but we swung our iron pipes and garden tools over our heads and fought with every ounce of strength within us. We lashed out with our makeshift weapons, knocking the soldiers off their horses, breaking bones with our iron pipes, and throwing firewood, stones, and whatever we could get our hands on at the riders.

The Cossacks came to give us trouble, but this time they were the ones who were surprised. We were Jews who fought back. We were strong and quick to defend ourselves. The Jews of Maitchet knew better than to hide in our homes and let them have their way. Even some of the Poles joined forces with us. This time the Cossacks got more than they bargained for. We knocked a lot of them off their mounts, clubbed them, and sent them back where they came from, running and limping down the road until the last

of them disappeared into the darkness. Then at last, we tended to our wounded, assessed the damage, put out a few small fires, and stood around in groups, still holding onto our weapons in case they came back. Each of us had a theory about whether they would return, maybe bringing more with them the next time.

We waited, standing around panting and checking ourselves for injuries. There were some gashes on hands, a broken finger maybe, red marks swelling into big bruises on some of the faces and arms, and a couple of bloody noses. But we were okay. We stood in a circle so we could keep an eye on every direction at once, and we recounted our battle down to the detail until we all, at last, started to calm down. Perhaps an hour passed before we said good night to one another and all made our way into our homes to settle down for dinner. My heart was still racing when I walked through our front door and into my mother's arms.

That night we were lucky. A hundred years before, the Cossacks nearly burned down the entire shtetl, and when I was a little boy, too young to fight, I watched as the Cossacks chased Jews in the street, through fields, and behind our homes. Women were raped and torches were thrown on roofs. After trying to fight them off for an hour, the Jews were bloodied and some nearly beaten to death, and the Cossacks were racing out of town. They returned the same night and rode to the water mill on the edge of town. Houses and barns burned all through the night, and the entire town worked to bring water from the river in buckets to dowse the flames. I do not know how many died that night or were made homeless or crippled. But if you asked me at that moment whether we were

Poles or Russians, my answer would be neither; the Cossacks, like everyone else, reminded us we were Jews.

I thought about the Cossacks when I grew into my teenage years. I wasn't afraid of them, but I thought about them when my father decided to build our family's new house on the street where Zayde and his sons lived with their wives and families. Memories of fires in the night made my home and family that much more precious to me. Our homes protected us from the cold and gave us a place to sleep and eat. But safety from random violence was a luxury we didn't necessarily share with our neighbors. Cossacks could turn the biggest home in the shtetl into ashes in a matter of hours.

Living with Our Differences

There is a Yizkor book (a memorial book) that was written about Maitchet. It's in Hebrew and it sits on my desk at home in my basement. It reminds me of my lost life. When I look at the pictures, I can slip into the Maitchet of my youth. I hear the children playing in the street. I see my little friends as we play soccer—Poles and Jews all mixed together, wearing the same dirt and cuts and scrapes. We argue over penalties and goals, and we fight one another with our fists. But when the game is over, we shake hands and run off. We'd see each other the next day on the road somewhere and start up a new game.

Some of these kids went to school with me, but most were kept out of school by their parents by the time they were ten. The Poles wanted their children to work on their farms; paying for labor was too expensive, and there was no end to the chores. This created problems, if not on the surface, then just below it. They wouldn't let their children go to school, but they resented that the Jewish kids were educated—girls and boys alike.

My sisters and their friends went to Bayt Yakov, a girls' school that not only taught secular and Jewish subjects but was also a center

of cultural learning, with school plays, performances, and dances. I went to both Polish school and Jewish school, as did my friends. This was our tradition: it was believed that education made you a better person and better able to serve others.

All the while, though, parents of our Polish friends complained about us. They mumbled under their breath about how the Jews owned shops and made a big profit at the market—that we were good in business. "The Jews know numbers," they'd say. Then they would be distrustful and reconstitute rumors about how we were shrewd or stingy. They used the word "clever" as if it was evil and a threat to their own security. The worst of the anti-Semites were farm children who were made to labor in the fields while Jewish children were playing or learning in school.

It wasn't like we weren't close to our Polish neighbors. Though the majority were simple folk who clung to superstitions and were afraid of anyone different from themselves, there were exceptional people among them. One such person was a neighborhood girl I knew named Tamara Ulashik whose older brother, Vlojik, eventually married a Jewish woman and rose to the highest position in the police department. I recall hours of talking with Tamara in the forest. She taught me how to play the guitar. For hours we would sing songs as Tamara would strum away at the strings to her old Spanish-style guitar. We would laugh when we forgot the words. Some of the words we made up altogether. Tamara would ask me about what I was learning in Jewish school. I taught her about the Talmud and she guided my fingers to the right places on the neck of the guitar. The more I explained Jewish law and tradition, the more she wanted to learn. But she was an exception.

We lived in a superstitious, prejudiced community, but stoking the fire of anti-Semitism were the town's churches. How could we ever see one another as individuals when the churches preached how different we Jews were from everyone else? They perpetuated stereotypes and unfounded gossip. Every Sunday the Poles learned how the Jews were the root of all evil in the world. To them we were Christ-killers. We were the "they" whom the priests talked about as killing their savior, not following the Christian religion, not fearing their God, and not terrified of going to hell for being nonbelievers. It was repeatedly told to parishioners that Jews spoke a different, secret language, that we had our own law, and that we wore funny clothes and partook in strange traditions.

We could never figure out the logic of this hateful teaching, and we couldn't escape the hate. Any progress in forging good relationships all through the week was canceled out by hateful teachings on Sunday morning.

All our logic and knowledge of the Talmud was no help to us in making sense of the Christian point of view that Jews were "the enemy." How could we be enemies when we were also neighbors? How could we be hated when the one person our Christian neighbors most revered and loved was a Jew? After all, Christ was a Jew. He was their God—a perfect being praised for his righteousness, honesty, and love. But weren't we—who were living next door—also Jews, just like their savior? The Poles could not bring themselves to see us in the same light. Week after week, for centuries, priests painted Jews as killers, thieves, and lechers, except, of course, for the Jew who hung larger than life on the walls of the churches, over beds, and in kitchens. I couldn't understand the hate taught in

the churches. Raised on the logic of the Talmud, I would wonder: If this Jew Jesus was a god, how could anyone, Jew or non-Jew, have really killed him? Or, if he was meant to die for people's sins, then why look for someone to blame for killing him? None of the Poles I knew had answers to these questions. I learned that it was best not to discuss religion with them. This way, we stood the best chance of getting along.

There were two churches in our shtetl: the Polish Catholic church and the Greek Orthodox. The Polish church taught hate; there is no other way to put it. Even the priest of the Greek Orthodox church, a gentle, family man who enjoyed spending hours in our house discussing local affairs with my father over a glass of vodka, was very uneasy about the level of anti-Semitism in the Polish church across town. Parishioners emerged from the building cursing the Jewish people for all their problems, from the murder of their savior to their failed crops. It was the Jews who had all the education; the Jews who polluted their children with books bearing new ideas and telling of diverse customs; the Jews who refused to accept Christ as their lord. The Jews, it was well understood, were the root of all evil. We had a big problem, although few of us realized that the ground beneath our feet was already starting to simmer.

My Yizkor book on Maitchet doesn't show the Greek Orthodox church, but I remember where it was in relation to the other buildings—right across the street from my house. We were neighbors on Handlowa Street. The church was a formidable structure gleaming in bright white with steeply-pitched roofs and elegant spires appointed with Catholic crosses rising toward the sky. The church's blue-gray domed spires could be seen from far away,

like a beacon to residents and visitors. Arched windows with leaded glass adorned every wall, inviting light into the church. The interior was beautiful, with golden religious objects on display and highly polished wooden railings and pews. In our poor shtetl we had a well-to-do church. In the winter the building was kept warm with fireplaces that burned day and night.

Every Sunday, across the street from our house, looking out our living room window, we watched scores of parishioners file through church doors in a long procession that wound out onto the sidewalk. After services there was a reception line where the priest patiently shook the hands of his flock as they carried thoughts of his sermon home with them.

I was inside the Greek Orthodox church many times, sometimes just for fun, playing around with my non-Jewish friends. On other occasions, I would be playing soccer or chess or going out with our school girlfriends when a fight would break out. Fights led to chases that led into the church, a place of sanctuary. I'd follow the perpetrators into the church, sit next to them in the quiet, and then follow them outside again where the chase continued until our disagreement would finally be settled one way or another.

The priest of the church was a good-hearted man. He was on very good terms with our entire family and the Jews of our town. Recognizing the wisdom of our rabbis, the priest would sometimes talk with Zayde about a problem he was having or how to mediate a disagreement between two parishioners.

All on One Block

We didn't always live across the street from the Greek Orthodox church. Before I was a teenager, we used to live in a small, cramped house behind Zayde's house, on his property. But it became obvious that, with a baby sister and plans for more children in the near future, there just wouldn't be enough room for all of us any longer. It was time to move into bigger quarters.

I remember when my father told me we were going to build a new house. I was a boy but old enough to be useful. Our new house, my father said, would join the row of homes on Handlowa Street that belonged to my uncles—my father's brothers—across from the Greek Orthodox church. Before I knew it, I was driving nails into the new walls. I was too young to see this as work. It was fun and exciting.

In those days, every inch of a house was built by hand. We had few prefabricated parts but no electric saws, cranes, or trucks. Maitchet was too remote to enjoy any of these modern tools. All wooden boards and studs were cut down from huge logs at a nearby mill. Neighbors joined in to help, especially in lifting heavy beams into place and handling the two-man saw needed to fashion timber

into girders. When the walls of our new home went up, it was a neighborhood celebration. Everyone took part in the success, especially our uncles, aunts, and cousins whom we joined on the same block.

Later my father and I would build a small house behind ours for my Uncle Zimmel so that all five sons of the Shmulewicz brothers, would live in a row. Our family took up more than half the street. From their house at the end of the block, my grandmother and grandfather would proudly look out onto Handlowa Street and see their children's and grandchildren's comings and goings. The head of the family was at the head of the block. My grandparents were very proud of their family. Looking out the window and seeing them parading back and forth was an exceptional source of *nachas*.

From the front windows of our house we had a perfect view of the beautiful Greek Orthodox church. We had a big open veranda with a wooden floor and a couple of chairs. Our houseguests loved to sit out there from late spring to early autumn and read the newspaper in the morning.

When you entered our house, there was a room on the left. It was a sort of reception or living room. Toward the back of our house was my parents' room and, next to it, my sisters Peshia and Elka shared a room. I had my own room on the side of the house.

My room was filled with books on all the walls—books written in Hebrew, Russian, Polish, and Yiddish. They were all very neatly placed and stacked according to subject matter on bookcases made of bricks and planks of wood. I can still see the titles peering back at me from my shelves—books of poetry, humor, history, and heroism. I was an avid reader of the most famous Jewish writer of

the Yiddish world, Solomon Rabinowitz, best known by his pen name, Sholom Aleichem. His stories of shtetl life and the hardships of Tevye the Milkman and his daughters left a lasting impression on me. We Jews had a special respect for Sholom Aleichem because he took our shtetl language—Yiddish—and made it a respected medium of literature. I also loved to read the poetry of Adam Mickiewicz, a local literary hero born not far away in Nowogrudek, who became Poland's greatest poet. I also had books written by the Russian poet Alexander Pushkin, Prague's Franz Kafka (his book *The Metamorphosis* remains one of my favorites), and other writers whose ideas and passion lifted me far beyond my shtetl surroundings. I used to read in my room well into the night while tucked into bed as the wind whistled through the trees outside my window. Not until I stirred from the clanging of baking dishes in the kitchen did I awaken, many times with my nose still pressed between the pages of a novel.

The kitchen came alive at dawn almost every morning, with food preparation as the focus of our home. While my mother went to work, my sisters started their chores. Our house was always tidy. Just before Shabbos, as with other holidays (especially Passover), Peshia and Elka worked with Momma to clean our house in preparation for the sacred occasion. When cleaning was complete, it was always back to the kitchen, the one place in our house that never rested.

The family kitchen sat right in the middle of our house. It was a big, inviting, open room resembling a restaurant. In the middle of our kitchen was a cast-iron stove and oven that gave off a tremendous amount of heat. Just behind the oven was another

oven, lined with a tiled hearth used for getting warm. We kept our fire logs in our barn, and my sisters carried loads of wood into the house to refuel the fire. In the dead of winter, when temperatures were well below zero and the Siberian winds rocked our house and whistled through the walls, we would bring cots into the kitchen or sleep in storage alcoves to keep warm by the blaze.

My mother was a wonderful cook. She got up very early in the morning to make me pancakes, and throughout the day she and my sisters would make bread, cakes, kugel, and soups. For special occasions and holidays, the three of them were like elves, turning out pastries like a bakery. Sometimes my mother baked bread for the poor and brought it to their homes, saying she just happened to be passing by. Like her namesake, Esther, my soft-spoken mother was the queen of our home; her presence graced the air and sanctified our lives. I can still hear her singing as she baked. So many times I would come home from school or work to listen to this music. The three of them would be lost in song, hands caked with flour and a fog of white dust rising through the air.

My father, a very handy and resourceful man, used his self-taught carpentry skills to make our windows and the shutters. It took months, maybe a year, to cut down trees and have them milled into planks for the walls and ceiling to build our house. We cut and nailed in strips of wood, wet the wood down, then filled the areas in between with cement. Because there were no sophisticated tools available to us, we had to align and construct everything by eye. My father had a knack for doing this, and somehow the walls came out plumb and the windows perfectly level.

One of the features of our new house was that it was partially used as an inn. Maitchet was a popular destination for tourists, and my father was wise enough to realize that tourists needed a place to stay and eat during their visit.

Visitors would come from miles around just to breathe in the scent of the pine trees. We had a forest so full of pine trees that in the winter you couldn't see the sunshine if you went for a walk deep into the woods. People believed that the pine aroma was good for the lungs and had healing powers. Maitchet was known as a popular resort from late spring to mid-autumn. But even outside of tourist season, we always had local people stopping in for breakfast, a bar of chocolate, ice cream, or a shot of vodka.

Having an inn at our house meant that there were always strangers staying with us. My mother was a good hostess, cooking meals and keeping our guests company. She made every visitor part of the family, cooking eggs and pancakes for breakfast, and for dinner the guests would join us at our table.

Breaking bread with our houseguests gave us a fresh perspective on the news from around the area; people would tell us what was going on in their shtetls: news of births, deaths, politics, and pogroms. They spoke of their relatives in America or the bigger cities like Warsaw or Kiev. Sometimes our guests even told us about towns that we knew little, if anything, about, including Jewish communities to the west and across the German border. My father was a great conversationalist. He knew how to keep people talking. Papa's interest in others brought the larger world around us into our living room and it kept visitors coming back over the years to stay with us.

After we built our house, my father set out to build a small shed to the rear of our property surrounded by a fence. In the little structure, which was closer in size to a small barn, we kept our milk cow. My cousins and I were always running to one another's houses with milk, cheese, cream, butter, and eggs. Our mothers and aunts were never without the essentials for baking, and nobody was going hungry.

Outside, my father and I fashioned a small area where we walked our horse around in circles tied to a wooden bar. The bar was attached to a grinder in the center, and with each step the horse would cut straw into food for the rest of the animals. Leading the horse around in a circle, I used to get dizzy and have to sit down to take a rest. I don't know how the horse stayed on his feet either. Maybe he was better at it because he had two more legs than I.

Our watchdog, Milsh (Russian for "shut up"), patrolled the area to the rear of our house, including the shed. He was an ornery, temperamental German shepherd who was very vicious. A big, powerful, territorial dog, he was prone to barking at everything that moved. You couldn't get near him without alarming all of Maitchet. Only my father and I dared approach this dog. In Milsh's case, his bite was greater than his bark. His ferocious growl and the show of his teeth made sure that nobody came within fifty feet of him. At night, he would bark and bark, pacing back and forth until he wore a path in the grass. He was calling out for the only thing that would settle him—our cat. Once the cat came to him and curled up at his side, Milsh would be quiet. The two of them would sleep together until the sun came up. Then the cat went his own way and Milsh returned to guard duty.

L'Chaim—To My Father

To me, my father was always a sweet, kind, and honorable man. He played the violin and the banjo and loved to sing. We used to get together with ten to twenty friends to sing and dance. These occasions would start off inside somebody's house then spill outside when there wasn't enough room for all the people who kept joining in the fun.

In shul, Papa was sometimes the cantor; he was like a rabbi, though not formally trained as a rabbi, but he could lead the worship services as well as anyone. He used to read the Torah with great attention to each phrase as if he were reading the passage for the first time, waiting to find out what would happen next.

Papa was a strong and capable man and people knew they could rely on him for help. He was never afraid of hard work. When looking at my old photographs, it is easy to see that I resemble him, with blond-brown, close-cut hair and an on-again, off-again mustache. His name was Shlomo, but when he was a young man, in his early twenties, he became very sick—so sick that our entire family thought he was going to die. Somehow, with an amazing willpower, he managed to fight his way back to health. When he

was fully recovered, he was given a new name—Chaim, which means "life."

Life was precious to my father, so his new name was fitting. He cherished life and the people around him. Nothing was more important in life than his family.

Papa enjoyed every celebration, from birthdays to Jewish holidays. He looked forward to any occasion that gave cause for singing, dancing, laughing, and kvelling. And in our shtetl we made a big deal out of celebrations. Papa taught me that a hard life has to be balanced with joy and lightheartedness.

Shabbos, of course, was the most special time for the Jews of Maitchet, but Purim was also important in our town. Purim was a huge event that spilled out way beyond the shul and home. It was a community-wide extravaganza, turning the entirety of Maitchet into a theater. My father loved to participate in every Purim festival. He and scores of others, including my mother and grandparents, uncles, aunts, and cousins, dressed up in homemade costumes to replay one of the most memorable events in Jewish history. Each year everybody celebrated the rescue of the Jewish people from the wicked Haman, an advisor to the king, by Queen Esther and her cousin *Mordecai*. Purim is a springtime celebration on the fourteenth day of Adar, in early March. It's one of the most joyous holidays on the Jewish calendar, so in Maitchet and hundreds of other shtetls in Eastern Europe, half the town came out to participate in food, theater, and parades.

The story of Purim has all the elements of a drama, with intrigue, deception, miscommunication, drunken parties, attempted assassinations, a foolish king, villains, and a beautiful heroine. We

put on a play outdoors that involved a hundred people, each as an important character. Even the Gentiles would come to watch the show. There was nothing like the Purim celebration, with people gathered outdoors, dressed in bright colors, draped with costume jewelry, and singing and drinking to their hearts' content.

My father was sold on the idea of tradition, but he was a modern man by most standards. He was clean-shaven, open to new ideas, and loved to tinker with appliances. But when it came time to celebrate Jewish values, he devoted all of his attention to detail. He made me realize that a strong, powerful man can be sentimental, loving, caring, and committed to ideals. He made life worth remembering. He taught me with love. He taught me that actions speak louder than words.

For my father, my sisters and I were the center of his life. And the relationship between my father and mother was more than special—the two of them were lovebirds, inseparable. I grew up in a family where everyone respected and loved one another.

Papa, like Zayde, also strongly believed in caring for those who were not so fortunate. He was an active member of several organizations, including the Gehmilot Chesed, a group whose purpose was to help people in our community. We all gave a little money every month to this group and the money was pooled. If you were without means but had a son who was a bar mitzvah, the organization would give you the money for whatever you needed, including a little celebration afterward. The money was also used for weddings as well as for the poor who couldn't afford bread. If a woman lost her husband, Gehmilot Chesed paid to get her on her feet. My father took these kinds of charity groups very seriously

and was proud to help his neighbors through hard times. "You can't turn your back on people," he used to say. "If you can help, then you help."

My father liked people and people liked him. For this reason, people in Maitchet made a tradition out of sealing deals in my father's house. When market day came around, people would make all sorts of bargains—Jews and Gentiles alike. But no deal of any consequence was made without commemorating the occasion with a drink. The choice was always vodka, and the place was the guest quarters in our house. I was appointed to fill the glasses with vodka and my father was there to make sure things didn't get out of hand.

There was one time when things turned a little ugly. The incident took place when I was already a young adult. This big guy named Pietrik Soshinsky, a local Pole who was much bigger than my father—maybe a head taller—got out of hand from drinking. Because of his size and weight, and the fact that he liked to carry a pistol tucked into his waistband for everyone to see, he wasn't used to being told what to do. But this was my father's house and Pietrik had become too boisterous. Pietrik was no stranger. Everybody in town was familiar with his whole family, including his two brothers. They liked to push their weight around ever since they were kids. Now, as big, strong men, Pietrik and his brothers had grown into first-class bullies. Pietrik drank almost an entire bottle of vodka in one sitting. He was speaking louder and louder, kicking chairs out of his way and feeling for the pistol in his waistband. When Papa told Pietrik he'd have to leave, Pietrik at first laughed at him and demanded another shot of vodka. Papa refused and Pietrik became

irate. He got up out of his chair, almost knocking his glass onto the floor. My father, instead of backing away, took a step closer.

"I said pour me another drink!" Pietrik said to my father.

Papa said, "You've had enough. Why don't you go walk it off?"

"If I pay you for a drink, you pour me one. Now bring the bottle here." Pietrik moved close to my father, practically a foot away. He towered over Papa and put his hands on his hips. "Well?" said Pietrik. He was about to take another step and his right hand was clenched into a fist when my father picked him up and threw the big man into the wall. Drunk and with a face red with anger, Pietrik Soshinsky screamed at my father while he scrambled to his feet. My father shoved Pietrik out the front door.

"That's enough," Papa said. "You're drunk. Go home."

Pietrik was shifting back and forth on his feet. His eyes were half closed and bloodshot. Standing on our veranda, he pointed his finger at Papa and said, "Shlomo, I could kill you right now." Then he pulled out his gun and pointed it at my father with a grin on his face.

My father said, "Go ahead." Pietrik just smiled, put the gun away, said to my father, "I'm going to kill you one day," and left. My father thought nothing more of it, but this was an incident Pietrik would never let rest.

Technology was always changing. New gadgets were continually being invented, but my father always had a way of fixing them. My father used to make radios and I used to listen to Tzayginer music on them on special occasions. He understood mechanics. Still, like all the rest of us, Papa continued to be taken by surprise now and then as the newest technology came to Maitchet. I was born

before electricity, running water, or automobiles were common, so naturally, when the very first car drove into Maitchet in the mid-1920s, we were afraid to touch it. Even Papa was cautious. Nobody wanted to get too close. The driver was a mystery, too. We didn't know what the car was or how it moved. It was noisy and smelly and its strangeness was a bit scary. How could a wagon move by itself? What was pulling it? With enough time, I bet my father would have figured out the engine down to the smallest parts.

I remember another time when I was in shul and all of a sudden we heard a big noise, rolling thunder on a clear blue morning. About ten or fifteen of us ran outside and looked in every direction. One of us squinted against the sun and breathlessly began pointing to the horizon where the sky met the tree line. We all shielded our foreheads using our hands as visors and strained to see. Then it appeared, growing bigger by the second—there was an airplane flying toward us. With all kinds of excitement we tried to figure out what we were looking at. We argued and shouted and pointed. We stood on our toes to get a better look, which of course did us no good at all. Eyebrows were raised in confusion. Shoulders were shrugged. What started out to be smaller than a tiny bird in seconds flew right overhead with a deafening sound. Mouths dropped to the ground. We held onto our hats. What was keeping this object in the sky? We were afraid it would come down. So, like a fire brigade going in reverse, we all ran back into the shul, shut the door, and hid. We hid for at least an hour. It was quiet, but we were afraid it might come back. It wasn't until a week or two later that we had houseguests from one of the bigger cities who knew what airplanes were. They had to explain what they were used for and

how they stayed in flight. When we learned more about airplanes, they became a curiosity and from then on we made a practice of searching the skies for them. Papa would point one out to us and we'd all bravely stop in the street with our hands on our hips to stare at it until it eventually disappeared from view.

Times were changing in Maitchet. There was a new dimension to our lives; people were living in the sky as well as on the ground. But none of us could have guessed that, in a few years, bombs would be dropped out of these airplanes, destroying everything in their path, razing shtetls to the ground, and turning magnificent cities, like Warsaw, into rubble.

The Meaning of Tzedakah

It was Zayde's natural sense of generosity that made him refuse to lease out portions of his property in exchange for payment. Zayde owned a sizable amount of land, including a large forested area and some of the richest farmland in Maitchet. He allowed several of the local Christians to use a portion of his land for growing food, but instead of taking money for rent or a share of the yield, Zayde asked merely that the tenants donate a small portion of their harvest to the town's more needy residents. More than this, he set apart a corner of his land to be farmed by the poorest of our poor. Zayde taught me the truest meaning of *tzedakah*.

Zayde taught me that God is the owner of all things and that a person with a field is only a temporary manager. He said the Torah teaches "all that springs forth from one's land is a gift from God, and it is required that this gift be shared with those in need." But just as importantly the needy must be able to take what they need in dignity. Tzedakah, Zayde said, is something all Jews are obligated to offer, regardless of one's finances; and to give a family a piece of your land to work was not just a short-term gift but a means of offering others a way to find dignity.

My friends and I were always curious to know who these people were who would be Zayde's newest tenants, but he wouldn't tell us. He didn't want them to be embarrassed about their poverty, and he didn't want to make a public display of his generosity. All he would say to me was, "No one should go hungry."

Zayde made a friend wherever he went. When people met him, they instantly liked him because he cared about people. As soon as he met someone, he wanted to know how he was and what his problems were. He wanted to know about his family and dreams. I learned from Zayde that the Torah teaches us to help other people, but Zayde took these teachings to new heights. He lived for other people; his greatest pleasure came from giving things to others.

It was no wonder that my grandfather became the mayor of our shtetl way back when Maitchet was a Russian border town. Zayde was popular, well educated, learned in Talmudic law, and knew how to make people happy. He was a pillar of our community and a diplomat. He was an articulate man who spoke a half dozen languages and was looked up to as a wise decision-maker. Jews and Gentiles alike would come to him to settle arguments over many matters of dispute. He arbitrated over property disputes, a fair price for a cow, fair payment for labor, and family squabbles.

My grandfather would sit in his home office with shelves lined with books in Russian, Polish, Yiddish, and Hebrew, lean back in his chair, run his rugged hands through his beard, and come up with a solution. Like the wise King Solomon, Zayde understood logic and the law and was thus imbued with a great sense of justice and patience. He instinctively understood how to get to the center of a problem and resolve it in a way that made sense to all involved. But

more than this, Zayde was a humanist. It was a mitzvah to help one's friend, family, and neighbor. He couldn't understand how anyone could look the other way when somebody was in need of help.

Today, people think a mitzvah is just a good deed, even a favor. But Zayde, my father, and the other respected men of our shtetl understood a mitzvah to be a commandment. Jewish law commands that one must be generous toward other human beings. It's a duty. "If you're a person," Zayde told me once, "then it's your obligation. Otherwise, you'd have needless suffering." Zayde was a bank full of mitzvahs. He also had a bank full of documents.

As mayor of Maitchet, Zayde's little home office was filled with legal papers, deeds, contracts, and permits. His desk drawers were piled high with official stamps, postage stamps, legal documents, maps, surveys, charts, ink wells, accounting ledgers, and pens with well-worn tips.

Zayde's reputation was widespread for more than just official duties. A network of people throughout Eastern Europe came to know his name and where to find him and he often opened up his home to strangers. And like his father before him, my own father would carry on the tradition of hosting visitors in his own home.

In their home, on any given day of the week, my grandparents hosted businessmen, tourists, weary travelers, political refugees, and anyone else who needed a place to stay. Among these guests were some colorful characters. I remember Bubbie telling me how one time a visitor came to Maitchet bragging that he was the strongest man in his village. My father was a young man at the time and was still living at home with his parents.

The houseguest boasted that he was stronger than anyone he ever met. "If I was in the Bible, I would be Samson," he said. "That's the reason people fear me. I'm a good man, but people need to be shown who's boss."

The man looked stocky and sturdy and had thick hands and a square jaw. A few old scars on his face showed that he had been in a few fights in his time. He looked the part of the strongman or a boxer, and he was full of confidence. Although my father was a quiet man with a relatively even temper, the visitor's constant bragging eventually got on his nerves. Waiting for my father to come back from his chores, the visitor sat in Bubbie's kitchen playing with a chain. When Papa walked through the door, the man rattled the chain so that my father was sure to notice. Then the visitor started to struggle with it, trying to pull apart one of the links. He wanted to show off. He pulled at the chain with all his might until his face turned red and his hands turned white at the knuckles. A large vein was bulging from his neck and his mouth twisted to expose two rows of madly clenched teeth. It looked like the man was about to burst. The chains pressed well into his fleshy fingers until at last his strength gave way and he slumped in his chair only to notice my father standing over him with his hand out. My father asked the man to surrender the chain. Then, with all his power, Papa pulled the chain and one of the links stretched like putty until it separated and broke—all this without saying a word. Papa tossed the broken chain at the man's feet and walked out of the house to continue with his chores. I don't know how he did this, but it made the man very mad. What made him even angrier was that people around

town began to talk about my father and how he was stronger than the braggart.

Unable to leave things alone, the visitor spent a sleepless night at Bubbie's house, bothered that he was bested at his own trick. The next day, after breakfast, while my father was heading out the door, he challenged him to a contest in front of the house.

"I have other things to do," my father told him. "Maybe later." But the man was insistent and blocked his way. "Wait here," he said to my father.

People started to gather around as the man brought two chairs outside. My father didn't know what the man was up to, but by this time he was very tired of him and was ready for the guest to leave town. Making sure he had an audience, the man put his foot up on one of the chairs and smiled as he said to my father, "Hit me as hard as you can on my leg." Obviously, the man had done this before—his thick thighs proving to be no match for even the strongest punch.

My father thought for a second then put his own foot onto the other chair and told the stranger, "You hit me first." The man made a fist then looked around to make sure everyone was glued to the action. He came down on my father's leg as hard as he could. My father didn't even wince. He didn't want to give the man the pleasure. Next it was my father who smiled.

"Now it's my turn," Papa said.

When my father smashed his fist onto the man's leg, it broke with a crack. The man was undone. Despite his pain and embarrassment, he shook my father's hand then sat down. When all the spectators walked away, the man slowly shuffled with great effort back into

the house. He packed up his things and left town that same day. He came to Maitchet bouncing on his toes but left with a limp.

So, once in a while, strangers left as strangers.

As the years passed, however, our meetings with strangers became far more profound experiences, with their fate resting in the hands of my grandfather. This brings us back to Zayde's business, officially and unofficially, concerning a special category of visitors who traveled a hundred miles or more to find him. They usually came in the middle of the night, just before dawn or right after sunset, sometimes alone and sometimes with their entire family, but it seems like it was always under the cover of darkness. Some were running away from the draft—forced conscription into military service. In those days, for a Jew to be called into the army could mean the end of his life or at least his freedom; many Jews never saw their families again. If a Jew had a family to support yet was called into service, his parents, brothers, and sisters would lose their sole means of support and be left destitute. Frequently, a father would be conscripted as a form of punishment, and young boys would be drafted and never heard from again.

There were some Jews who came to see Zayde because they had been accused of crimes they did not commit. This was not all that uncommon—an anti-Semitic Gentile would call the authorities on a Jewish merchant or landowner. If the merchant couldn't prove his innocence, his accuser could make a handsome profit in the deal. Punishment for crimes, whether one was guilty or not, was more harsh for Jews.

And then there were those who just wanted to flee Eastern Europe for political or personal reasons. Maybe they had relatives

who were waiting for them in America or perhaps they foresaw the future of the Jews in Poland. By the 1930s, the political scene seemed to have changed overnight. Those who were once loyal to a king or czar became criminals when the communists took over their region. A few years later, law-abiding Soviet citizens and bureaucrats were transformed into the enemies of new fascist governments. Jews to the west were feeling the rising tide of anti-Semitism in Germany, Czechoslovakia, Hungary, Romania, and Austria. They were worried with good reason. Many decided that there was no time to wait—they had to get out even if it meant leaving most of their worldly possessions behind.

The Jews could barely survive these winds of change, and there were thousands struggling to leave Europe. Sometimes people thought it would be harder to flee through western ports, so they headed east toward Russia. But how were they to get out? They needed someone they could trust—someone who knew the escape routes, what kinds of documents were needed, and how to avoid the pitfalls.

To rely on a complete stranger, as Zayde was to them when they knocked on his door carrying their suitcases, was to put their lives in his hands. There were many times that I sat enjoying cake and milk in my grandparents' kitchen when the knock came. My grandfather would get up from his reading, glance at Bubbie, then make his way to the front door. He never hesitated to open it wide as if the most pleasant surprise was just waiting on the other side of the threshold.

Standing out in the cold on one occasion, I remember, was a family of four—a mother, father, and two little ones. The first

thing that they saw was Zayde's warm eyes, thick beard, and broad smile—a warm welcome after days of exhausting travel. Nervously, the father greeted Zayde with a forced smile. He exhaled with a strange, mixed sense of consolation and anxiety. A cloud of steam was coming out of his mouth and dancing in front of the dim light shining on him from inside the house. His wife stood a few feet behind him in the shadows of Zayde's front porch. Her arms were around her children, her hands holding them tightly to her body.

To their relief, Zayde invited them inside without the slightest hesitation, waving his arm as he said, "Come in, come in." Zayde spoke in Yiddish to make them feel more secure. The man and his wife kissed their own fingers then touched the mezuzah on the jamb as they passed through the front door and stepped into the living room. The children were silent as the snow, standing there with glowing red cheeks and wide eyes surveying all they could see in front of them in this, another in a series of unfamiliar surroundings. Speckles of snowflakes immediately began to melt off their shoulders as the man took off his hat and the woman rubbed her hands together, eyeing Bubbie and me straining to look at them from our seats in the kitchen. My grandfather put his arm around the man, the way you do when you see a dear old friend, and, as if on cue, Bubbie started rummaging through her cupboards, preparing something for the family to eat.

After brief introductions, the man, almost stuttering in his nervousness, said to Zayde, "We were told you can help us." The man was proud and did not want to ask for favors, but what else could he do? This is why he came. He reached into his vest pocket for his billfold, but Zayde smiled and shook his head no. He wouldn't

accept any money. The man glanced at his wife and shrugged. She had nowhere to look so she cast her eyes down toward the floor. The ice from their shoes crept down to form puddles at their feet.

By this time, I was standing behind Zayde who introduced me to the visitors before he led the man into his study. Their voices faded into a low rumble as Bubbie invited the woman and her children to sit at the kitchen table. I walked back into the kitchen and stood near the stove. I could tell by their accents that these people were not from around our area. Maybe they were from Lithuania or somewhere else up north. This meant they had traveled a very long way to find my grandfather. Several wagon rides, a train trip, and walks over long distances brought them to Zayde's door. They were tired, hungry, and a bit anxiety-ridden. They had left their family, their home, and their shtetl without looking back. When you arrive in an area—any unfamiliar town—in the dark, you have little idea of where you are. It's like being dropped in the middle of the desert: everything is strange and foreboding. You don't know if any area is safe. Zayde's visitors were disoriented. Their eyes, now visible in the light of the kitchen, were sunken with dark rings under them. Their lips were dry and the woman's hands were a bit shaky. Bubbie put her hand on the woman's shoulder and said, "What can I get you?" The woman wanted to be polite, but she was too hungry. She didn't answer, but Bubbie set out a couple of plates with kugel and leftovers from dinner. Bubbie prompted the children, "Go ahead and eat as much as you want." The mother eked out a "Thank you." She was almost in tears at the hospitality. "You don't worry," Bubbie said, "everything will be all right—you'll see."

What brought these people to Maitchet? Where were they going? My grandfather had heard their story over and over again. Things were bad in Eastern Europe. There was no future for Jews; anti-Semitism was too much to bear. There were pogroms and intolerable conditions. The only hope for a better tomorrow was to leave their part of the world. Over the years, some of the people who came to Zayde were on their way to Palestine. But this man and his wife had decided that they wanted to go to America. The problem was that they needed to travel across Europe, through a half dozen countries to reach a harbor and board a ship headed across the Atlantic. To accomplish this great feat, they needed the proper paperwork—passports and visas—to pass from one checkpoint to another. Without the right documents, Jews were regarded as escaped criminals. This, at last, is why they came to Zayde's house. These people were refugees. Like others who had set foot in my grandparents' living room in the cover of night, the woman at Bubbie's table, now watching her children eat their first meal in days, told us that she and her husband had to sell or give away all that they owned—their furniture, their books, their clothes, their property, and their business.

"Twenty-five years of our life we had to get rid of in a matter of a month," she said. "We left some things with our neighbors to send to us. I don't think we'll ever see them again."

In their suitcases the family carried a couple dozen photographs and only the bare essentials to make their way across Europe. They said good-bye to all their relatives, no longer had an income, and were on their way to places that were foreign in every respect, from language to customs.

I walked to the doorway of Zayde's office. Inside, the man took a seat across from my grandfather, in front of his desk. I stood in the hallway and kept quiet. As Zayde began to open his desk drawers, the man put his attention on the desktop with its deluge of papers—official documents, notes, and pending business. The man by now understood that my grandfather didn't need to be asked for a favor. He knew what to do; he knew what this family needed. Zayde was there to do a mitzvah by helping a fellow human being make a new life for himself.

"Relax," Zayde said to the man. "Everything will turn out all right. You'll see." The man opened the buttons of his overcoat and folded his hands on his belly. Zayde waved for me to come into his office.

"Motel Leib," he said, "go and get me four passports."

I had already done this several times before, so I didn't need to be told where to find them. I grabbed a lantern then went into the hallway and pulled down the ladder leading through the ceiling into the attic. The musty smell filled my nostrils and the frigid air gripped me unexpectedly. It was dark but I knew my way around. I stooped over to protect my head from the rafters and took careful steps over wooden crossbeams, feeling my way through the blackness, holding a small kerosene lamp that wasn't especially helpful.

After a minute or so, I came to a large wooden crate filled with official transit papers. In the semi-darkness I counted out four of them. While my grandfather was giving the man careful instructions on how to present paperwork to crossing guards at checkpoints, which trains to catch, and the best route to take, I climbed down from the attic and put away the ladder. Then I returned to Zayde's

study and handed him the papers. He patted me on the back, reached into his pocket, and handed me a couple of coins that were to burn a hole in my pocket until the next morning. Zayde winked at the man; he got a kick out of tipping his grandson.

Zayde took out his pen, a couple of stamps, some glue, a pair of scissors, and a tweezers, and within an hour he had fashioned new documents bearing names, dates of birth, country of origin, and so forth. He placed his mayoral seal on all the documents. Now it was official. The family was now equipped with travel passes, and in the morning they could be on their way west until eventually they arrived in Germany—maybe Bremen or Hamburg—where they'd take an ocean liner to America, most likely traveling in the steerage or cargo part of the ship.

Zayde was sure to tell the man he had relatives in America. "My wife's sister," he said, "lives in New York . . . It's a wonderful place; you're doing a wonderful thing," he assured the man. "You and your wife will be happy there." Then Zayde insisted the family stay the night, which is a good thing because the children had already fallen asleep in the kitchen as their mother filled Bubbie in with all the news about their shtetl. Since Bubbie was one of the easiest people to talk to, the woman laid all her fears on the table of traveling into the unknown. Bubbie listened and nodded as she made beds for the family and made sure they would be comfortable for the night. Before sunrise Bubbie would make them all breakfast and pack them extra food for their journey. The man would insist on paying something for all the help, but Zayde's would be the same answer every time: "You do a mitzvah for somebody else and I will be paid."

It was already quite late, so I said good night to my grandparents and took a look at the strangers for the last time as I quietly closed the door behind me. I walked down the block to my house with my hand in my pocket, jiggling the change Zayde gave me for "working" for him.

I didn't realize it then, but this family, like the others who were to come and go over the years, was lucky; they were leaving a couple of years before the Holocaust, before the total destruction of all the Jews in our part of the world. My grandfather saved hundreds of people this way, providing just the right documents to get them safely across Europe, through a maze of border crossings, police barriers, and checkpoints. Like a true savior—a personal Moshiach—Zayde never took a penny for helping these people. In fact, on more than one occasion he sent them on their way with some extra cash in their pockets.

"Money is not something you hold onto," Zayde told me more than once. I agreed wholeheartedly, and I knew just where to get rid of it. The next morning I bolted out the door and onto the street, rolling my fingers over the coins Zayde gave me, making them jangle in my pocket. I ran all the way to the seltzer store downtown, knowing full well what I was going to do with my change.

The store was really a combination factory and storefront owned by the Wolinsky family. It sat on the market square in sight of my grandparents' house. In the back the seltzer was made and the bottles were filled; in the front a counter and a small array of consumables were for sale. When I set foot in the door, I had only one thing on my mind. I was greeted by the owner's daughter, Miriam Wolinsky, who oversaw the little factory as her three brothers worked in the

back filling bottles, turning water into a bubbly drink guaranteed to make you *greps*. I can still hear the sound of clanging and clinking bottles—like musical notes.

Miriam was one step ahead of me. "What do you want?" she asked. But before I could answer her, she teased me and said, "Your grandpa gave you some money, didn't he?"

I put my change down on the counter and Miriam handed me a great big chunk of dark chocolate wrapped in brown paper and tied the package tightly with string. Just to drive me crazy, she slowly tied a bow before handing it over. Even as I think of this today, my mouth waters like it did then, so much that I don't even know whether I said good-bye to her before heading out the door. A minute later I was running back down the road holding the chocolate in one hand and half a loaf of bread in the other. I was in heaven. It was cold but the sun was shining and crystals of ice were glimmering on the rooftops. I ran all the way home with a little gift for my little sisters—for each a piece of chocolate that I cut with my knife. I can still see their eyes lighting up, and before you knew it they were wearing a wide ring of chocolate around their mouths. We made an entire meal out of chocolate and bread and milk. Simple pleasures. I'll never forget the novelty of eating chocolate in Maitchet.

Our World Started to Change

By September 1939, somehow Europe had grown smaller. Germany and Hitler were no longer a world away. The political climate in Germany spread like a fire. Stalin had made a deal with Hitler to take over Poland and divide it between the Soviet Union and Germany. This was the very first stage of the war that was to end my life. The Holocaust began to sprout from seeds planted generations ago.

Immediately, people began running away from the German advances through Eastern Europe and western Poland. Hundreds of thousands of people were pushing to the east, trying to escape with their lives from places like Poznan, Lodz, and other towns. Most didn't even know where they were going. People were traveling on foot, some by wagons, and others on bicycles and in trucks. Trains were overflowing with frightened travelers and their suitcases. They only had what they could carry and soon the roads were flooded with refugees. Some who managed to get away were lucky, because in another couple of years their hometowns became the sites of mass murder and deportation centers to the concentration camps. Most who ran away from their homes in 1939 were eventually

trapped in newly-occupied German towns and sent to their deaths. Germans, and those of German descent, were suddenly granted the right to take over Jewish shops, businesses, and homes so that Hitler could Germanify as much of Eastern Europe as possible. If you were German, you got a promotion—a right to own something that was not your right to own. Jews were forced to leave everything behind and take to the road.

Years later, when we heard how Germans were shooting people to make Europe *Judenrein* (free of Jews), we found such reports difficult to believe.

Still, we were close to the Russian territory, and the rumors remained, to us, outlandish. Life, business, and entertainment went on as usual in Maitchet. Hitler's rhetoric on politics, as well as the brewing war to the west, remained vague and surreal. Pogroms were nothing new to us, but how could you believe that there was a plan to get rid of all the Jews in Europe? For the most part the Jews in my town wondered what Germany's politics had to do with our daily lives of working, swimming in the Molczadaka, or going to shul to learn Talmud. "They're just rumors," some people would say. "Why should we worry about Germany?" Others said, "There have been wars before. Somehow we'll get through this one."

Those who came running through Maitchet with their scared expressions and woeful stories were seen, by most, to be exaggerating. It will all pass, we thought.

Without great fanfare or notice, we were soon to be at war. Germany attacked Poland in 1939. At the same time, according to Stalin's pact with Hitler, the Soviet Union took over eastern Poland, where we lived, including Belarus and western Ukraine. When this

happened, there was officially no more Poland. It was now in two parts—German and Russian districts. The Polish army was defeated almost overnight and for a short time we were Russians again.

For the most part, on a personal level, 1939 was uneventful except for one incident I recall. By the time the Russians took over Maitchet, we had our own railroad and I got the assignment to work for our local stretch of tracks. Having an artistic talent, I found myself making signs along the railroad—stop, go, directionals, warnings. I had good handwriting and was good with a paintbrush. Another guy from my town, a Pole a year or two younger than I, was my assistant. We would cut a piece of wood, then carefully paint letters on the signs in both Russian and Polish, then attach them to long wooden stakes, erecting them in well-placed areas alongside the tracks. At night my colleague and I worked the late shift by setting out across the tracks with kerosene lamps. Our assignment was to carefully and continually inspect our section of track to make sure there were no problems. We looked for loose spikes, missing track, rotten boards, and obstructions—anything that might jeopardize the trains, passengers, and cargo passing through and around Maitchet. It was our job to keep our one section safe.

On this one particular evening, we were walking along the tracks when it began to snow. The wind picked up and whistled in our ears. The snow was coming down now so heavy that we couldn't see fifty feet in front of us. We had to turn our heads to hear each other. At one point my friend said he needed to sit down to eat, so we found a tree nearby and sat down, taking out our lunches. The tree blocked most of the falling snow. I took out a big slice of bread that my mother had made the night before, and to go

with it I produced a chunk of cheese. My friend had some bacon with him, and we began to share our food and try to talk against the wind. When we finished eating, we began to walk again, but now it was snowing so heavily that we couldn't even turn our faces to the wind. The wind, too, picked up and we were pushed along beside the tracks as we walked.

As we stumbled along, it was like being in a hypnotic state. Everything was white and all we could hear was the whooshing of the wind in our ears, but there were no other sounds. For some reason, I wandered a bit away from the tracks but kept my eye on my friend as he followed the rails eastward. He was a dark image outlined against the white of the sky and ground. We never heard the train that was bearing down on us, and the conductor probably never saw my friend on the track in front of him. Before I could even tell what was happening, my friend was run over and completely disappeared from sight, being dragged for miles on the snowy railroad tracks out of town. Not a trace of him could be seen.

I was shocked and sickened at what happened, but there was no one to run to. I could barely pick up my feet and my heart sunk into my stomach. How could someone be here one minute but then erased from existence in the next? The thought gripped me and I wanted to cry. I fell to my knees and stared at the track, which was already beginning to be covered up by the snow until it disappeared altogether, as if nothing had happened—as if my friend never existed. He was gone—as if it had all been a dream; as if I had been alone the entire time. Although I did not know it at the time, this was a foreshadow of what 1939 was yet to bring.

The German Invasion

Maitchet was so close to the Soviet Union that people thought we'd be protected from the Nazis. They clung to this hope—a flimsy defense against the Nazi advances. Maybe we'd be safe, they reasoned. Maybe it was just a political struggle over land. Maybe the Germans had all they wanted and would leave the rest of Poland to the Russians. In the meantime, we were part of the Soviet Union and life went on as it had for hundreds of years, except for perhaps a new feeling of uneasiness. A Soviet radio blackout stifled reports of what was happening in Germany and the increasing violence against the Jews.

We were a bit nervous but on Shabbos we continued to go to shul; we worked the fields like any other time; and my father and I traveled to Baranowicze for supplies. Travel remained free and easy. But our trips were short-lived. After the "Polish Defensive War of 1939," Baranowicze, now occupied by the Soviet Union, was overrun with refugees. The roads were crowded. The local Jewish population grew from around nine thousand to twelve thousand. That means three thousand people were milling around without a permanent residence or a way to earn an income.

It was only a matter of time before the Germans organized their takeover of all of Poland. This was in the summer of 1941. Hitler broke his treaty with Stalin and pushed all the way through what once had been known as Poland. Maitchet wasn't spared.

People started to change. Many Poles welcomed the Germans with open arms, like long-lost friends instead of a conquering army. Jews who were fleeing the rapidly expanding Nazi border rushed eastward. Zayde worked tirelessly, providing as many passports and visas as he could muster for the strangers who came to his door. His visitors were more than just weary from travel. Now there was panic in their eyes. More and more Maitcheters began opening their doors to refugees. From 1940 onward, all Maitcheters had strangers living with them. We wouldn't say no to our fellow Jews, and our population swelled to ten times its pre-war size.

One day in 1941, Papa was working in the market area when a small family approached him—the Bachrach family, consisting of a father, a mother, a daughter named Chana, and a son about my age named Shmulek. The father of the family told Papa that the Germans were quickly advancing. Like thousands of other Jewish families, the Bachrachs had to leave all their possessions, their house, and work, and run away. Mr. Bachrach pointed to four suitcases at their feet and said, "This is all we could take. It's everything we have."

The Bachrachs were from a big town called Mezritch on the new German border, about sixty miles southeast of Warsaw. Mezritch had more than twelve thousand Jews; in fact, most of the town was Jewish and it had been that way since the mid-1600s.

The Germans took over Mezritch in the middle of September 1939 then withdrew a couple of weeks later to let the Soviets occupy the town. Less than a month later, in accordance with the Molotov-Ribbentrop Pact, the Soviets abandoned Mezritch to be reoccupied by the Germans. At about this time, hundreds of Jews began to flee to the east, looking for a place—any place—to go that was still under Soviet control. Toward the end of 1939, Mr. Bachrach told my father that a *Judenrat* was formed. This word, *Judenrat*, was new to us but would soon become a common phrase throughout all of Eastern Europe. Whenever the Germans took over an area, they created a Judenrat—a council made up of Jews to act as the intermediary between the German command and the Jewish community. The Judenrat was eventually to be put in the impossible position of enforcing Nazi racial policies on its own fellow Jews. Sometimes this meant helping with "selections"—deciding which Jews were to be murdered, which ones would be sent on trains to concentration camps, and which Jews would be given over to work camps.

Under Action Reinhard (named after Hitler's highest-ranking Nazi official in charge of the Final Solution), more and more Jews were forced into Mezritch—it became a way station to the concentration camp Treblinka. The Bachrach family escaped that horrible fate—if only for the time being.

When the Bachrachs reached Maitchet, they were tired and frightened. They had had a glimpse of our future. Papa insisted the Bachrachs come home with him. Momma would feed them and find them a place to stay in our house. They could take their time to decide where to go and what to do next. Over the next few weeks,

the Bachrachs poured their hearts out to Momma and Papa, using words that we never heard before, like deportations, concentration camps, work details, and ghettoization. Their stories were unbelievable—people being forced to turn over their homes, being robbed on the street by the police, and even being shot. Despite their plight, we still wondered how any of this could be possible. Thousands of people were on the roads running eastward through Poland. Every avenue was lined with refugees so thick in some places that traffic slowed to a crawl. Good thing, we thought, we were safe in Soviet-occupied Poland. The Germans would never be able to invade Russia. It was much too vast and had a powerful army. As Soviet citizens, we could look around us every day and see that all was normal—it seemed that the Russians were once again in control. Zayde was, after all, put into position as mayor when Maitchet was a Russian village. We were safe, we kept telling ourselves.

I was spending a lot of time with twenty-year-old Shmulek Bachrach during this time. He was a house painter by trade and wasn't particularly interested in the Talmud or Jewish learning; yet we had enough in common to become friends. He was easy to talk with and more than willing to help out with my chores and pull his own weight as a guest in our home. At one point he told me that we were not safe from the Germans and that the Germans were murdering people in the streets. "If not for my parents," Shmulek told me, "I would run away as fast and as far as I could go—maybe to Palestine."

I was alarmed. I tried to imagine the picture he painted of thousands of people on the road with their belongings, violence in the streets, and German soldiers taking over one shtetl after

another, but still, it was too difficult to understand what he was saying to me.

"The Germans come into the towns and take out the Jews and shoot them on the side of the road. I saw this happen," Shmulek told me.

I was so convinced by Shmulek's account of German cruelty that one day I went to my father and pleaded with him to leave Maitchet. "We have to go," I said. "They're killing the Jews. We should leave right away." My father listened to what I had to say as we paced outside in front of our house that stood at the end of the street lined with all of my uncles' houses. It was very clear that this was all we had.

"Our whole family is here," Papa told me. "This is our home; where could we go?"

"Away," I tried to argue. "We should all leave."

"What would we have? We should leave all that we have and everyone we know? And then what?"

Part of what Papa said made sense. We, the Shmulewicz family, were never people to run away from our problems. We stood up to the Gentiles when they spewed their hateful anti-Semitic words at us. We defended ourselves against the raiding Cossacks. We stuck together. My father never backed down. It was clear that Papa would never turn and run; he was a strong man with a strong sense of reason and honor. Looking down our street, seeing the line of homes owned by Zayde's sons, the idea of picking up and leaving seemed ominous. I tried to imagine our entire block deserted, without cousins or uncles or aunts. I tried to imagine the silence. I couldn't and neither could Papa.

This was our world. Maitchet was us, and we were Maitchet. Most of all, Maitchet was part of the Soviet Union. The Germans would have to be crazy to invade Russia. It would be suicide. No, it was obvious, by all logic, that we would be spared the German cruelty spreading throughout Europe. Why would the Germans want Maitchet anyway? Maybe Papa was right.

Yet people in town—in stores, in the shtiebls, in shul—talked about the war and the Germans and the shifting politics. It was unavoidable. And so, for the first time, I was faced with thinking about the real possibility of losing everything. The German army was advancing swiftly to the east. Like so many others, I held a bundle of conflicting and confusing thoughts in my head. As a young man, I knew I could run. I could leave it all behind. I had nothing but my family keeping me in Poland. But my father and mother had their home, their neighbors, their Yiddishkeit, their traditions. For them, the thought of leaving—of fleeing—was impossible. And how could I leave? I would be abandoning my family. For the same reason I never went with my friends to Palestine, I felt I had to stay in Maitchet and wait out the storm. All storms pass.

We weren't rich. There were so many of us. Things had been bad for the Jews many times before. How bad could things get? No, we would stay in Maitchet with the other Jews, the other members of our family. We would stay in our beautiful home across the street from the Greek Orthodox church and its bright white walls and its friendly priest and his family. Nothing had changed in Maitchet. No need to panic. We were safe here.

If you've never been faced with the idea of having to leave everything at a moment's notice, then it's hard to describe what was

going through our minds. These conflicting thoughts become an obsession. I now had a firsthand understanding of how all of those people felt who had been coming to Zayde's door in the middle of the night. And though my mother's sister, my Aunt Frieda, was already living in New York, America wasn't even real to us. We didn't give it a second thought at the time. We would just wait and see. Nobody could imagine or predict what was to come. It defied logic. It was random and surprising. And it was so sudden that we were in a state of paralyzing shock. We had never encountered such behavior, and we certainly never expected it from our friends and neighbors. As it turned out, it wasn't just the Germans that we should have been worrying about. Our worst enemies, as strange as it sounds, were our friends.

One cool, dewy morning, carrying a sack of flour over my shoulder, I was walking down the street with Shmulek talking about my friends, the Zionists, who had left for Eretz Yisroel the prior summer. We guessed what they might be doing now, working on a kibbutz in the desert. We laughed, we sang a song on the road back to my house, then we worked the rest of the day planting seeds in our garden.

The next morning we were met with a new world. Nothing looked the same. There were clouds hanging low, hardly blocking out a blood-red sky. No birds. Nobody breathed. At the break of dawn, Maitchet was awoken with the ugly, guttural sounds of German motorcycles spitting up a cloud of dust a half mile long. A few other vehicles followed close behind, carrying maybe a dozen German soldiers. Maitchet had been invaded. Just like that. Hitler's henchmen had reached our very door. But it wasn't the kind of

invasion you might think. There weren't hundreds of trucks teeming with an army of soldiers. No tanks came through and no heavy artillery rolled in. Germans didn't march down our street in front of our houses, goose-stepping over the cobblestone pavement past the Greek Orthodox church, past Zayde's house, and into the middle of the town where the marketplace was held. No German rifles were fired; no homes were set ablaze. No, this was a quiet invasion at first; it was a presence, a change of ownership. Completely without warning or ceremony, the Russians were gone and now we were in German-occupied territory. This was the spring of 1941.

What happened over the next month is a blur of terrible memories. Our neighbors, the Polish farmers and townspeople, went through a Kafkaesque metamorphosis and became something unrecognizable and surprising—something inhuman. We who had lived with these people our entire lives could not recognize them. They welcomed the Germans, brought flowers, and stood along the sides of the road, joining in the fascist cause with the briefest of invitations. Why? Possibly this was their opportunity to have everything that belonged to the Jews. It was time to get even and release the anti-Semitism that had been bottled up for so long. It was time to lose all pretense of morality.

Remember that we are speaking of a poor town of ignorant, superstitious, and jealous people who, up to this hour, had been kept in line only by common decency, an oppressive Soviet government, and the dictates of the law. But now the Germans made all that was disagreeable and taboo socially acceptable. With peer pressure and the new Nazi law, cruelty became the norm.

At the beginning of summer, when the skies should have been blue and the birds chirping, only black clouds rolled in from the west, threatening to smother Maitchet in hellish darkness. The fate of hundreds of other shtetls had now taken root in our small town.

Our Polish neighbors became more than just willing collaborators and enablers—they became the leaders and the initiators of every unspeakable act that lies dormant in the soul of evil beings. When the Germans came in, they enlisted the help and cooperation of the Polish police. The head of police, Vlojik Ulashik, the brother of my childhood friend Tamara, had a dilemma that needed to be worked out. Vlojik was married to a Jewish woman. His daughter was therefore half Jewish. He had been married for ten years to his wife and they had a good relationship; we'd see them walking through town with their daughter on Sunday mornings. But this was a new day in a new life. When the Nazi command challenged the Poles to abandon their Jewish neighbors, and they were told there would be a death penalty for helping the Jews, Vlojik marched all the way home from the police station and brought his wife and daughter to the center of the town square for Nazis, Poles, and Jews to see. He then pulled out his service revolver and shot his wife and his daughter in the head. Just like that, Vlojik Ulashik proved his loyalty to the Nazis and set an example for every Pole in Maitchet that a Jew was of no value as a human being. We couldn't believe our eyes. This was only one sign of things to come.

What could have happened that would change these people from neighbors into monsters? Is it conceivable that behind every smile, for years on end, was an insane soul with murder on his mind? Was it really possible that these people who worked, played,

and interacted with us really hated us all along? Were they simply pretending for hundreds of years? These Poles, our "friends" and coworkers, classmates, and playmates, needed no great amount of encouragement or prompting by the Germans to carry out the Final Solution in Maitchet. As soon as the Germans arrived with only a handful of soldiers and an officer, the Poles took the cue. This was their opportunity to show their colors, take revenge, and steal all they could lay their hands on. They would have their orgy of gluttony and disgrace in full view of, and with complete sanctioning by, the new law.

The first order of business was to force all of us Jews of Maitchet into our homes. If you had a gun or a hunting rifle, you were made to give it up or were shot on the spot. If you tried to run away or hide you would also be shot.

We dared not go outside. One or two Jews unfortunate enough to find himself or herself outdoors met with savage beatings in the middle of the street by gangs of roaming Poles. They were kicked, screamed at, punched in the face, spat upon, and humiliated. A few were beaten to death. All that the rest of us could do was watch from our windows and try to make sense of it all, which, of course, was impossible. There was no sense at all. No humanity, no dignity. It was surreal.

We couldn't even run to our relatives' homes to see if they were safe, if they had any information, if they had a plan. It turns out that they didn't. None of us knew what to do. We were stunned. We were prisoners in our own homes.

Shmulek and his family had run away from Mezritch to this— something as bad and maybe worse. They had merely delayed their

fate. The Nazis had occupied, with exacting and brutal force, the major cities of Krakow, Warsaw, and Vilnius. Nearby Baranowicze was at this time being converted into a ghetto with a labor camp.

With no automobiles or telephones, there was nowhere to run. Every road out of Maitchet led to another German-occupied town. A feeling of hopelessness was just around the corner as days passed without our being able to set foot outside. People began to grow hungry. The long, torturous hours turned into black, horror-filled nights.

In the early hours of the morning, a number of young men my age ran away from their families, trying to hide. They climbed up into attics, haystacks, and barns, and some ran into the forest. We all considered running and hiding. We strained our minds trying to think of some way out, to find some opening for negotiation or escape.

After days cooped up in our house with the Bachrach family, a couple of Polish brothers we knew came to me and asked me to go with them; they would hide me. I had known them all my life. They were friends. We went to school together. They told me they were already hiding my cousins Chonyeh and his brother Moishe. But I couldn't leave my family. They disappeared into the night and I never saw them again. To this day I don't know what their true intentions were.

Only in the evening did a few brave souls dare to poke their heads out of a doorway. The streets were emptied of Jews. Shabbos came and went without the familiar voice of Moishe urging the men to shul and the women to light the Shabbos candles. There was no more discussion of Talmud in our shtiebl, and the cold

synagogue sat vacant, with no Jewish voices talking to God. We were all now just waiting though we didn't know for what. All we could do was sit and worry and listen to the sounds of gangs. Then there would be a scream. A girl would be taken from her home and raped repeatedly in front of her family by boys who used to work the fields with me. A protesting father would be beaten to death and then his body would be hacked into pieces with farming tools. The rest of the family could do nothing but watch through their living room windows.

Next the looting began. Randomly, a Jewish family would be pulled from their home while a mob forced its way inside only to reappear on the street ten minutes later carrying lamps, chairs, silverware, clothing, food, coats, and whatever else they could get their hands on. They tore up the floorboards, feeling certain that beneath them were treasures. Our Polish neighbors thought, as poor as we were, we were hiding fortunes. All Jews were rich, they believed, living over a foundation of gold and jewels, sleeping on mattresses stuffed with money.

In the middle of the street, Polish men and boys, with women standing by, holding their babies, went into our shtiebl and synagogue for our Torahs and Talmuds. They threw them on the ground, spat on them, set them on fire. Next came the books—thousands of books representing thousands of years of learning, law, philanthropy, and civil teachings went up in a blaze while the criminals shared flasks of vodka and cheered. Their faces, lit up by the blaze, revealed twisted, drooling, savage expressions, begging for more and more violence and an outpouring of hate. They resembled actors playing the role of dybbuks; but theirs was no act.

What happened to the unfortunate Jews who were thrown out of their houses when looting began? They were beaten to death—mother, father, grandparents, and the children—unrecognizable and left by the burning fire with no one to help them. Inside our houses we cried and trembled.

And then came the morning.

While looking out the window of our house, across the street at the Greek Orthodox church, I saw a mob storming in our direction. There were about twenty young men, half drunk, swearing and laughing. Their eyes were inhuman—hollow, without light. Their faces were sooty, sweaty, stale. Hair matted. Their grimy hands were balled into clenched fists and their heaving chests were thrust forward. Many were holding farming instruments—spades, hoes, picks, and axes. Others had pistols and knives tucked into their trousers. Some held shotguns. One carried a rope that dragged and jumped behind him.

All of us in my house, and the homes of my uncles, aunts, and cousins, were glued to our front windows. As I carefully peeled back Momma's hand-sewn draperies to peer at the unfolding scene, I saw my own unruly hand vibrating out of control. I was breathing in short gasps and my mouth was dry. I stole a glimpse of my family. We were all terrorized.

Were they coming for us? Where could we go? Nowhere. Instinctively, I looked at our bolted front door. My little sisters cupped their hands over their ears as Momma held them tight. What would happen to us? The mob stopped in front of our house and looked our way. Instinctively, we withdrew into the shadows. Their agitated feet never stopped moving, their hands slapping their

farm tools. They stared at one another. Then they turned, showing us their backs, and descended on the Greek Orthodox church directly across the street. Like a swarm of wasps, savages screaming and still drunk from the night before, they all shoved in through the front door of the church. Then there was silence. We saw nothing. We shifted and looked at one another. We exhaled and swallowed. I could hear my own breathing.

The silence lasted only a couple of minutes, until the mob exploded outside and the screams and curses once again flooded into every corner of the neighborhood. Two young men pushed their way out of the crowd. They were clutching the priest, our neighbor, by the arms, their fingers digging deep into his biceps as he tried to keep his footing. He was pleading with them to come to their senses as he tried in vain to wrest himself free. He was hit in the face and told to shut up, first with a fist then with a metal object. Next came the others, shoving the priest's wife, daughter, and son out onto the church grounds. All four of them were pushed against the wall of the Greek Orthodox church. We couldn't turn our eyes from this terrible scene. The family was taunted with shouts of "Jew lovers!" Then several men at once produced pistols and waved them in their sweaty hands. They pointed their guns point blank at the priest and his family, then fired. Over and over again, they shot these poor people in cold blood. We were sick. Sick. The white walls of the church ran red. How could this have really happened? Did this really happen? To shoot a priest? To shoot his little children and his wife? The Bachrachs held their heads in their hands and stared at the floor in shock. Our hearts were beating in our throats. Our faces and heads were throbbing and our stomachs turned inside-out. Our

eyes were lying to us. What kind of madness was this? The priest? Even one of their own?

Now even more than ever, there was nowhere to run. Our future—our fate—was not in our hands. The entire day passed in stunned silence. The priest's face, twisted in terror, straining to understand, trying to use reason in the face of madness, was all I could see when I closed my eyes. The blood, the red blood of these innocent people, was left splattered onto the bright white walls of the Greek Orthodox church, turning purple-black as the day wore on.

When night fell once again in Maitchet, we could not see a thing. We could hear screams, shouts, and drunken rage. A weapon fired here; a glass shattered there. A young girl's shrieks of terror. Silence, then a rush of noise. Shouting, boots running through gardens. A door kicked in, rocks crashing through windows, another series of faint screams.

Hunger was eating away at us. We were to meet our fate either way, murder or starvation. We had not eaten in days. Our food had run out. The men huddled together while Momma, Peshia, Elka, and Shmulek's mother whispered in quiet conversation in the kitchen. Hours passed in the darkness. Then at around midnight came a very quiet knock on the door. Our hearts began to race. Who could be out at this hour?

My father strained to look out the window at the front door. We all stood up as he slowly opened the door. A young girl pushed her way in. She was nervous and spoke so softly that we couldn't hear what she was saying. In her arms was a basket covered by a blanket. When she pushed her scarf off her head we could see the girl was Tamara Ulashik. Nervous and breathing heavily, without

saying but a word or two, Tamara came in and gave us the basket. In it was a gift of food—bread, butter, some cheese, and some meat. We were in disbelief. Tamara had risked her life to feed us. Waiting until dark, she left her house and headed for the fields, then walked completely around the edge of town, through backyards and over fences to get to our house without being seen. She made nothing of her act of kindness. Her eyes scanned our house as if she was making sure we were all okay. She was worried about us. She was frightened. When her basket was emptied, she looked out the front window, saw that the street was clear, then slipped out through the door and disappeared into the darkness. Tamara Ulashik tried to save us—to keep us from starving. Each time we would run low on food, Tamara would steal out into the night and bring us enough to live on.

To me, Tamara Ulashik was the Moshiach, at least in this moment. To this day, I wish that I could find her and thank her for her courage and human kindness. In Yad Vashem, the Holocaust memorial in Israel, there is a term reserved for such people as Tamara—the Righteous Among the Nations—Christians who practiced the true spirit of their teachings and became Messiahs in their own right. They were saviors who reached out to their fellow human beings because they never lost a sense of morality, dignity, or compassion. Selfless acts of humanity were in short supply, but those of us who survived will forever remember them. I remember our angel, Tamara Ulashik. After the war I had her name listed as one of the Righteous Among the Nations in Yad Vashem.

And Then We Were Slaves

Lost in the madness of Maitchet, we had no idea that all of Poland, right up to the Soviet border, was going through the same terrifying experience. Every shtetl was in chaos and suffering from mob rule. Somewhere in this dark hour is when the first of millions were buried. Possessions were being buried all over Eastern Europe. Into the ground and under floorboards went photographs, jewelry, a small bag of coins, a Torah, and candlesticks. Shabbos tablecloths handed down from mother to daughter to granddaughter were folded tightly, stuffed into a box, and buried in the yard with wedding rings, deeds, books, and papers. So many things were buried; most lost forever, with their owners buried elsewhere without nearly as much devotion, contemplation, or sacredness. The first into the ground were our things, returned to earth, given back to God for safekeeping with the hope of recovery in brighter days to come, days that never came, days that the world seems to want to forget. Days full of events that now, without ever having been there to witness these events, many are saying never happened.

The Germans had diligently converted our bigger towns into holding centers and ghettos. Warsaw, Minsk, Bialystok, Radom,

Lublin, Kielce, Lodz, Krakow, and other towns were now homes to hundreds of thousands of homeless, helpless, exhausted, confused, beaten, and starving Jews. The Nazis turned beautiful, culturally-rich, and teeming towns into filthy, disease-ridden ghettos. With small armies of forced labor, they walled off sections of cities to create internment camps where people starved to death without food or water; no way out and no way back in. The Germans had plenty of Polish helpers to enforce their new law, as well as to rout out Jews in hiding. We were a bleak, occupied country with most of those occupied doing the bidding of the aggressors.

All the while, every day and night, we heard shelling and bombing and planes flying overhead, with the German army pressing on. A war was going on but we had no details, no information. Radios and telephones were forbidden to us. We sat alone with our fears. We only knew that the Germans had driven the Soviets out and to the east and that the Nazis were ruthless and murderous.

Baranowicze was converted by the Nazis to a processing center, thousands of Jews were brought from neighboring areas and forced into a new Jewish district that was walled off and gated. Behind this wall of wire, thousands of Jews were imprisoned while the Nazis carried out well-planned programs that decided their fate.

I stood at the wooden counter in my mother's kitchen looking for something to eat. There was a slight chill in the air. I rubbed my arms with my hands. There was no fire burning anywhere in the house. My entire family was in the living room, along with some guests, huddled together waiting. Once in a while, my father would stand up and look out the window then go back to the sofa beside

my mother. It was the middle of the day. Nobody was working. My stomach growled. I was growing hungrier by the moment. What was I looking for in the cupboard? Anything. I stood staring at an empty plate, my thoughts drifting far away. It was too quiet. I looked out the window. The street was deserted. I turned around and sat down on a chair and crossed my legs. This kitchen that I helped my father build was, for once, quiet. It was a foreign feeling. No pots and pans and baking dishes were clanging. The laughter was gone. The stoves were cold to the touch. It was deathly quiet. Then I heard a boom coming from the living room. *What was that?* It sounded like a log smashing into the front door. It jolted me. Everyone in the living room had jumped in shock.

Boom, boom, boom! Fists were pounding on the door and a young, familiar voice was shouting. Demanding. *Open this door! Open or I'll smash it in.* I ran to the door. Everyone was wide-eyed. My father stood with his fists clenched at his sides as I opened our door. In front of me stood my boyhood friend, Stach Lango. His seething expression, his twisted mouth, and sick gaze belonged to somebody else. What happened to him? He pointed a pistol to my face, grabbed me by the collar, and said, "If you fight me, I'll shoot your mother, your father, and your two sisters right in front of you." Stach pulled me by the shoulder and yanked me out of my house. My family watched on helplessly as I was dragged into the empty street and pushed all the way to the police station and into a room with a wooden table in the center and a glowing fireplace by the wall.

A small stack of wood and some iron pokers leaned against the dirty, paint-peeling wall. Once inside, still with a pistol pointed at

my head, I was forced to undress. *Hurry up, goddammit, Jew!* Then Stach tied me to a table in the middle of the room. I couldn't move. My wrists were tearing from the ropes. My eyes followed him as he tucked his gun inside his waistband. He picked up one of the iron pokers and angrily shoved the end of it into the embers. He knew I was watching and relished his power over me. The iron grew hotter and hotter until the tip of it pulsated in red and white. "I'm going to kill you, Jew," he said. His voice was monstrous. He brought the iron toward me and I could hardly bear the heat even from several inches away. Smoke was rising from the glowing tip.

With a maddened calm, Stach told me, "I'm going to kill you slowly. I want to hear you scream."

My heart raced and I felt sick. The poker was pushed slowly and torturously toward my face, and all I could think of was, "God, take me quickly." I called out for God, God my rescuer and confidant, the God I knew as a Yeshiva student, the God of our Torah. Where was God in all of this? I braced myself for the worst as Stach came toward my eyes with the iron. The heat was burning me from several inches away, and the glowing tip of the poker was sizzling in the humid air. Sweat beaded up on my forehead then dripped into my eyes. I shook uncontrollably and waited for the inevitable. Then the door flew open and Stach turned to face his friend who was exhaling puffs of steam and trying to catch his breath. He had been running, racing against time to find Stach and tell him something of urgent importance. He whispered something in Stach Lango's ear. I couldn't hear what was being said, but without a word spoken to me, I was untied and set free. I don't know why. I don't know to this day why they let me go. I ran out the door and ran and ran

until I came back to my house in a pool of sweat and called for my mother as I burst through the front door. I saw her face through my tears and she opened her arms. I held her tightly and felt every fiber of her dress in my hands. I breathed in her hair and laid my head in my own perspiration, and tears running down her neck and soaking her collar. I couldn't let go, and she held me; I was her baby and she held me. She sat down and I dropped to my knees as Momma held my head on her lap and stroked my face. I sobbed and she tried to console me.

Months passed. Our every move was tentative, and we took our lives in our hands with each step away from our homes. We did very little, the bare necessities on our farms and with our animals. There were daily killings—people were burned, beaten, and butchered, taken out of town and left for dead. People were constantly disappearing. Mothers were worried sick about their boys and husbands. They waited and waited, but it was over. They would never come back home. All of our days were coming to an end. One by one. A distant scream, a shot, pleas for mercy, shattering glass waking us from our beds in the middle of the night. Lives were tragically coming to an end. Cousins, neighbors, friends. The murder rate was sometimes ten, twenty, or thirty a day.

Then they came for me again. Stach Lango and a group of his friends. I cannot even remember most of the details, only that I was in my house with my family and the Bachrachs when fists started pounding on our door so loudly that we thought it would split in two. Black boots, farm boots, muddy, heavy boots kicked at our door, the door my father built with his two strong hands; the door I helped set upon its new hinges in my other life. Standing on our

porch, stomping on our veranda, they kicked and punched. They called for us, Shmulek and me.

When we came to the door, we saw a wall of angry, hateful men and boys outside, spilling onto our front lawn, standing and stomping in my mother's flower beds. Stach Lango pointed his gun at me and said, "Come on, let's go." I didn't know what to think. Were we going to replay the events months earlier when he had been about to burn me alive? Then his gang pushed in through the door and grabbed me and Shmulek. There were horses and wagons lined up, one after another on our street. Several men pulled us outside, kicking and punching us and prodding us with the handles of farming hoes and rakes. We tried to cover our heads and faces from the blows as we were being shoved. I don't know if I fell or not, but in an instant we were carried along by a mob to the middle of town where the market square was, in front of Zayde's house. The market was crowded with more than a thousand people. We were all in one another's way, tripping over one another, turning in different directions, trying to understand the confusion. Next, one by one we were dragged over to a wagon where, along with all the other young men, we were tied by our necks to the wagon's railings. Three or four of us were bound to a single vehicle. There were some from Maitchet, others from towns nearby, and boys like Shmulek who came from the west with their families trying but failing to reach the Russian territory. I looked around and saw so many familiar faces: the same boys who stood with me to fight off the Cossacks; the same ones who studied Torah with me in the shtiebl. We were all there: every young man they could get their hands on. As I was being shoved and beaten, I saw my friend, Rabbi

Chonyeh Goldstein, thrown to the ground. He struggled back to his feet and was dragged to a wagon. Also near me were my friends Chaim Novomicheski, Yankel Silverman, and Mayer Rozanski. A couple of Poles a few yards away were tugging at the arms of a woman. I couldn't see her face. She tried to pull away, to sit, to kick as she wailed. One of the men took out his revolver and shot her in the head. A dark-haired doll, rumpled and broken, laid lifeless with a gentle red stream trickling away from her body.

We were tied up with our hands bound at the wrists behind us. The rope dug into our flesh, burning our skin as it scraped and tore into us. Our throats ached with harsh, wiry rope pushing into our windpipes and cutting off our circulation around our necks. Our eyes were open wide, but with more and more people crowding the square, we could not see more than dust, clenched fists, and a train of wagons driven by farmers. Wagon wheels shifted unsteadily as the horses revolted against a deafening roar of hate and commotion. Tied up and jostled, we waited under the sun drowning in a din so loud it stifled the sounds of our mothers as they screamed for us in torment through the windows of our houses. Scores of young men fell to their knees then, without the use of their hands, and being choked from the ropes around their necks tried to right themselves. I widened my stance and inched closer to the wagon to avoid being knocked over as the horse up front shifted position and yanked the wagon.

I had been torn from my mother, father, and two little sisters; I could not take one last look at them. Any chance to utter a single word to them, to say "I love you" with words or gestures, was stolen from me. No words of parting. No warm and loving hug, robbed

of my mother's softness, of my father's strength and courage, of my sisters' sweetness, of Zayde's wisdom, of Bubbie's loving gaze. A suffocating feeling of loneliness swept over me in the stampede. We were entwined souls ripped harshly apart in the darkness of mid-morning, in the silence of a riotous crowd whose hate and vengeance was now an avalanche. Someone—I did not see who—hollered an order in uneducated gutter language. Another brought his riding whip cruelly down onto the horse tied to the other side of the wagon. The animal screamed and the wagon jolted, wrenching our necks and forcing one or two others beside me to their knees. They struggled to their feet just in time as the wagons pulled away with all of us running in tow to keep up with them. Some, starting with a limp from the force of the wagons at their joints, were doomed not to make it. Our families watched from their windows with burning eyes as we became part of a long parade of slaves dragged out of town.

Have you ever seen a human body torn apart from being dragged over a rocky road? This is what happened to two of my friends who tripped or fell from exhaustion. The rope from the back of the wagon dragged them screaming and moaning. Then the screams stopped. All I heard was a body, then another, bumping in torn pieces along the road. Their legs were ground down into bloody stumps and their faces were no longer faces at the end of bouncing ropes.

My biggest fear for the moment was not keeping up and falling. With very little energy from a lack of food and sleep, we were pulled along by our necks like this for miles. We would stop for an hour or so here and there to rest the horses, then we were off again

until we reached a little farm town called Koldichevo. When we got there, the Poles were raping girls and women out in the open.

We were at last untied then pushed with gun barrels into a barn that was partially filled with cold standing water and animal refuse. We were given a piece of bread and stayed in Koldichevo for two or three days before being tied up again and dragged off to Baranowicze.

Baranowicze. This was hardly the city I remembered. The busy Jewish hustle and bustle had been smothered. The Nazis created a Judenrat that told us to find a place within the ghetto and settle down. We were all kept as prisoners awaiting our next instructions.

With its great network of railroads directly and indirectly connecting Baranowicze with every city from Moscow to Berlin, Baranowicze was now a way station for Jews from shtetls north and south. Who would have thought that the trains that once brought fathers home to their families and Yeshiva bochers, like me, to learn from the greatest teachers would now be the instruments of an ultimate and irreversible tragedy. Jews were being packed into train cars and carried away, far away from this land and these memories. No more Jewish life, no more families, the last vestiges now just a memory.

The buildings of downtown Baranowicze, inside the ghetto, were makeshift homes for twelve thousand people concentrated into a small area, with six or seven buildings. More than a quarter of its Jewish ghetto population was made up of Jews from other areas. Even more were on their way as the Nazis meticulously swept through every shtetl in eastern Poland. I tried to imagine Baranowicze as I knew it only a couple of years earlier. I wondered

what had happened to my uncles in the garment and lumber business. Where were the rabbis and the Yeshiva students?

The once-enchanting Baranowicze of my youth had become an ugly, desolate prison. Gone were the prosperous Jewish businessmen. Their houses and properties scattered throughout the countryside were no longer theirs. The best of their homes were stolen and occupied by Nazi officers. Local gangs ransacked smaller houses; others were left intact as Polish neighbors simply moved in and carried on life as usual. Small farms and fields or mills owned for generations were now abandoned. And shops in the middle of town stood empty, looted, lifeless.

The Baranowicze ghetto was cordoned off with fences guarded by Ukrainians, Poles, and Lithuanians who anxiously waited for an opportunity to murder or beat up the Jews, Russian prisoners of war, or other "enemies" of the new Nazi order. If you were found outside the ghetto you were to be shot—no questions asked.

In Baranowicze, Shmulek and I found ourselves among a crowd of others who were brought there in the same manner. We were all forced into one wave of men and older boys through makeshift gates guarded by Polish police until shoved in behind the fence of the ghetto. Others, including women, mothers, grandmothers, children, babies, and toddlers, were forced onto the trains, locked in hot cars with standing room only, then shipped out to concentration camps in never-heard-of towns.

Along with the few young Jews from Maitchet, Shmulek and I melded with hordes of others from surrounding areas to await our fate. We had no idea what would happen next.

It was not our right to know our fate. There were only rumors but no real information. What would happen to us? Word spread that we would be used as laborers. What we were not told, but what we suspected was that we had become dispensable, unhuman beings. We had already seen that to shoot a Jew was like killing a fly. Our lives were worthless. The term "labor" was a convenient lie. Real laborers in a normal society had a value, but we were slaves, prisoners who committed no crime. This condition forced me to adjust, to see the world in a different way—without a future. My life as a person ended when I was forced into a crowd of angry, confused, tired, and defeated men and locked in this ghetto at Baranowicze.

As days turned to weeks, my goal was only to survive in the midst of a dozen people daily lining the sidewalks, exhausted and filled with fear, or taken out in small groups never to return.

Once the ghetto was stocked full of Jewish prisoners, the Nazis established work details that were sent out every morning. Some of us were made to clear roads, others to labor in fields. Still others dug mass graves. Without knowing it, they were digging their own graves, so they could be massacred in large numbers and swallowed up by the earth.

Every long, stressful day in Baranowicze was one step closer to death. Dead bodies were strewn on the sidewalks until we stopped noticing our own efforts to step over them on the way to scrounge for food and water. Vacant eyes, swollen bellies, hopeless, helpless faces. Confused, sad, and beyond anger, with no more bodily fluids left to produce tears. Baranowicze was dying quickly.

For the time being, I forced myself to stay strong. Hard work was nothing new to me, but the uncertainty of life created more and more anxiety. Only death awaited me in this ghetto. I had to get out, even though I knew that a work detail could be a death sentence. So far, Shmulek Bachrach and I had avoided selections for work details. We had escaped the notice of the guards, spending our days out of sight or, when appropriate, blending in with the masses.

Looking around, I could see that some of the older or frailer men would never survive any kind of labor. Their delicate fingers were meant for pointing to the pages of the Torah and their weak legs to take them to shul or to spend the day sitting at a desk. They were scholars or merchants, never having pulled a plow or carried heavy bundles on their backs for miles. I was a farm boy, and these were city men. They would never make it. They would be the next to go, and their families would never know what happened to them.

I trusted that God would give me the strength to take on the unknown that was ahead of me. In the meantime, I slept in the street, as the few buildings inside the ghetto were overcrowded with those wearier than myself. People were sleeping in stairwells, hallways, looted-out stores, abandoned offices, and warehouses. Some died in their sleep, and the smell of death grew heavier each day. Shmulek and I slept at night using our jackets as pillows, but we did not rest. We asked ourselves whether this was it—whether this was how our lives were to end.

Each day people were randomly singled out to leave for work. Overseen by German soldiers, our guards would assemble a group

from our ranks who were taken away to work clearing fields, cleaning out railroad cars, repairing roads, digging trenches, and erecting buildings—all for the Nazi war machine. Not everyone came back.

One day a tall, good-looking Nazi officer in a brown uniform came to the ghetto and asked if there were any painters among us. Standing slightly behind him was his Polish interpreter, a man named Grabowski. Shmulek, a painter by trade, raised his hand then prompted me to do likewise. The officer, known as Herr Doktor Wichtmann, nodded his head and pointed at us. "*Diese*" (those), he said. Grabowski pushed his way through the crowd standing near the gate, then grabbed Shmulek and me by the sleeves.

We were selected to leave the ghetto. But where were we going? Should we have felt lucky? Were the others envious? Why should they be? Maybe it was better not to be separated from the rest; maybe it was a cruel trap. The Germans were quickly gaining a reputation for cruel tricks. A work detail was many times not a work detail at all. They marched you to the forest, ordered you to the edge of a ditch, then started firing their rifles. Twenty, fifty, a hundred at a time, shot into a ditch, and covered over by Russian prisoners and another work detail of Jews. We wondered, we feared, what we were volunteering for. But we feared even more to ask. To ask often was the end of it all. We didn't ask. We didn't resist. We followed Grabowski out through the ghetto gates.

It was a sunny, cool summer morning as we obediently shuffled out in front of Grabowski with Dr. Wichtmann walking ahead of us in his crisp brown officer's uniform and shiny black boots. His hair was a blond-brown and carefully combed beneath his officer's

hat. His fingernails were manicured and his back kept straight to impress us with his superiority. Expensive cologne wafted through the air—a strange diversion from the smell of death we were leaving behind. Dragging our feet, with our stomachs growling, we followed the tall officer at a brisk pace for ten or fifteen minutes along cobble-stoned Wilenska Street. He walked on the sidewalk, a place forbidden to Jews. We walked in the road, past the buildings, along fields of wild flowers, weeds, grass, and scattered fruit trees until the ghetto was no longer in sight. We were, by now, a mile away, far enough for Wichtmann not to smell the stench or be inconvenienced by the groans of the starved and dying. We were in the country, with the forests lying not far beyond and the breezes free to blow over wide open fields of tall, yellow-brown grass.

At last we arrived at the doctor's house, his new quarters. Wichtmann had taken possession of the home and land of a well-to-do Jew who would never return. The outside of the home was being groomed by Russian POWs working without rest under the sun. They were shirtless and their ribs stuck out of their skin. A few guards sat in the shade of nearby trees keeping an eye on them. Whether the guards were Germans or Ukrainians, I could not tell.

All around the house, the gardens were bearing flowers. Broad-leaved trees were in full bloom now and shaded the home and yard. A clean, bright white picket fence ran along the front of the house, separating the lawn from the sidewalk. Like my own home in Maitchet, this house also had a front porch made of wooden planks and trimmed with a railing. On the property were a couple other buildings too, maybe a maid's quarters, where the Russians now lived ten to a room. There was another building as well just behind

the main house—a tiny structure with only a couple of windows that were tightly shut, even in the summer heat. Little did we know what hell was going on in there. Later, I was to find out.

When we stepped inside Wichtmann's house, we knew it had once belonged to a rich family. Fine furniture and carpets adorned the rooms. Windows were covered with delicate curtains and the floors were polished to a shine. Elaborate, expensive paintings hung on the wall, specially brought in from Germany and Nazi-occupied countries. Wichtmann had found paradise in Baranowicze. He was working on putting his personal touches on this prize of a home—Germanizing it on the fringe of the new German frontier.

Like other Nazi officers I had the misfortune to know, Dr. Wichtmann was a special breed of family man. On "his" furniture were photographs of his wife and children taken in portrait studios somewhere in Austria. They were all dressed in their Sunday best: clean, sturdy, each of them fulfilling their roles as model Aryans. Over the course of several days, we would come to meet Mrs. Wichtmann, who now lived here with her husband. From what we could see, the doctor treated her and his maid kindly. And they served him well with quiet, unquestioning loyalty.

His face and his gestures suggested Dr. Wichtmann was a polite, kind man. His face and his eyes smiled and sparkled, but what did this mean? What was behind this façade? We found out that Dr. Wichtmann was, in his own domain, God and the Devil, suffering from the same sickness as the others—he could kiss his wife with affection in the morning, smile to his maid as he walked out the door, and ten minutes later order fifty Jews to death by blowing their brains out on the side of the road.

Dr. Wichtmann proudly and arrogantly wore his brown-gray uniform. He was a high ranking Nazi officer who belonged to a special class of murderers, an instrument of the Final Solution—the plan to rid the continent of all its Jews. Here, in Baranowicze, Dr. Wichtmann lived according to his own laws. He was the law, the arbiter of life and death. He dictated efficiently, oversaw the numbers, and decided fates. While people fell dead with bloated, bursting bellies from starvation a mile down the road, the doctor, with a single phone call, procured country ham, French wine, and cheese, bacon, farm-fresh eggs, and overflowing baskets of perfect fruit. Shmulek and I were his slaves. We had been added to Dr. Wichtmann's list of assets. For now his only plan for us was to paint the inside of his house. Every order was given with politeness, sometimes even with a smile or pat on the back. Sometimes the order was given directly, and at other times through his maid or his wife or Grabowski, who was not only Wichtmann's interpreter but also a manager of sorts. Wichtmann was certainly a friendly, orderly, polite, well-mannered murderer.

On the first day at the Wichtmann house, Grabowski showed Shmulek and me where we were to be working. On a quick tour, poking our heads through each doorway, we saw all the rooms, what furniture we would have to move, and the areas we had to prepare for painting. Knowing just what to do, Shmulek began the prep work; I followed along. We tried to pace ourselves. Maybe the longer we took, the safer we'd be. If we finished our job quickly, we'd be taken back to the ghetto for different work. Or worse. So Shmulek and I laid out drop cloths, lined up our paints, brushes, and scrapers against a wall and, with our putty knives, scraped down

old paint and rough spots. We were meticulous in an effort to stall our fate.

At the end of the day, before dark, Grabowski, with rifle in hand, directed us back to the ghetto. When we returned, there were fewer people than when we left. Scores had been taken away never to be heard of again. The dead and dying were still strewn about the sidewalks. After spending a day in the cool breeze and hospital-clean interior of Wichtmann's house, in the ghetto we became reacquainted with the odor of human decay.

Shmulek and I found a place to settle down for the evening then, like everyone else, fell asleep. Our arms and hands or shoes or shirts were our pillows; the cloudy sky was our ceiling; the streets or alleyways our latrines. We fell asleep to the sounds of others mumbling about death squads and *Aktions*—a German word we would never forget. It meant organized, planned killings. In an Aktion, a group was selected from among the Jews in the ghetto, taken to a field, and murdered on the spot—either mowed down with machine-gun fire or shot in the heads with pistols at close range. If by any chance there were babies brought in from a surrounding neighborhood, they were tossed into the air so that the soldiers could see who could shoot them before they fell into the pit. These things were happening all through Eastern Europe. And worse.

The selection from the Baranowicze ghetto was seemingly random and somewhat based on one's inability to further serve the Germans. This wasn't usually a choice. The old men, injured, weak, and helpless were the easiest targets, but there were others who were strong and vibrant who were called out as well. It was maddening. We lived on the edge of death but we never knew where the edge

was. There was no sense to any of it. The most we could do was to try to make ourselves seem sprite and useful. We learned to lie with our expressions and forced ourselves to be alert.

In the morning, Shmulek and I found ourselves again near the gate, waiting. Then we heard Grabowski yell out, "Shmulek! Shmulek!" Again we were singled out for work at Dr. Wichtmann's house. The next day it was Dr. Wichtmann's maid who came for us, also calling for Shmulek. Day after day they called for us. I can still hear them yelling over the din, "Shmulek! Shmulek!"

When I sat down to write this book, I had for years forgotten Shmulek Bachrach's first name. "It will come to me. Maybe it will come to me," I'd say. A year went by, and then I had a dream. I dreamt I was standing in a field and looking at the Bachrach's daughter. She was yelling, "Shmulek! Shmulek!" She asked me if I had seen her brother. I awoke with a start and shook. I wept uncontrollably. In the middle of the night, shaking, I turned on the light on my night table and scratched down his name on a piece of paper. In the morning I had not forgotten.

Wichtmann's maid stood by the ghetto fence and called, "Shmulek!" and we reported for work. We were taken away from the dying ghetto to Dr. Wichtmann's sunny, lively residence. On the way down the dusty road, we would pass by the familiar team of Russian prisoners of war working in the doctor's fields. These Russians, for the time being, were among the lucky ones. Blistered, with sunken faces, under the summer sun, they cleared away weeds, dug drainage trenches, and planted seeds. German soldiers, always on patrol throughout Baranowicze, were never too far off to track them down and shoot them if they tried to escape.

Shmulek and I realized that as long as there was work for us at Dr. Wichtmann's house, we would stay alive. At least we were fed and given water. Dr. Wichtmann's wife, especially, seemed not to understand that we were the inferior race, and I had the feeling she was sneaking us food or feeding us more than her husband would have allowed. When Shmulek and I spoke to one another, always in Yiddish, Mrs. Wichtmann would watch us out of the corner of her eye. I could never tell if it was hate or curiosity. Was she suspicious or distrustful? I thought maybe she was, like us but to a lesser extent, trapped as well, beyond her control, fulfilling the role of wife, living a life not of choice but of temporary convenience.

For now we were safe, a mile down the road from death, fed and working indoors—out of the sun, out of the dirt, away from the shouts and insults and fear of being shot without notice. The work groups out of the ghetto, meanwhile, continued to decay from hopelessness and a well-founded fear of death. Even those who were fed on work details were burning up far more calories than they were fed. It was only a matter of time before they were worked to death or deemed unfit to work, taken away forever.

One day, after many hours of work at Wichtmann's house, Shmulek and I returned to the ghetto to widespread panic manifested in whispered tones and the insane pacing of caged animals. Word was spreading that there would be an Aktion in the morning. One person heard it from another who was tipped off by another, and so on down the line. An Aktion was coming. Few were able to sleep through the night, myself included. When you hear rumors, you try to tell yourself they're not true. Exaggerations; ears festering to words. But nothing can stop your heart from pounding

and your mind from straining in vain for solutions. You're looking at rooftops and basement windows for exits and hiding places. You think of ways to make yourself useful. You plead your case in your head. You try to think about what you have of value to exchange for your life. You stick out your chest and try not to look the way you feel inside, full of dread and fear.

When morning came, I began to study the faces all around me in more detail—the hundreds of people milling about were individuals rapidly losing their identities. Unshaven, sunken cheeks; dried-up mouths with swollen lips. Clothing started to hang cheaply over their bodies, ill-fitting and uncultured. Pants, now too loose, were tied at the waist with makeshift belts of rope or wire. Dirt clung to skin; beneath fingernails, more dirt. Hands of violinists and farmers looked the same. The teachers had all been shot, the doctors lost among the unhealthy and diseased. Faces without smiles and eyes that wanted for nothing but food. Numb minds. Hopeless glances. Vacant expressions.

As the sun came up, those who could rose to their feet—a show of vitality to fool death. Then at the gate, Dr. Wichtmann appeared, clean-shaven, his cologne ever wafting away to the sky. His white shirt, pressed and crisp, hugged his chest and arms beneath his woolen jacket bearing the black SD insignia on his left forearm sleeve. Dr. Wichtmann calmly squinted against the rising sun. He was slightly annoyed by the sun's heat as he scanned the mass of men pushing toward the gate until at last his eyes fell upon Shmulek and me. He stared at us for a moment. No smile today; no pleasantries. He waved us over then took us back to his house. Shmulek and I weren't sure that we would ever return. We had grown to rely on

that smile, as false as it may have been. We were afraid of change. Were we being selected? We followed him with trepidation. We tried to read his demeanor. He seemed agitated, more stern than usual. Maybe he was through with us.

As it turned out, the beginning of this day was no different from the others for us. But we knew what we were leaving behind. We believed the rumors that there was to be an Aktion. And on our return, fewer souls would be left to greet us with blank stares.

As usual, Shmulek and I set to work with diligence. We spread drop cloths on the floor of Dr. Wichtmann's living room and, with a damp rag, dusted off the window sills and wooden molding where we were to paint. It was still early in the morning, but Dr. Wichtmann had already had his breakfast hours earlier. On this day, he left the house immediately after dropping us off. We slowed our pace. Through the window, I saw the doctor strut away down the street, his hat tilted slightly and his heavy, jack-booted feet stomping away at a determined pace. A breeze picked up and the weeds bowed to the Nazi officer as he passed by and the dirt dared not blow onto his shiny boots.

As I was painting the hallway, Dr. Wichtmann's wife, still in her nightgown, grabbed me by the arm and pulled me into the bedroom, locking the door behind her. This was the first time I had looked directly at the woman. She made me look at her face and eyes. She was pretty but stress had left its mark on her. Maybe it was fear, or even disdain for the life she was forced to live far from her family in Germany. Nervously, she sat on the bed in front of me and chose her words carefully but quickly. To me they were a riddle; my mind could not immediately understand what they meant. I stared

at her full lips, caked with red-orange lipstick, and her perfect teeth. I was trying to read her words.

She said, "There are many Jews still in hiding in Berlin." Tears were forming in her eyes. She got up, went to the door, peeked out into the living room, and said, "Now you can go," and left the room.

I stood there for a moment trying to understand what she was saying to me. I had the feeling even that she may have been Jewish herself, as she seemed so interested whenever Shmulek and I spoke to each other in Yiddish. Waiting for a moment or so, mulling her words over and over in my head, I left the bedroom and continued my work in the living room. The rest of the day, her words weighed heavy on my mind like a riddle from the Talmud.

Shmulek and I worked until an hour before sunset, having neatly and expertly painted a new coat of off-white onto the living room walls and a glossy coat onto the doors, baseboards, and window trim. After we cleaned our brushes with paint thinner and carefully stored away the materials, Dr. Wichtmann returned through the front door. He held his hat under his arm and combed his fingers through his hair. We didn't look directly at him as we went outside where Grabowski was waiting to take us back to the ghetto. Dr. Wichtmann stepped out onto the front porch and sternly instructed Grabowski, "Tonight, don't take them back." Shmulek and I were told that we would be staying the night on Dr. Wichtmann's property.

"Tell them," Dr. Wichtmann instructed Grabowski, "that next morning there will be an Aktion." It would be inconvenient for us to die and leave Dr. Wichtmann's house unpainted, so that night

Shmulek and I slept under the stars. We were relieved that our lives were spared, but it was clear to us that it would only be a matter of time before we too would be killed.

The Aktion that next morning in Baranowicze, like all the rest, was a planned mass murder. We found ourselves in a kind of insane world of premeditated murder—wherein people were killed not in the act of self-defense, or even as casualties of war. Neither man nor God intervened.

Our days were numbered.

I lived in a state of constant uncertainty. As each day came, I didn't know whether it would be my turn to face an Aktion or whether I would live to see another sunset. When our work at Dr. Wichtmann's house was finished, so were we.

Never did I stop wondering, even in fear for myself, what my parents and my sisters were doing. There was, of course, no news, no communication. I hoped and prayed that Tamara Ulashik was still bringing them food and water. I hoped that the violence in Maitchet had run its course. I was worried sick.

At times, when I spent the day tediously painting the walls, my mind would drift. My mother's cholent was on my lips; Zayde's voice rang in my head. I missed Papa, Elka, and Peshia. I wondered if the ugly crowd had had enough and if life had gone back to the way it was in pre-war Maitchet. Maybe the Poles thought they had taught the Jews a lesson. Maybe it was over. Maybe life returned to normal. I'm sure my family was worried about me, but I also feared for them to no end.

What was my life now? Why was I being punished? I was lucky to be a painter out of thousands who were suffering with other

chores. But this was not luck; I was not free. When would my time come? At the end of the day, I didn't know whether I would be sleeping in the street alongside dying people or whether I would be called for more work at Dr. Wichtmann's house. Each time he sent for us, we were spared another day. But each time we returned to the ghetto, there were fewer and fewer men. They were evaporating in the early summer. When I was first brought to Baranowicze, the buildings of the ghetto were overflowing with people. I couldn't find a place to rest under a roof. Now, at the end of the day, the buildings were half full; those remaining on the street at night were the dead and others too weak to move.

On one day, as Shmulek and I were painting one of the bedrooms, Dr. Wichtmann came to us with an explicit warning. He spoke to us like he was talking to children. Grabowski interpreted for him, but he looked directly at us, staring down at us, glaring at us. I could understand most of what he was saying, his German being so similar to Yiddish. The doctor's face was serious and his eyes burned. He said he was going away for a short while, but in no case should we ever go near the small house to the rear of his residence. Under no circumstances, *verstehst du*? He said anyone going near that structure was to be shot without question.

Within an hour, a German staff car pulled up to the front of the house and Dr. Wichtmann climbed in. Through the front window of the living room, I watched him drive away. Then Shmulek and I began painting the baseboards of the living room with a glossy white paint. In one hand I held my paintbrush and in the other a rag soaked in turpentine to remove any spills or drips that went onto the polished wooden floor. Shmulek showed me how to hold the

paintbrush at a certain angle, using just enough paint for coverage but not too much to cause a run. I became quite a neat and efficient painter, but we purposefully worked very slowly. Each brushstroke brought us closer to our own demise.

I waited another hour or so before I decided to take a break. I put my paintbrush down, cleaned off my hands, then looked out the window again. Except for the breeze blowing the curtains and some far-off buzzing of truck motors, all was quiet. Grabowski was not on the property. We were left alone, with the maid in the house. I walked out the front door, stretched, then looked over my shoulder to make sure nobody was watching me from inside the house. Shmulek was lost in his painting. I stepped down off the front porch and snuck around to the little forbidden house in the back. Not far off, in the fields, the Russian prisoners were working; they took no notice of me as I made my way to a small window on the side of the one-room cottage, determined to peek inside. My heart was beating fast and my mouth went dry with anticipation. I didn't know the reason it was forbidden territory. Maybe there was money inside, or stolen goods. I placed my hands on the window ledge and put my face to the window. I was not prepared for what was inside and at first sight, I could not find words to interpret what I was looking at . . .

When I realized what I was seeing through the window, my stomach turned inside-out. I put my hand to my mouth, as if trying to muffle my own outburst. I nearly vomited. Now, more than sixty years later, I still cannot erase the vivid, terrible image from my mind. I felt like I was bursting inside and at the same time I wanted to run far away. But there was nowhere to run. Inside this

structure, in a little room, sat a young boy of eleven or twelve, strapped to a chair so he could not move. Above him was suspended a mechanized hammer that every few seconds came down upon his head. The boy had been driven insane by the torture. Over and over and over, this hammer came down upon his head; it was inhuman. Dr. Wichtmann, the tall, fair-haired family man who, not too many days before, generously saved us from an Aktion, kept this boy alive to be tortured slowly, endlessly, mercilessly. Tears running down his cheeks, his face red and swollen, his eyes mere slits, his moaning was reduced to a dying, wounded animal's whimper. I dropped to my knees in sickness and disgust and I trembled.

I heard a noise somewhere. Someone was coming. I pulled myself together and left the area immediately, making my way back to the house, praying that I hadn't been seen. When I stepped inside, I must have been white as a ghost; the blood had drained away from my face and my hands were twitching on their own. I kept my head down as Mrs. Wichtmann walked by. I pretended to be wiping paint from my fingers. My mind was filled with the image of a kind of cruelty that the Germans alone seem to have mastered.

The smiling, friendly Dr. Wichtmann was a monster wearing the mask of a human being. The depths of his heartless being could not have been painted more vividly than in this unforgivable scene. The poor boy had been turned into a suffering, helpless vegetable who could only moan hopelessly in agony yet could not die. The boy, the poor boy is now, thankfully, long gone, but I am his witness. I remember him. I cannot bear to say kaddish for him, but I do.

After seeing this tortured boy, I fully realized: there was no tomorrow—no future. There was no longer value to human life. No more innocence; no hope; no trust.

Later I told Shmulek what I saw. At the end of the day, we were taken back to the ghetto. Now the buildings were sufficiently emptied so we could find a place to sleep almost anywhere inside. That night I did not sleep. My mind would not rest. It was filled with terrible images.

Then came the fateful day that will never leave me in peace, in the summer of 1942. In the heat of June, on a Sunday in which the sun shone as brightly as ever, I once again found myself near the gate of the ghetto, waiting to see if Grabowski would come get us. I was lost in my thoughts for a short while when I happened to look up at the gate at the edge of the yard. Standing there was Oleg Soshinski, the brother of two policemen from my hometown. I was taken aback. What was he doing this far away from Maitchet? Did he come just to see me? It did not seem very likely that Oleg would travel nearly twenty miles to find me, but it was true. What did he want from me? Oleg's brothers, Pietrik and Vladik, had a long-standing reputation for anti-Semitism and violence in Maitchet, but since the Nazi occupation, the pair had risen to supreme gang leaders.

Oleg waited for the guards to move away before he walked up to me. For a moment or two we stared at each other past the barbed wire. I waited until he spoke. I could see in his face and his eyes that something was not right. He shifted back and forth on his feet and would not focus his eyes on me for long. What could it be? More Aktions? I had no idea. Then he told me, and this warm, sunny day

became the darkest day of my life. I could hardly hear; the blood was pounding in my head. I was too shocked and overwhelmed to even cry. Oleg's words rang over and over in my mind and continue to do so to this day.

Oleg said, "Motel, you have no more family. Your mother and your sister were killed the first days, but my brother Pietrik took your father and cut him into thousands of pieces. And your sister was raped and thrown away like garbage. They butchered the whole town."

When the killing began, Oleg told me, Pietrik took my father out with my older sister and said, "I will save you." It was a trick; and I'm sure my father knew it, but what was he to do? Pietrik had come to seek his revenge. I could find nothing to say. I could find nothing to do.

What did he say? What did Oleg Soshinski say to me? My mouth was open. I don't know what I felt. I looked at him as if he was speaking in a language I could hear but not understand. What did he say? I was afraid to ask him to repeat what he said, but he did anyway.

Oleg told me that my mother, father, and sisters had been rounded up by the local townspeople. They were beaten, brutalized, and terrorized. They were lured away by Oleg's brother Pietrik, who promised that he would hide them. It was a ruse. He and his friends repeatedly raped my sister then cut my father up with their knives, one finger at a time, one facial feature after another, until he was no longer recognizable. Meanwhile, the rest of the Jews of Maitchet were herded toward the woods. As my sister Elka was forced to march alongside my mother, she did not march fast enough. This

was an excuse for a Polish neighbor to smash in the back of her head with the butt of his rifle. She fell and my mother reached down to collect her brains; then, she picked up her daughter, my beautiful little sister, and trudged to the edge of the forest. There, my sisters, my father, and all the rest of the Jews in Maitchet, including the visitors who had run away from other towns, like the Bachrach family, were shoved or carried or dumped by jeering, laughing, and screaming Poles into a large pit, where they were buried, most of them still alive.

My cousin Moishe was among them. He saw everything. He too was buried, but he did not die of his wounds and waited until night fall to dig himself out of the mass grave. I was to meet up with him later and relive the emotions I felt upon learning of these murders.

When Oleg told me of the fate of my precious family, I decided that there was no place for me any longer. I had no home. I had no life. I had no family. A part of me died in June of 1942. Most of me, in fact. My heart had been ripped from my chest, my breath gone, my eyes afraid to search for God. This was the year when the most Jews were murdered in all of the war years. This was the year when I lost my life.

Most things in history have the fortune of fading gracefully to a manageable conclusion. They erode, grain by grain, until they slip into the background, a slow disintegration back into the earth. Yet nothing disappears; they are never totally gone—here and there a thread, a clue, a fragment linking the present and the future to the past. But there is an exception to every rule. Our shtetls were the exception. One of the richest cultures the world has ever known

is gone now. The memory of our Yiddish civilization was buried with tortured souls or left to us, the few survivors, haunting our minds for as long as we breathe. The memory of what shtetl life once was, is now forever tainted, stripped of all innocence. The goodness, the joy, the warmth does not stand alone in the heartbroken, bittersweet memory. No, these memories are not truly bittersweet. They are much worse. Tainted and distorted is the sweet, loving world of family, Torah, Shabbos, flavors, aromas, smiles, tears, faces, homes, shuls, and Yiddishkeit. These are memories we cannot divorce from the storm of terror that swept away our families and our lives. Erased without mercy were our shtetls, not even afforded the dignity of resting in peace. And now my own family was taken as well. More than eighty relatives, each with his and her own name, were murdered without cause.

I come from a place and a people that I cannot even prove ever existed. The rain would not stop falling.

Escape from Baranowicze

I awoke to near-empty streets. People in the Baranowicze ghetto were summer puddles, evaporating as the day wore on. A city of orphans, disconnected. Our past, present, and future were melting. The last cries of the Shema drifted high over the killing fields, souls returning to heaven—souls whose last words sang our eternal oath to God. In the morning when I awoke, I was greeted by the sun, indifferent in the sky, too far away to feel the pain that numbed me. How could I go on and face this day or any other to follow? How dare the sun shine.

I hated my own innate instinct to survive, to pick myself up from the floor. Yet you learn that your fate is not your own. Sometimes we have a will to swim to the surface against all odds. I was a young man with no past, no family, no love. For hundreds of miles the shtetls were erased of their Jews. I was adrift and yet I continued to paddle forward. Don't ask me why or how. I do not know the answer. As long as the eyes are open, we are looking forward.

Shmulek and I returned to Dr. Wichtmann's house with the sun just coming up behind our backs. We were dropped off to work, to postpone our own demise. On this day, nobody was home but

the maid. Unsettled by the stillness of this morning, as well as the absence of Grabowski, the doctor, and his wife, I became uneasy. I didn't know why, or whether this feeling of agitation portended good or bad. This particular day was different. The maid was watching us more intently than we had grown accustomed to, as if interested in our every move, or waiting for an opportunity of some sort. I thought maybe she was told to keep an eye on us.

Shmulek and I began taking out our paintbrushes and preparing for work when the maid began to stare at us. I looked at Shmulek and he looked back at me. There was something about her eyes, as if she was trying to say something to us without speaking. I brushed past her as I walked across the room to pick up a drop cloth. She didn't move. When I returned to the paint bucket by the wall, I removed the lid and noticed she was still starting at me. I looked at her and she shifted her eyes back and forth. Was she trying to say something with her eyes? Finally, she spoke. "*Komm mit.*" Come along. I slowly stood up, walked over to the window, and peeked out. Nobody was there. Then I walked to the edge of the room and peered around the corner. Still quiet. The house seemed deserted. Shmulek was holding his paintbrush over his open paint can. It was dripping thick gobs of paint silently back into the white liquid. His eyes flitted from me back to the maid. He looked at me and shrugged his shoulders. Now the maid was beginning to fidget. She waved her hand: *Come with me.* Shmulek stood up as I replaced the lid of the paint can and took a step toward the maid. I jutted out my chin as if to ask her, *What?* She turned and began to walk but did not take her eyes off of me. Shmulek came by my side, then all three of us, nervous, suspicious, afraid, excited, and trembling, walked one

behind the other as the maid led us into the bedroom, signaling in silence, not daring to speak. Then quietly, just above a whisper, and with hand signals, she began insisting that the doctor's wife said something needed to be fixed behind the bed. *Come, come— over here.* Shmulek hesitated. He didn't trust her. He said there was nothing to be fixed. What could be behind the bed? It didn't make sense. Shmulek turned as if to walk back to our paint supplies. I began to back away from the woman. What kind of trap was this? We had been in that room a dozen times. Behind the bed was the wall, nothing else. We stood still with paint rags in our speckled hands, all three of us staring at one another for a moment. But something in her expression transcended words; her eyes pleaded with us to follow her. *Into the bedroom, now. Hurry! Come along!* She reached out her hand but neither of us took it.

I moved carefully toward the room and Shmulek followed me, looking over his shoulder. When we were in the doorway, our eyes scanned every corner for some kind of trap. Maybe she told Dr. Wichtmann that I disobeyed his orders about the little house where the boy was being tortured. I was trying to figure out what was in store for us in the bedroom. The maid quietly but forcefully kept shooing us inside the room toward the bed with a waving hand and a nodding head. *Geh! Geh!* We kept our eyes on hers as we backed up into the room toward the bed. Nothing seemed out of place. The room was spotless. The bed was dressed in a laced spread. The pillows were neatly fluffed and laid out at the headboard. The dresser was polished and all the pictures in their frames were dusted. Not a speck of dirt was on the windows or the sills. It was all so ordinary.

The maid was now standing next to the bed, beside us. She shifted her eyes. She was pointing with her eyes. We noticed that the night table drawers were open. The maid pushed her chin at the night table. *Look inside.* Leaning over, Shmulek and I saw that there were two pistols and extra magazines in clear view. In an instant we understood.

The maid—this servant of a Nazi officer—was risking her life by handing us an opportunity to run. I felt like a child standing in front of a candy counter when, unexpectedly, the glass between me and the candy had shattered into a million pieces of dancing light. I saw my own hand reflexively reaching out to one of the pistols. I picked up the gun and held it in my hand; it was heavy and cold; my chest was heavy; the air was heavy. I told Shmulek to grab the other gun and the magazines. We were shivering in the warmth of the bedroom, silent and staring into each other's eyes. Already we were taking too long. We were wasting time. Time is a monster when you are in fear of being caught. Standing in the house, we were already free, and not free. I don't remember if I said it, but Shmulek heard me: "Let's go!" We tucked the pistols in our pants and cautiously walked out of the bedroom door. It was still early in the morning. Maybe the doctor, his wife, and Grabowski would be gone for hours, or maybe back in five minutes. We stood in the living room waiting for direction of some sort. What was the rest of the maid's plan? The curtains shifted in the cross current of warm air. The breeze blew across our faces then out the window, calling us to follow, leading the way. The maid stood at the threshold of the Wichtmann's bedroom, holding something in her hands. We hadn't noticed at all until this moment. She handed

us food wrapped in paper and said, "You'll have some food for the road."

In the hallway were two long winter jackets draped over a coat rack. In the middle of winter we wouldn't have taken any notice. But it was summertime; two jackets oddly out of place, positioned at eye level, were looking at us. Perspiration was running down our faces, necks, and backs. I kept running my hand across my waistband, checking for the pistol. As nervous and wide-eyed as we were, the maid said nothing, but we knew the woolen coats were for us. We were still afraid to leave, still hesitating, wanting to bolt from the house, afraid to go, knowing that only death awaited us if we stayed. What were we waiting for? What did we have to lose by running out of the house? Our hesitation was the source of growing anxiety for the maid. A false security enveloped this house with its big roof shading us from the outside world of hate and murder. A rush of courage washed over this little woman whose hands were calloused and knotted with arthritic joints. She was a mother now, telling us what we had to do. In Yiddish, with stern eyes and a deliberate tone that nearly screamed at us, she ordered, "*Geh gesundt!*"

Yiddish? Shmulek and I were dumbfounded. We were backing away from this one little woman whose out-of-place, familiar words had stunned us. We were armed with pistols, two strong young men, backing away from the maid. We were caught off guard by her directive in Yiddish. Was the maid Jewish? Of course she was Jewish. As if the woman wasn't standing right in front of us—as if a wall stood between us—Shmulek said to me, "*Sie ret Iddish!*"

I asked her, "*Du ret Iddish?*" (Do you speak Yiddish?), but now her courage lapsed into a state of near panic. Again she was a simple

woman, a jittery maid pushing us out of her life. Time was running out. It was all too uncomfortable. She was looking around, full of a well-founded apprehension that someone may return home and discover what she had done, what we were about to do. With her hands—her tiny, bony hands—she came after us, driving us toward the door with every ounce of her being. I grabbed the doorknob and turned it while staring into her eyes. Shmulek pushed the door open without checking to see if anyone was outside. Then the woman screamed in a whisper, "*Geh! Geh!*" Shmulek and I went through the front door without looking back. Despite our hurry, we did not run. We walked right down Wichtmann's front path, through his garden—the garden of an unfortunate, well-to-do Baranowicze Jewish merchant whose intelligence and business sense could not save him from a common destiny. Shmulek and I walked through the white picket fence, carefully closing the gate behind us. The fence, the house, the garden, the grounds—all disappeared behind us as we headed down the street with winter coats slung over our shoulders. Like Lot, we dared not turn to look back over our shoulders. In no more than five minutes, Shmulek and I passed a couple of Polish policemen. We all ignored one another. We kept walking, our feet wanting to move faster than we would let them. We didn't run; we didn't talk; we just kept moving. Moving ahead. Away.

I was no stranger to these roads. I had driven our horse and wagon over them on so many occasions with my father. Baranowicze was my second neighborhood, familiar and a part of me. I knew the roads that left the city and with each step we were making good our escape. Far enough away from any living soul now except for a

cow or two standing in an open field, our first words were spoken. I
told Shmulek to follow me; we were not going to get lost—I knew
where we were going. Right down the middle of the road, in broad
daylight under a clear sky, we headed off in the direction of Mush,
on the outskirts of town. We were two Poles casually hiking down
the road.

As we walked, I told Shmulek if anyone comes to bother us, we
shoot them. Don't hesitate. Feeling for his gun at his waistband, he
agreed. Mine was sage advice from one who never fired a gun in his
life. I didn't know what it was to shoot anything, even a tin can. But
from this point forward, we had nothing else in our lives to lose.

When we got far enough away from Baranowicze, we began
walking mainly on the shoulder of the road, ready to dive into
the weeds should someone happen by. They wouldn't take us by
surprise, though—you could hear someone coming a mile away.
Tires make a lot of noise on gravel, and vehicles stir up a cloud
of dust. We kept vigilant. Our ears were sensitive to every sound:
rustling leaves, gnats, mosquitoes, sudden gusts of wind, our own
feet. Our feet were so loud, ceaselessly crunching and shuffling.
There was no way to muffle our own shoes.

We walked along at the same pace as when we left Wichtmann's
house—slow but steady. All around us were wild fields watching us
with suspicion. In the not-too-far distance was a stand of trees, and
behind these stood the forest. We decided we would run toward the
forest if we were chased. But not a soul was around, and we walked
until at last the sun went down. Once it became dark, we couldn't
see far in front of us. The night was filling the world with ink. Still,
we worried that someone—a Polish farmer or a hunter—could

come up on us without notice, so Shmulek and I trudged deep into the high grasses of the fields and hid. Clouds had gathered in the sky; the city was far behind us. No light. We sat there together: faceless, formless, homeless orphans.

We didn't know what to do next. Where would we go? We knew that Poland was under Nazi control. German soldiers were in every town. The Poles were proud and anxious to find Jews and turn them over to the Germans. They lived for the praise that was specially set aside for productive collaborators.

In the far distance, in the stillness, when the breeze stood still, we could hear gunfire or bombing, reminding us that we were alone in the world—a hostile, cold, murderous world. How could we survive? Then I thought of going home. I said, "Let's go to Maitchet." Anywhere but nowhere. Somewhere familiar. Maitchet was still alive in my head. Maitchet was my family, my home. I knew that my family was gone, but to me Maitchet was what I knew best. With minds too restless to sleep, we walked through the night with the idea of finding one of my cousins, Chonyeh, who I knew was at one point hiding with a Polish friend just outside of town.

On the way to Maitchet, with the sun soon to be rising on yet another day in another sky, I got another idea. I remembered that my grandfather had a Polish friend, a farmer we called Mr. Glatki, who lived close by. We abandoned plans to enter Maitchet and set out toward the Glatki farm.

Shmulek and I had been walking for hours. Just around dawn, I recognized the familiar narrowing of the road in front of us. Though exhausted, with aching feet and rubbery legs, I picked up my pace. Shmulek stayed close. Here it was—the farmhouse with failing

paint, the big barn, the well. We had made it to the Glatki farm. Chickens and geese were noisily running around the property. At last we came upon Mr. Glatki's door in the early morning. Dew was dripping from the roof and the eastern wall of the house was bathed in orange light. The new day was warm but the windows were half shut. Our shirts were sticking to our skin. I couldn't hear anyone inside, but I knew the Glatkis—Mr. and Mrs. Glatki and their daughter—were all awake.

My fist rose up in front of my face and gently knocked on the door. Then a louder rap. A dog started to bark nearby. Inside we heard footsteps scuffing over wooden floors. I turned to look at Shmulek. We were nervous to be standing outside on the Glatki's porch and continually looked over our shoulders. Finally, the door opened and in front of me was the Glatkis' daughter, Marie, who greeted me warmly, though I hardly recognized her. Maybe I just never paid much attention before. The last time I had seen her she was a little girl. Children are always reinvented. Now she was a teenager with a big smile. Marie greeted us with such happiness and friendliness that I was taken aback. My face must have betrayed some desire for reassurance because she threw open her arms and called out, "Motek! I know who you are; you are Shlomo's son." Marie Glatki ushered us into the house like long-lost relatives whom you rarely ever get to see. Shmulek and I followed her as she led us into the great room. Without any fear in her voice—maybe she was too young, too innocent to understand the danger—she told me, "We have your cousins hiding here."

It was a sorrowful reunion, though we were elated to see those who had survived the worst in Maitchet. My cousins Yossel,

Moishe (Chonyeh's brother), Elleh, and Yudel were in the Glatkis' great room, along with my two uncles, Michoil and Zimmel. Also, there was a doctor named Yakobovich, a man named Noah, and my father's closest friend, Chatzkel Rabetz. They all looked at me with as much surprise as I had for them. Which among us was a ghost? How did they all end up here? How did they escape the massacre at Maitchet?

We all shared an odd feeling in this reunion—happiness, sorrow, and pity. There was too much to say and nothing to say. We were all disheveled, dirty, and tired. Worry drew down our faces; eyes were bloodshot from a lack of sleep; feet were swollen and heavy; words didn't come easily. Minds were still too numb, with no time to mourn for our shared and private losses. Even a trace of fleeting happiness at this impromptu meeting couldn't hope to bring a smile to our faces. Yet when we entered the room, we were greeted with kisses and hugs as if we returned from the dead. We touched one another's faces to make sure we were real.

Everyone was eager to hear what had happened to me. I spent hours filling them in with all the details of how I ended up in Baranowicze with Shmulek, and how we made our escape. I told them I had heard what happened to my family but knew little else or even how much to believe. And then my cousin Moishe began to tell me what I never wanted to hear again. He confirmed Oleg Soshinski's story. Moishe, along with the rest of the Jews in Maitchet, were marched to a grave at the edge of the forest. The Poles were murdering everyone, shooting them, beating them to death, driving them in convulsive fear and tears toward the forest.

I couldn't listen. He confirmed what happened to my family, my grandfather, our shtetl, the homes, the babies. My God, driven to a pit, the dead along with the living, the dirt thrown over them by a hundred Polish men and women, neighbors, in an orgy of madness. Moishe was among them, buried alive. But he scratched toward the surface as it grew dark. He continued to claw and claw until he reached the air, breathing once again. Moishe climbed out of the grave and stood crying and shaking among the leaves. Beneath him in the grave was his family. He paused to think about them. Then he was spotted. Two Poles, vestiges of the murder party, began chasing him. He ran through the forest until he got away.

In the middle of it all, Moishe's story and my own, I realized I was not alone in my grief; each pair of eyes gazing upon me shared my loss—each told of their own. Each of their own families met the same fate—murdered, tortured, some in Maitchet, others elsewhere. It was the same in every shtetl. A room full of orphans together, alone. Too ugly for words; too much to let in. There was no ground beneath our feet. We were all lost; drifting, surviving but no longer living.

The Glatkis fed us all. For now we were safe, with a place to sleep and ponder our next move. In this small house in the middle of a farm in the middle of a field, we thought. We were a small group of people who could ill afford to drift. We couldn't stay and we couldn't leave. I was aware that the Germans were still there, that the Poles were still drunk with a murderous appetite, that they had killed everyone in Maitchet, and had stolen all the Jews' possessions. Many had even already moved into our homes; they were sleeping in our beds, with fingers, shoes, and shirts soaked with Jewish blood.

I didn't want to hear any of this. My family. I kept thinking of them, over and over again. And what of Bubbie and Zayde? They were old; what happened to them? What of my mother's parents in Morozovichi? I found it hard to believe that Zayde, in his wisdom, in his foresight . . . I closed my eyes. I couldn't even bear to think of him. My heart was tearing apart.

One of my cousins told me that Zayde figured out what was happening as soon as he looked out his window. Then a neighbor took him in—a Polish neighbor. Zayde was led up into the man's attic.

From above the street, through the slats in the wall, Zayde watched the brutal scene unfold. He watched in horror as his family—his sons and their wives and his grandchildren—were beaten, clubbed, dragged, punched, kicked, and stabbed while driven toward the forest. With his hand held gently over his heart and tears coming to his eyes, Zayde had told me so many times over the years that his family was the light of his soul. He would tap his heart, saying with his wet, half-closed eyes, *Here, here is where my family resides.* Zayde stood up in the attic. Zayde stood up and walked out of his hiding place. He walked through the living room of the Polish family that kept him safe and out of sight. And he walked out into the heartless street in plain view of the Polish gang and joined his family. Within an hour, Zayde, too, was gone. With his family—with my family—Zayde was buried, still alive. No more Jews in Maitchet. No more.

Free for Now

While Jews were being murdered all over Eastern Europe, shot in the streets, stabbed with farming instruments, burned alive, I was in hiding at the Glatki farm with a band of runaways. We ate. We were given water. We had a roof over our heads. We cleaned ourselves and treated our bruises. But there were so many of us, and we all knew that we would have to be moving along shortly. We could not stay—not all of us. Every moment we remained with the Glatkis we risked not only our lives but theirs as well. One of the first orders of business when the Germans conquered Poland was to impose the death penalty on Poles who dared to hide Jews. The Glatkis, whose humanity and dignity surpassed their fear, tempted fate by hiding us. I was to learn later that their farm and their home was a constant way station for runaway Jews. They would not turn their backs on their friends; they would not shed their humanity; they would not become ugly or contaminated with a fear that would erase their compassion. When the war was over, in years to come, I had their name listed at Yad Vashem with the Righteous Among the Nations.

The Glatki family was put to the test. We endangered them with our every breath. Throughout the Nazi occupation, the Polish police and vigilantes willingly went door to door, farm to farm, no matter how remote, looking for Jews in hiding. Nothing was more important to them than to kill every last one of us. Many times Polish farmers and White Russians took it upon themselves to search for Jews; they took their guns and their dogs and hunted for Jews in fields of tall grass, cellars, rooftops, and silos. Every farmer was suspected of hiding Jews. There was no trust.

Shmulek and I were with the Glatkis only two days before the inevitable happened. Three of the most ruthless killers—Stach Lango, who almost burned me alive when the Germans first took over, and his comrades Bodgrabah and Polulich (whose first names I cannot recall)—galloped on horseback onto the Glatki's farm. Hearing the hooves and neighing of the horses, the Glatkis opened a trap door beneath the kitchen floor and the entire lot of us was ushered into a tiny space, crammed tightly together on top of one another. Mrs. Glatki, a small, plump woman with a kind, round face, thin eyebrows, and full lips, took her place in the kitchen among the pots and pans. We could see some of the room from down below as we peered up through cracks in the floorboards. Our eyes strained, along with our ears, as the men arrived at the front door. We didn't dare move; we could hardly breathe.

Someone, maybe Mr. Glatki, maybe their daughter, invited the men in. We heard boots trouncing on the wooden floors. Dirt between the floorboards drifted down on our heads. Now a sudden barrage of curses in Polish could be heard. Foul street language making forceful demands. Mrs. Glatki was the brunt of their anger

as they towered over her. In their hands, I could see, were rifles. They opened cabinets too small to fit even a child. They looked under furniture and behind chairs and drapes. Stach Lango screamed at Mrs. Glatki: "You are hiding Jews! Where are the Jews?"

Bodgrabah and Polulich stormed through the other rooms. We could hear furniture being thrown against the walls, glass breaking, things being overturned. But of course they found nothing. The house grew quiet. We could see nothing. The boots clunked away. Stach stood in the front doorway with one eye toward the Glatkis as his men went out into the barn, poked rakes into haystacks, and climbed up onto the loft in their search. When they came back and reported to Stach that nobody was there, he flew into a rage. He grabbed Mrs. Glatki by the arm and screamed at her, "Where are the Jews?" Mrs. Glatki refused to turn us in, and we watched her face turn red. That's when Stach lifted up his rifle. We braced ourselves. With both hands tightly around the barrel of the weapon, using it like a spade, he jammed the butt of the weapon down onto Mrs. Glatki's shin. The poor woman screamed in pain and fell to the floor crying and moaning. She was on the floor, inches over our heads. Stach Lango had broken her leg, and the three men left the house with Mrs. Glatki unable to stand. Yet minutes passed and we didn't dare move, though we wanted to reach out for the poor woman writhing on the floor above us. Tears rolled down her face as she held her bleeding leg.

Through the floorboards, we told Mrs. Glatki that if the men came back we could all just wait for them and jump them. They would be no match for all of us. But Mrs. Glatki, through her tears and agony, insisted that there would be no such fighting in her

house. We were at a loss. Still beneath the kitchen floor, once again we heard the galloping of horses. It was only two to five minutes later that the three men returned and burst through the front door. Stach Lango came back over to Mrs. Glatki and again demanded that she tell him where she was hiding Jews. He screamed with veins pulsing at his neck and spit flying from his mouth. He waved his rifle at her as she tried to pull herself up to a chair while clutching her leg. She didn't answer him; she wouldn't look at him. Without warning, Stach again brought the butt of his rifle down on Mrs. Glatki's leg—the same leg. Then he rode away, satisfied with his brutality. I do not remember whether Mrs. Glatki passed out from the pain, but we waited a long time down below. We waited to be sure that Stach Lango and the others would not return. Finally, we emerged from the trap door into the open air of the kitchen. Dr. Yakobovich began attending to Mrs. Glatki's swollen, red, bleeding leg. He used whatever he could to treat her, bandaged her, and set her broken bone in makeshift splints as the rest of us watched and tried to help. Now we all knew we were dead if we stayed. We would be dead and so would the entire Glatki family. So, we waited for darkness, then fled. Everybody took off in different directions. Shmulek and I stayed together.

We ran quickly through the fields and into the blanket of trees where we could hide and gather our thoughts. All day and night we ran, far enough into the forest but close enough to periodically emerge and try to figure out where we were. There was nothing keeping us from running as far away as we could go. We ran and ran, still carrying with us our pistols and our winter coats. We put the coats on in the summer heat—one less item to carry. I knew this

land, but I didn't know where I was going. I ran without purpose, without anywhere in mind. We were homeless again, always looking over our shoulders, trying to cover longer distances at night. But the truth is that we didn't know where to go. We didn't know where it would be safest; we didn't know how far east the Germans had invaded and set up their outposts. The forest became our home.

Partisans

There were others in the forests. We, on the run, wandering without a plan, were not alone. Little did we know that there were thousands in hiding—remnants of the shtetls, bands of Poles, communists, Russians. Resistance fighters mixed with farm boys and Jews. But don't think for a second that we all got along. There was just as much anti-Semitism in the partisan units as in Europe—it was just as lawless, maybe worse. You could be killed for looking at someone the wrong way. Jews were constantly being murdered in the thick of the forest. If you had a gun, you had value (though that was also another reason to kill you).

Life in the woods was at once organized and disorganized. Cells, gangs, and bands of soldiers cut off from their command centers staked out territory and bonded according to a strange chemistry of fear, ideology, nationality, common hate for the enemy, and animal instinct. Partially armed, unarmed, disarmed; wounded, young, old, lost; women, boys, grandfathers; lost remnants weaving in and out of cruel branches, tripping on wires of gray vines, scratched in the face by sharp twigs, searching for berries and mushrooms, hidden

from the sun, mottled with leafy shadows, drinking from puddles, praying for rain.

In this invisible forest world, there were partisans with caches of weapons who were exceptionally organized. The Bielski brothers—big, strong Jewish millers from Nowogrudek—were leading more than a thousand Jews deep into the foliage. Ruling in military style with confidence and determination, the Bielski boys set up a thriving village just out of view from the "outside" world, like a ghostly fairytale.

The Bielskis raided German outposts, raised livestock, galloped on horseback, set up a communal hierarchy, and ran their unit like a military operation. Tuvia Bielski was the leader and his younger brothers were his enforcers. For the duration of the war, the Bielski clan evaded the Germans, struggled with Soviet militia, and avoided the Poles. To the Russian military camps, Bielski and his community claimed they were loyal Soviet citizens. This way they could avoid persecution and retain control over what little weaponry and supplies they had managed to scrape up. Whenever you identified yourself, you first wanted to know who was asking the questions. If we met a Russian, we said we were Russian. To the Poles, we were Poles. And to the Jews, we were Jews. After the war, I was reunited with more than a couple of friends who had survived with the Bielski unit.

Then there were those who had formed smaller bands here and there—groups of ten or twenty. One division of partisans—Jews from a Russian unit—in the dead of winter trudged through knee-high snow into Maitchet in search of the murderers Stach Lango, Polulich, and Bodgrabah. Lango, however, had fled deeper into

Poland, but partisans found the latter two at home, gagged them, then dragged them to a fence where they tied them to a post and shot each one in the head. The temperature was well below twenty degrees and the slumping bodies quickly froze as the partisans returned to the thick forest, their footprints disappearing in the white snow. For more than a week, the Poles of Maitchet looked upon these lifeless shadows as a reminder that justice would be done. Afraid to remove the bodies, the Poles watched as the corpses turned into icy monuments, haunting everyone who set eyes upon them.

Thousands of partisan groups, set deep in the forests and frozen swamps, were living out of huts—underground bunkers carved out of the earth that we called by the Russian word, *zemlyankas*. People slept there in the early morning hours or hid from the cold during the day, raiding nearby farms under the stars. There were many types of zemlyankas. Some were so big that they housed livestock or were used as community rooms. Some held small stoves. Others were mess halls. All were camouflaged on the outside. Without the zemlyankas, there was no way for a partisan to survive the winter.

I think most of those who called themselves partisans were not so different from Shmulek and me, who were on the run with no plan in mind, trying not to starve, and drinking the dew from leaves before the sun came up. History may now refer to us as partisans, but we were just people on the run, fighting for our lives—aimlessly, hopelessly, then once again hopeful, that we would find someone or something of sense. Anything. The more organized partisans were content to call the forest their home until the war would end. They stayed in one place for as long as they could but

never tried to flee Eastern Europe. It was just too dangerous to leave the forest. They had no choice but to depend on one another as a community, continue to fight and hope for the best.

Shmulek and I kept moving. We were tired and hungry. We were thirsty and alone. We were never far from home, a home that was no longer there. We had been running along in the forest for days and nights. Then we were found. It was nighttime and overcast. We heard the crackling of leaves and twigs and our hearts started to race. We stopped in our tracks and drew our pistols. Figures cautiously emerged out of the darkness, hardly distinguishable from the gray-green pattern of branches and dense, leafy undergrowth. Somehow we had run into a group of tattered survivors from Maitchet, in the middle of nowhere.

With dirt covering her face, hands, and clothes, a girl greeted us in almost a whisper. Her name was Galla. She was alone, having lost her family. She was now living with an infamous anti-Semite, the head of the Grozny Russian partisans. Barely twenty years old, Galla's cheeks were drawn and her eyes old and wise. Her face was streaked with dirt, her hands caked with earth and stripped of their feminine softness. With a small but taut body, Galla made up for any physical shortcomings with an outer confidence and resolve. For the time being she had found safety with Grozny's group. Grozny, Galla told us, operated a raiding party from the woods. He and his men who had been separated from the Soviet Red Army behind German lines went out at night and attacked German supply lines, stole weapons, blew up equipment, and lived day to day in their zemlyankas.

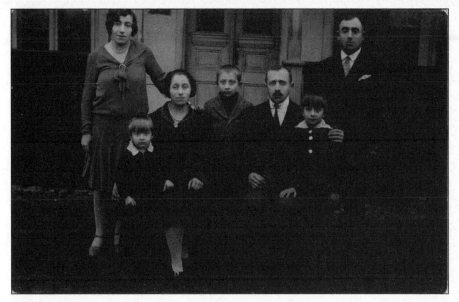

Left to right: Aunt Frieda, Elka, Momma, myself, Papa, Peshia, and Uncle Yossel, in front of our home in Maitchet.

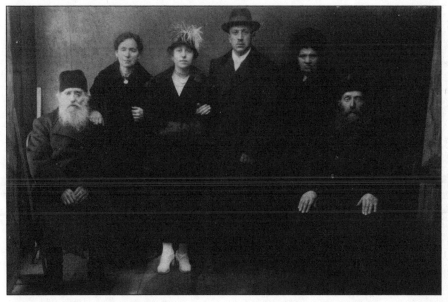

My parents' wedding photo. Left to right: Momma's parents, Eliyahu and Sheyna Bielous, Momma, Papa, and Papa's parents, Shifra and Avraham Shmulevicz.

Momma's family in Morozovichi by the lake where my grandfather, Eliyahu, had his flour mill.

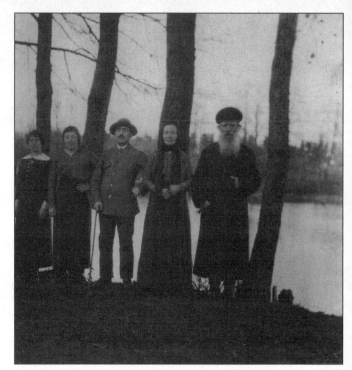

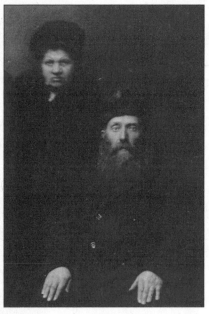

My father's parents, Bubbie and Zayde.

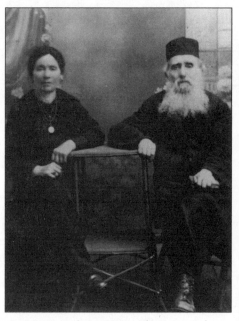

Momma's parents, Sheyna and Eliyahu Bielous, at home in Morozovichi.

This is my old synagogue, the Kalte Shul, where I became a bar mitzvah. I spent almost every Shabbos here praying alongside Zayde and Papa.

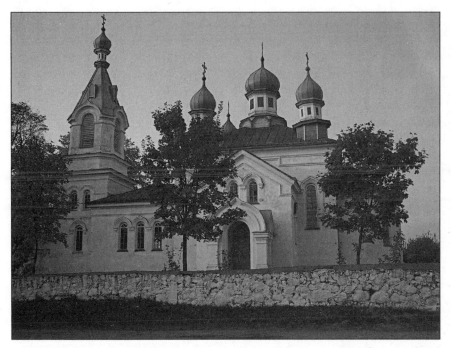

Greek Orthodox Church. This side faced my house. Our friends, the priest and his family, were shot against the wall next to the tree on the far right.

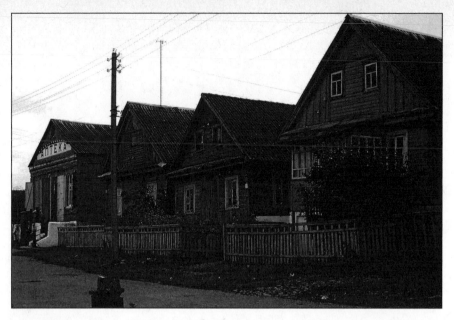

Jewish homes across from the marketplace in Maitchet. Far left: Drug store owned by the Dvorzesky family. To the right was the town bakery (not pictured). Photo courtesy of Myrna Siegel.

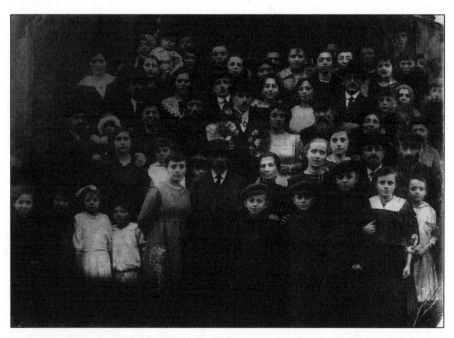

Large gathering of family for my uncle's (cousin Chanyeh's and Moishe's father's) wedding. Everyone pictured here was murdered in the summer of 1942.

My parents, Esther and Shlomo Chaim Shmulevicz, at home in Maitchet.

Left to right: Peshia, Momma, Elka, and I in front of our pine forest in Maitchet.

My parents,
Esther and
Shlomo Chaim
Shmulevicz, with
me between
them.

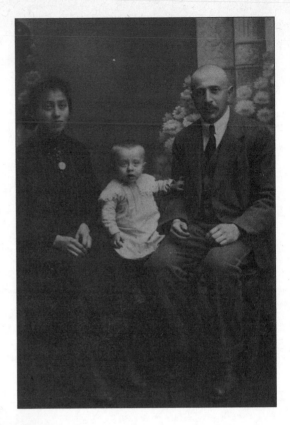

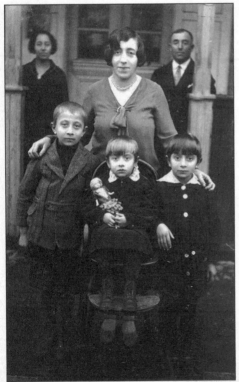

Aunt Frieda standing
with me and my sisters
in front of our house.

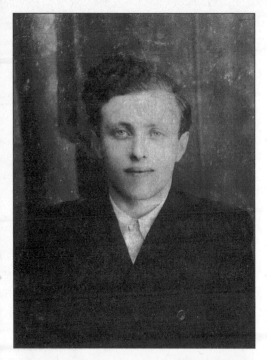

Cousin Chonyeh,
who I met up with
at the Glatki farm in
1942.

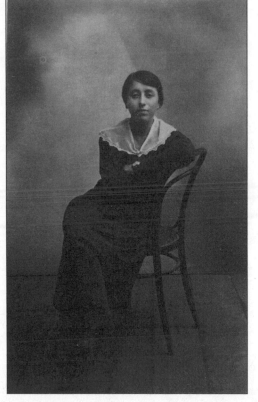

Momma.

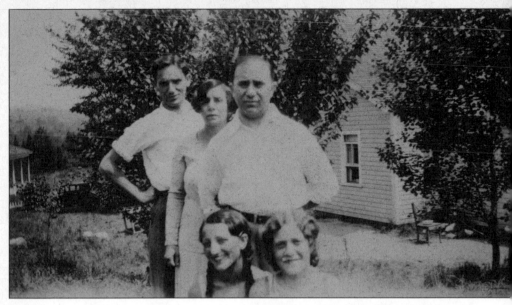

Uncle Harry Berman at home in New York with his family.

- FREEDOM -
LISTEN - LISTEN
CAN YOU HEAR THE
PEOPLE, A THOUSAND BORN.
IT IS THE SWEET MELODY
OF FREEDOM
"FREE FREE AT LAST"

This is my rendering of "Freedom." We would enviously watch
the birds come and go over Mauthausen concentration camp.
I drew this while imagining the American soldiers cutting the
fence so that I could become one of the birds.

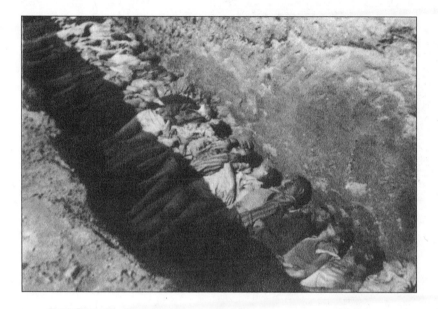

These photographs were taken in Mauthausen concentration camp, May 1945, by Captain Elmore Fabrick, who wrote, "Conditions that existed when we arrived . . ." If not for our American liberators, I would have been counted among my poor friends, the skeletons and decaying human beings.

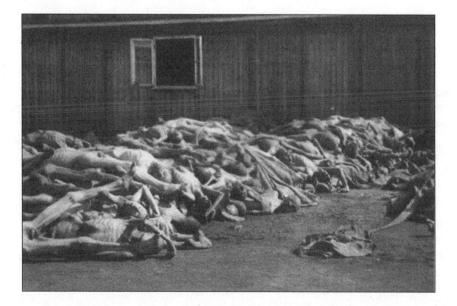

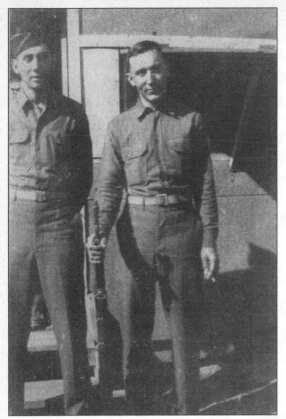

Jim Curry (right) and
his close firend, David
Lesher, 65th Infantry
Division, U.S. Army,
before shipping off to
Europe, World War II.

Me in the displaced persons
camp, Cinecitta (Rome), Italy,
after the war, 1947.

Anzio, Italy. Holocaust survivors and members of the Jewish Brigade, ready to leave for Palestine, 1947.

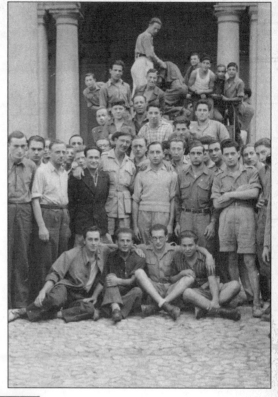

I'm on a Jewish Brigade army truck, Rome, shaking hands with friend, David Rosenbaum, fellow survivor.

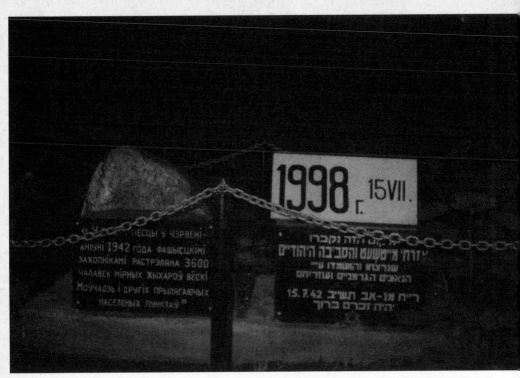

Memorial site at the edge of the forest in Maitchet, in Hebrew and Polish, marking the mass grave in which 3,600 people, including my family, were murdered and buried.

My friend and liberator of Mauthausen concentration camp, police officer Jim Curry, near Central Park, New York.

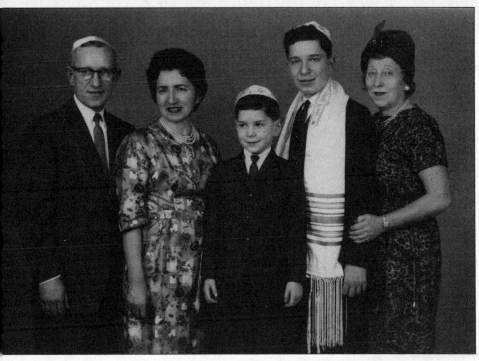

The Silberklang family in New York. Left to right: Baruch, Rywka, David, Melvin, and Aunt Frieda. David, pictured here as a boy, grew up to become a professor, worldwide lecturer, and leading expert on Holocaust historical studies at Yad Vashem in Jerusalem.

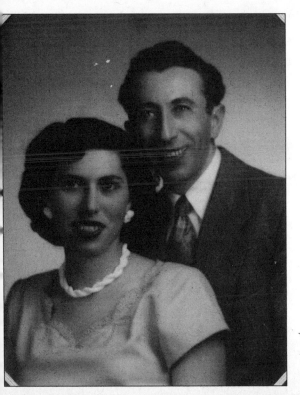

Wedding photo: Doris and I, 1951, New York.

My children, grandchildren, and great grandchildren in Colorado,
September 2007. Left to right, seated: Bill, Vance, Samantha, Julien,
Miriam, Ezra, myself, and Doris. Standing: Jenniffer, John, Jacob, Jaden,
and Jennifer. Not pictured is our great grandson, Grayson Andrew.

Visiting my great friend, WWII veteran Jim Curry, at Jim and Jeanette Curry's home in Long Island.

I am standing at the Old Wall in Jerusalem fulfilling the dream of my people, "Next year in Jerusalem!"

Me, Martin Small, age ninety-one, sitting at home in Colorado in my basement office, surrounded by my Holocaust research, photo albums, books, awards, and memories.

"If we do nothing else," Galla said, "at least we keep the Germans away from the war effort. And whatever supplies we take are kept out of the hands of the Wehrmacht."

Galla shared her food with Shmulek and me and gave us whatever news she had about the status of the war, the murders of Jews, and the activities of the partisans. Not trusting Grozny, we thanked Galla and quickly moved on.

Many years later, having survived the war, Galla would die in peace in New York. Looking at her, as an old grandma, one would never know how many Jewish lives she saved, often just by steering them clear from anti-Semitic partisan leaders, Poles, Germans, and the elements. Galla told us not to trust anyone in any partisan unit. At this time, Russian partisans were killing Jews they found with rifles. People would kill you for a shotgun or a pistol. The only chance of surviving with the Russians was to proclaim yourself a fellow comrade of the Soviet Union. With so many factions in the forests, so great a chance of being murdered, Shmulek and I decided never to linger in one place for long. Endless running; always moving; never resting our minds or bodies. We ran half asleep. There were times when our feet trampled through the woods and my eyelids grew so heavy that I'd close them for a few seconds, drifting in and out of consciousness. When I reopened them, I'd look behind me and Shmulek would be doing the same thing. When we finally collapsed from exhaustion and slept, we found no peace. We would sleep deeply then awaken with a start. When we slept, we were as dead, lying sprawled out on the floor of the forest crawling with insects, sheltered by moaning trees, nearly invisible steam rising from our mouths and pores—rising gently into the breeze and hiding in

the leaves. Hunger, fear, exhaustion, and confusion were constant companions. We tried to take turns sleeping, but neither of us could stay alert. Our bodies and brains were so starved of nutrients that, when we did rest, they shut off like a light switch.

We learned to listen for differences in sounds, including the movement of boots on the forest floor or voices on the wind. Our minds fought between the desperate need to be vigilant and the craving for rest. But we never stopped fearing an accidental run-in with the notorious anti-Semites roaming the forests. We were all on the same side unless we were Jews. So we avoided them all whenever we could, many times walking miles out of our way to keep from coming into contact with them.

We plodded along further and further south, staying close to the forest and using the rising and setting sun as our compass. We became obsessed with our own hunger, always looking for bushes bearing berries, mushrooms poking out near the trees, or food that may have fallen from a farmer's wagon on a dirt path or field.

Not knowing exactly where we were or where we were going, Shmulek and I wound up in the wrong place. Though we made a plan for one of us to remain awake and on lookout while the other slept, we both succumbed to sheer exhaustion and lost consciousness. In the middle of a field, in the early morning, we looked up to find that several local farmers were cautiously approaching and pointing their rifles at us from about fifty feet away. We threw our guns in the high grass and surrendered. They were pleased with themselves, as if they had had a successful hunt. They screamed at us and struck us with the cold steel of their shotguns as we rose to our feet and were made to walk in front of them.

We were given over to a paramilitary group of Polish collaborators and brought to a labor camp in Koldichevo. After all of our running and hiding, we were back where we started, about ten miles outside of Baranowicze. Two thousand captured Soviet and Polish resistance members, along with those Jews who had survived massacres in their shtetls, were all forced to labor for the Reich in this little town in the middle of nowhere. No longer a community, Koldichevo was a sad collection of concrete buildings and overworked farmland, with dilapidated barns, animal stalls, and tool sheds. The town was partitioned with an endless fence of barbed wire to create a makeshift prison. Among the prisoners of Koldichevo was Dr. Yakobovich, the physician who hid with me in the Glatkis' kitchen, and his wife, Sarah. And there were others I recognized as well, men as well as women.

The summer was behind us; leaves had fallen off the trees. All was now bleak and gray. It had been four or five months since my family, friends, and neighbors had been murdered in Maitchet. This tragedy was something I still had no time to grieve for. Maybe Shmulek and I would meet with the same outcome. Maybe this was just an eventuality; we may just have been waiting our turn. Madness. We had gone nowhere for all of our running, starving, and calculating.

Shmulek and I worked through the winter in various barns set up as factories. Slave laborers with uncertain futures sat for endless hours making watches and clothes for the Third Reich. Winter outerwear was fashioned out of coats taken from Jews. We put the finishing touches on shirts, socks, gloves, and other clothing, which were crated and shipped by rail to Germany. As the cold of

winter set in, there was a greater demand for warmer clothes for the German soldiers on the eastern front. Much of what we produced was put on railroad cars bound for German-occupied Russia. We, in effect, were struggling to keep alive in order to keep the Germans from dying in the plummeting cold of Leningrad.

The less fortunate among us were sent off to hard labor. Many never returned at the end of the day. We never really knew where they went or how they died, whether from exhaustion, malnutrition, or random killing. By the end of the war, more than twenty thousand people had been murdered in Koldichevo. It was a camp that, for the most part, would escape hardly a mention in the history books.

We knew that the Koldichevo work camp was like all others and that our chances of surviving diminished with each day. We were being used for our labor, and once we came to the end of our vitality, we were discarded. This was an inevitability, because no human being can subsist on scraps of bread and putrid water for long. There was no tomorrow. Murdering Jews had become a pastime of Nazis and their collaborators; survival was not in the stars for any of us. Our numbers were always dwindling.

One day melded into another in Koldichevo. I lost track of time. We worked all through the winter, and Shmulek and I were fortunate enough to work indoors while others died from the cold in the street or on the march home from a work detail. Toward the end of February, our fate was about to change. I do not remember how the decision was made, but at the end of one particular workday, with the lights out in our barn, a group of men gathered in the middle of the structure for a meeting. We spoke in hushed tones

while several men kept an eye on the guards patrolling the grounds. We came to a quick conclusion that to stay in Koldichevo was not an option and we would have to dig a tunnel and attempt an escape. Koldichevo was surrounded by a barbed wire fence but was not far from a dense forest. It was agreed that with men working furiously every evening, we could make a passageway in a matter of weeks. The first order of business was to gather tools. Shovels without handles, tin cups, spoons, and blocks of wood were all used for digging.

Scores of us worked in shifts to chip away at the roots, gravel, and soil during the night—every night until dawn. We clawed with our fingers until they bled. The ground outside was hardening from the cold of winter, but several feet beneath the topsoil the earth could be loosened and removed. A team of about a hundred men took turns climbing into the tunnel, filling cans, pots, and bowls with moist, dark brown soil and passing it along the ranks back into the barn where the entrance had been dug. We had to get rid of the soil we removed from the tunnel, so dirt was hidden in the legs of our trousers and carried into the open, released onto the ground, and scattered about with our feet. At every opportunity we tore wooden planks out of barns and sheds, picked up scraps of timber and branches, and lugged them deep into the tunnel to fortify the walls and ceiling to keep it from collapsing in on us. We worked in the dark with very little air to breathe and learned to stifle our coughing from the dust that drizzled down on us each time we dug into the tunnel's ceiling. The tunnel was barely wide enough to accommodate one man. It was a squeeze to move through, and

there wasn't enough room to turn around. In order to return to the tunnel's opening, we had to back up on our hands and knees.

At this time, there were no careful inspections by prison guards, so our enterprise went on unnoticed until finally we had managed to create a tunnel fifteen or twenty meters long that extended to the very edge of the Koldichevo forest.

I believe it was the beginning of March when we finally finished the construction of our crude, subterranean hallway to freedom. There was just enough room for one man at a time to crawl on his belly, knees, and elbows in the direction of the woods. Kerosene lamps lit the way at a couple of points, but it was still nearly impossible to see inside. At the determined hour we headed, in the middle of the night, through darkness into more darkness. I was one of the first to climb into the tunnel. I don't remember being frightened. It was more frightening to stay in the labor camp than anything else. Now we had a chance for freedom. I crawled like a lizard as fast as I could and reached the end of the tunnel in a few minutes. Then, I lifted myself into a squatting position with my hands over my head to poke through the opening by the forest. Immediately, I felt the cool night air brushing my sweaty fingers. I peaked my head through the hole. I couldn't see especially well; my eyes had to adjust to the darkness of the night. I pulled myself out, feeling the next person after me pushing against my legs. A blast of fresh air hit my face and burned the inside of my nose. There was dew on the grass and the trees were watching me through the thick night. The first thing I noticed was that we were short of the forest. I'd have to run across a field to reach the trees. But it was now or never. We could hear the guards talking to one another,

parading around the perimeter of the ghetto. We could see puffs of cigarette smoke billowing in the distance as the guards casually shuffled further and further away from us. I whispered to warn the man beneath me to be careful so he could pass the message down the line. The forest was just a wall of blackness; I would be running into a void, into the unknown. There were almost a hundred men yet to go. Running as fast as I could, I tried to stay low and quiet. I could hear my own breathing and my heavy feet over rocks and weeds.

Right behind me was Dr. Yakobovich, a strong young man in his mid-thirties who walked with a noticeable limp. I wondered how he would manage to run. The doctor, like Shmulek Bachrach, fled western Poland during the Nazi invasion only to lose his entire family to the murderous Poles in Maitchet. Sarah Yakobovich stayed right beside her husband as they ran into the darkness. Behind those two were the other escapees, all emerging from darkness into darkness. Like ants in the middle of the night, we poured out of our nest, eager to flee, with hearts pounding out of our chests and eyes open wider than wide. One by one we were running away. But the sounds of our feet grew collectively louder, like a stampede, breaking the silence of the night.

I tried to be invisible but didn't get very far before one of the guards turned around, spotted us, and started shooting randomly. It was a wild scene with gunshots cracking and splitting the night. Bullets whistled through the air and bounced off the ground. I could hear them pass over and around me. They hit the trees and splintered branches and exploded the bark. We were running toward the forest but not in a direct path. Some fell to the ground to avoid

the bullets while digging their fingers into roots and crawling to the forest. Others ran wildly this way or that. We were all in some way panting and scratching our way toward the trees. People were tripping, falling over one another, crying, whimpering, wetting themselves, diving for cover, and rolling along the ground. I could hear the commotion but barely saw a thing as I made my way through the thicket. There was no time to think. Our only instinct was to reach the trees and meld with the night. I heard a bullet whoosh and whistle past my right ear, cracking a branch only a meter in front of me. And that's when I felt something tear at my right arm. Maybe a sharp branch. I was stung but desensitized by confusion and adrenaline. The cold air was cold on my arm then warm again, then cold.

My arm burned. Warm blood was not just trickling but pouring down my arm and down along my fingers. I didn't realize I had been shot. I didn't feel the full effect of the bullet right away. I wasn't consumed by pain, but quickly the pain began to burn like a flame. As I ran, my arm dangled lifelessly by my side, swinging wildly. My fingers were wet and slippery but growing numb. I ran and ran along with the others whom I could barely see. My arm was all at once useless. Try as I might, I could not control it as it whipped leaves and branches. I used my left hand to feel through the darkness, to grab my right wrist, now drenched with blood, and hold it as my feet stumbled over the forest floor. My immediate world was swallowed up by silhouettes, ghosts, crunching leaves, crackling twigs, panting, coughing, wincing, sloshing, and pounding feet. My jaw clenched from the pain in my arm as I continued to hobble through the forest. I didn't know who was in front of me or

behind me. Voiceless, we ran like a herd of animals, instinctively, bumping along then turning this way and that, sweating profusely in the cold air; following whomever was in the lead. The breathing was in bursts—wheezing, gasping, choking, coughing, spitting up phlegm. Animal sounds, grunting, with sweat stinging our eyes and ears, and noses burning from the cold. Our only goal was "away"—as fast as we could run, on empty bellies and starved minds. We ran and ran, deeper into the forest and away from the guards, until Koldichevo was far behind us and the gunshots faded into silence.

At the time of our escape from Koldichevo, I had no idea of the scope of this event. But now, after sixty years have passed, I have come to learn that, on that night, close to a hundred of us reached the partisans hiding in the forests of Naliboki. None of our group died in the escape, yet Shlomo Kushnir, the leader, was captured almost instantly. He committed suicide while in the hands of the Nazis. But Shmulek Bachrach and I, my friend who had aged with me since the days we were torn from our families in Maitchet, had made it again to freedom. Most of the others joined up with the Bielski brothers' partisan group that was, at this point, the largest and most organized of any group of refugees.

When eventually, as if in mutual agreement, the herd came to a halt, exhausted, gasping for air, spent and falling to the ground, I at last fully realized how badly I had been shot. Our eyes had become adjusted to the darkness and moonlight filtered through the trees. My sleeve was red with blood, draining out of me from my upper arm, halfway between my right shoulder and elbow. I was

lightheaded, pale, and tumbled onto the forest floor until someone took notice and called for Dr. Yakobovich.

The light of dawn was just beginning to trickle through the trees to the east. We had been running, walking, moving, dragging ourselves along all through the night. This was the first time I was able to assess my condition. The bullet in my upper arm had shattered the bone. I saw nothing but blood matted on my dirty shirtsleeve. My right hand was numb and the wound was throbbing. I could do nothing but sit in pain while staring at the muddy ground. When I looked up, Dr. Yakobovich was hovering over me and my useless arm. I studied his kind face with its furrowed brow, deep-set black eyes, and pointed nose as he squatted beside me to study my wound. He spoke with a soft, caring voice, "Let's take a look." He peeled back the material of my shirt clinging to the wound and squinted to get a better view.

In the middle of the forest, Dr. Yakobovich set up his "hospital" without anesthesia, a sterile environment, medical tools, gauze, or adequate lighting. Dr. Yakobovich found two men to hold me still as he dug deep into my tissues with his fingers and a knife, and pulled out the bullet. The pain was unbearable as he probed around in the open wound but, gritting my teeth and taking deep breaths through my nose, I would not allow myself to scream. I would not betray the silence; I wouldn't convey my own weakness as the doctor did the best he could to remove loose bone fragments and stop the bleeding. My arm was badly damaged. I had no choice but to suffer with it. With whatever rags he could find, Dr. Yakobovich dressed the wound. All I could do was to hope for recovery, and hope to keep up with the others and fend for myself.

Over several months of hiding in the forest, living with the partisans, then heading out on my own, using urine as the only disinfectant, and rags as bandages, my arm had healed. But I could no longer straighten it and it lost most of its usefulness. But I managed to get along on sheer will and reliance on my left hand to feed me; there was no other choice. At least I was far from Koldichevo, alive in the company of a new group of partisans.

More Aimless Wandering

The days and weeks after the escape from Koldichevo melded into one long struggle. Shmulek and I parted ways from the other escapees, banking on our own independence. One day, wandering the countryside in search of food and shelter, we came upon a small farm in the woods with a barn in the corner of the property. It was sometime toward the end of the day, beneath a drizzling sky, that we snuck up on the barn and let ourselves in. As the rain came down harder, we scratched around for a few minutes and found a couple of ears of corn lying near some hay. We drank out of a rain barrel outside, ate the corn, and rested against the wall of the barn. Soon we fell asleep to the monotonous beat of raindrops on the roof and a steady drip of water from a wooden beam overhead into a growing puddle.

In the morning Shmulek and I were awakened by the sound of someone rustling outside. There was no place to hide, so we braced ourselves when we heard footsteps shuffling toward the door. We tried to peer through gaps between the wooden planks of the barn wall, using hand signals to say that someone was about to enter the barn. We were ready to pounce with whatever strength we had

left and we crouched behind the door. An older Polish woman dressed in a long skirt, black boots, and a ragged scarf swung open the rustic barn door and looked at us with hardly a surprise in her wrinkled face. Like two schoolboys, we stood before her, waiting to be reprimanded. But the woman didn't ask us who we were or where we had come from. I suppose she assumed we were Jewish runaways. But this did not matter to her. Instead, she saw in us a mutual benefit, told us to wait where we were and that she would bring food, which she did.

By late morning, after the farm woman fed us, Shmulek and I were put to work for her. We busied ourselves the rest of the day separating ears of corn from their stalks. For the next week or so, we worked hard in exchange for food and shelter. We regained a great deal of our strength and were breathing easier in this place miles from the nearest neighbor. We repaired equipment, fed the woman's pigs and chickens, slaughtered animals for food, collected eggs, and hauled in crops from the fields. Then one day, without notice, we were told to leave at once. A neighbor had come over to visit and asked who we were and how long we had been working on the woman's property. The lady tried to explain that we were relatives visiting and helping out, but the neighbor looked at her with too much suspicion. She knew now that it was too dangerous for her to have anything else to do with us. And we were on our way, carrying whatever food we could in our pockets.

Shmulek and I resumed our schedule of walking mostly between dusk and dawn, but in a matter of days we were beginning to starve, and our energy was fading. Our heads were hanging low and we were tripping and falling. One morning, under a clear sky, we at last

came to a spot to rest in a field. We decided to take turns sleeping and standing guard. I cannot remember who was given which assignment, but neither of us could win the battle against fatigue. We both fell asleep.

When the morning light came over us, we were awakened with shouts and barking dogs. We got up and began to run as fast as we could. Shmulek went one way and I went another. Polish farmers fired warning shots, but I continued to run as fast as I could. Eventually, I found myself alone in the forest. Shmulek was nowhere in sight. This was the last I ever saw of my dear friend. Like everyone else in my life, he was gone and I was by myself. I called for him in my sleep, but I awoke always alone.

For endless days and nights I wandered in the forest. My head was dizzy with hunger and my tongue was swollen inside my parched mouth. My feet were sore and blistered and my face unshaven, dirty, and covered in small sores. My wounded arm throbbed and my fingers ached. I began to grow senseless. Random words drifted unkindly through my mind: names, places, Hebrew, Yiddish, Polish, Russian. I don't know if I was speaking to myself out loud or whether my mind was speaking to me with questions and answers. I was no longer cautious and lost my wits. I would fall down, sleep in the middle of weeds, get up, make my way into the forest, and lay down under the trees then continue on my way again. I don't know whether I was hallucinating or looking at the world through my half-shut eyes.

It was morning and a flock of black birds flew past me. Their wings flapped over the tree line. There was no breeze. I chewed on a blade of grass but could barely swallow. I wandered away from

the forest and found myself scanning the ground for food along a dusty, unpaved road. I felt every rock and pebble through my shoes. I don't know what I was looking for. Maybe mushrooms or berries. Something. Then I saw a long train on the horizon. It sat motionless. I was so hungry that I dragged my aching body in the direction of the parked train, all the while gazing with dead, hungry eyes at the ground. I don't know why I was magnetically drawn to the train. I suppose I figured that if there was a train, there must be someone with food nearby. Maybe there was a station, so I walked until I came upon the train. Then I began to walk alongside the cars, peering underneath them in the shadows on the tracks. My head was numb and my ears were ringing. I was so hungry that I couldn't even hold my head up or lift my feet as I walked. I just wanted to find a piece of bread, any scrap of food or garbage lying on the ground.

I stopped and stared at the train a few meters in front of me, wobbling on my feet. I didn't even notice the German soldier who came up behind me. A big, starker man, the soldier didn't even bother to point his rifle at me. I was no threat to him. He looked at me with stone eyes.

"What are you doing away from the train? Get back on the train," he said.

I understood him, his German simple, guttural, and direct. But I did not realize my own predicament. I did not answer. I was in a daze and, in my delirious way, was relieved to be found. Maybe there was a chance to eat and rest. The soldier pushed me with his rifle.

"You shouldn't be off the train," he said. "Get back inside. Go!" The next thing I knew, the door of the train opened up. To my

bewilderment, I was standing in front of a wooden car packed with people dressed like they were going on vacation. There were men, women, and children jammed so tightly together that there was almost no room to sit down. One of the men reached out his hand to me and pulled me into the train. The German shouted something I did not understand then slid the heavy wooden door closed. Inside the train, the well-dressed businessman with a small leather valise offered me a piece of bread—the only thing I had eaten in days. We spoke in Yiddish as the train slowly began to pick up speed. He told me the train was mostly carrying Hungarian Jews, but no one knew its destination, only that we were heading west, deeper into German territory. I ate the bread, drank a thimbleful of water, and passed out.

Rocked by the train, weary, hungry, and emotionally drained, I drifted in and out of consciousness. I do not remember much of that trip, but after a couple of days the train screeched to a stop, shoving us all to the front wall of the car. By this time the stench was suffocating. People had died in the car during the journey. They defecated, urinated, and vomited. There was hardly any air to breathe, so when the doors finally flew open there was a rush to jump away, gasping for air and open space. We were jumping from the fire into the frying pan. Our train had reached its final destination: Mauthausen concentration camp in Austria.

We were met by mean, brutal German guards as well as men in prison uniforms holding clubs and hitting people as they tried to help each other disembark. Mothers were clutching their children and men tried to stay with their wives. A special unit of prisoners was immediately sent out to clean the train cars, dragging the dead

and dying onto the ground like sacks of flour. There was mass confusion until we were corralled like cattle into lines and groups. They made some of us stand five to a row in long lines. Others were still milling about in confusion. Never before had I heard the ugliness of the German language. I will always associate it with the sound of abuse and inhumanity. The language of hell.

Right away the Germans began separating people, deciding that some should fall into a queue to the left and others to the right—a process known as a "selection." Life or death? This was the end for most of the people on my train. Yet, at the time, none of us had any idea that people were being selected to live or to die. Little children, grandmothers, elderly men, and the disabled were shoved to the left. Able-bodied men to the right. I bent over and grabbed a handful of dirt and rubbed it over my wounded arm and tried to hide it from view. Though weak and dizzy from hunger, I tried to stand up straight and tall. In the distance we could see smoke rising from a building. The odor coming from this direction was repulsive; we gagged on it. Floating down on us from the air was a white dust. It was precipitating on this warm, clear day with the rain of human ashes.

A few yards from me a little girl, maybe eight years old, stood crying. She found a young German soldier and tugged on his jacket. He bent down as she cried to him that she could not find her mommy. The German said in a soft, almost loving tone, "You want your mommy? You see that smoke coming out over there? There's your mommy. She'll be coming out any minute." In the next instance, and I can still see this in my mind as it has played over and over since that day, the German pulled out his revolver and

shot the little girl in the head. He returned his gun into its holster, stepped over the child, and continued shouting orders at people coming off the train cars.

Many years later, when living in Colorado, I went to an event where Holocaust survivors were giving speeches. One of the speakers, a man named Emil Hecht, went to the podium and began to tell a story that amazed me. Mr. Hecht told the audience of how he was arriving at Mauthausen when he watched a German soldier tell a little lost girl that her mommy would soon be coming out of the chimney. Mr. Hecht then described how the soldier shot the girl in the head. My wife, Doris, turned to me excited and said, "That's *your* story, Martin!" It *was* my story. But it was also the story of Emil Hecht who happened to be right there at that same moment as I. I have since spent time with Mr. Hecht, exchanging memories that make us both cry. I still don't know, though, whether it is more amazing that we both shared the same experience on that same day when we arrived at Mauthausen or that we both survived the Holocaust.

Mauthausen has often been described as the worst of all the Nazi concentration camps ever devised by Hitler's destructive machine. You might wonder how this can be when there were places like Auschwitz, Treblinka, Dachau. For any individual suffering in a concentration camp, no one place could have been worse than another. Death is death. Suffering is suffering. Yet in terms of its design, purpose, and function, Mauthausen had no pretenses of being anything other than what it was: a place where human beings were brought to suffer a slow, agonizing death. The "work" we were forced to perform had no purpose other than to cause pain and

death. Mauthausen was where human beings wasted away until life disintegrated. No words can describe Mauthausen. No words. We didn't live; we didn't look for hope. We tried to survive just another minute, thinking with brains that failed us. Starved brains; starved bodies. Vacant eyes. Corpses on legs that were sticks. Bodies in soiled rags. Shoes missing soles. Mouths that would not close. We were abandoned beings, hidden from human dignity and the eyes of the world. We wondered ourselves whether we actually existed.

How can a person survive this? I can only surmise that if God wants you to live, you'll live; I have no other way to explain. So in telling my story, I do not want to focus on the details of the daily horrors that were continually without hope—these memories are too painful to recall. A nightmare, my time in Mauthausen has never left my psyche in peace and has to this day haunted my dreams, night after night, year after year.

How can you begin to describe a concentration camp? It can only be described in physical terms—not psychologically, emotionally, or spiritually. My mind wants to forget, but at the same time I need to remember so I know I am not crazy. I want to remember for the sake of those who went in and never came out and for those who suffered with so few witnesses to validate what happened. I want to remember so that the world will know the depths of depravity and that there were gas chambers and human bodies burning in ovens. And that for sport, our German captors pushed living human beings off of high cliffs and laughed as the screams terminated with bodies splitting and splaying onto jagged granite down below. I want to add my testimony to the history of mankind and to say that I was there to witness this dark, unspeakable era of horror, hate,

injustice, and decay. I toiled night after night loading bodies into ovens. I cannot shut this out of my mind. It is impossible.

What men can do to other men is unbelievable, and Mauthausen concentration camp is the manifestation of man's potential for extreme ugliness, hate, and negativity. There are many books written on the sick, demented, and barbarous conditions and activities peculiar to the Nazi concentration camps. Without sinking into details of despair and cruelty, I will only say that the Nazis and their collaborators, and all those who failed politically and militarily to lift a finger to help, were the co-creators of this damned abyss.

What was Mauthausen? Where was I? Mauthausen was a group of associated concentration camps in Austria. The specialty of the camp was torture, and the inmates, of which I was one of tens of thousands, consisted not only of Jews but of Jehovah's Witnesses as well as American prisoners of war, spies, soldiers, OSS (Office of Strategic Services) agents, intelligence officers, Gypsies, resistance fighters, and Russians. The most hated "enemies" of the Nazi state were sent to Mauthausen to die a painful death under the pretense of being sent to a work camp. The Nazi state used Mauthausen to punish its enemies to death under the direction of a stout, dark-haired, round-faced psychopathic camp commandant named Franz Ziereis.

At the site of Mauthausen was an infamous granite quarry. Inmates were driven as slaves to carry heavy slabs of granite up an equally infamous flight of 186 stone steps that became known as the "stairs of death." Given our starved and weakened condition, this task alone more than often amounted to a death sentence. At the base of the quarry the rocks were stained with blood. Man

after man had fallen or was pushed to his death. The German guards found sport in this brutality, enjoying the sights and sounds of human bodies cracking open like eggs against an iron skillet.

In my term at Mauthausen, I was tortured, beaten, made to stand for hours in the frozen air, and had to load lifeless, ruined human beings into furnaces. Some of these people, I am ashamed to admit, were still alive. They were burned alive. How can I bear to remember such things; how can I bear not to? The choice is not mine. There are so many vivid images, odors, sounds, and errant shadows that follow me every waking moment.

I recall one day in particular. We prisoners were made to line up in rows of five and stand at attention as the Germans played a little game. They singled out the Jehovah's Witnesses among us and brought them to the front of the assembly of prisoners. A German soldier walked over to one of the Jehovah's Witnesses and handed him a revolver. Then the man was commanded to kill one of the Jews.

"We'll see how strong your religion is now," the soldier laughed. "If you don't shoot one, I will shoot you."

The game began. But it was a one-sided game. The members of the Jehovah's Witness religion refused to kill. They would not do it. They would drop their hands to their sides and let the weapon fall to the ground. So the Germans shot them dead. One man after another, watching his brother have his brains blown out, refused to kill a Jew, a fellow human being. In a few minutes there was a pile of dead Jehovah's Witnesses in a red heap in front of us. None of them even gave a moment's thought to killing one of us. To this day, if a Jehovah's Witness finds his way to my door, I will

not shut it in his face. I invite him inside for a drink or food and tell him this story.

My survival was merely a miracle. To this day I don't know how I managed to live, day after day, with my bad arm, my body starving and wasting away, my back broken in several places, and my entire being deteriorating from neglect, beatings, and accidents. All the while I watched so many needless deaths—murders—that the cries and pleas never leave my ears. Innocent men, women, and children were poisoned, gassed, beaten, assaulted, burned, humiliated, abused, hanged, and shot. What kind of a world allows these things to happen?

In this Austrian hell, I lost my soul and my sanity. Was I a human being? Were the others around me humans too? Where was my identity? It was fading, starving along with the rest of us. Knowing that I was once a Yeshiva bocher, the men who knew me asked me to say prayers—to give them even some glimpse of comfort.

They'd ask me, "After I am dead, who will say kaddish for me? Who will say kaddish for my family?"

I had no answer. For all I knew, none of us would survive. The men in my barracks encouraged me to sing Hebrew prayers. It gave them comfort, if not hope. Somehow it offered a shadow of human dignity.

When I go to the synagogue, even now, I close my eyes and see the faces of those whose lives were wasted, ruined, taken, destroyed, lost. And I say kaddish for them all. I say kaddish for them to keep my promise and to restore dignity to them and to answer their plea: "Remember us."

Over the years, from time to time, I have met up with Mauthausen survivors. A very few of them knew me personally.

These men have come up to me and said, "I remember you. We used to call you 'the rabbi.' You knew all the prayers." One of the goals of the Germans who operated Mauthausen was to work us to death. So we wasted away in the most literal sense. Starved, our bodies wilted until we were human skeletons. We walked around with neither muscle nor fat. Our faces lost their human form and color. As time passed, our minds lost the ability to think clearly and to serve us other than in the capacity of automatic motion. We no longer even had the capacity to shed a tear or worry or rejoice. There was nothing to us. We stopped being human. We were souls trapped behind windows called eyes.

Imagine hauling slabs of granite when you haven't eaten anything but a bowl of thin soup once a day. Most starving people cannot even walk or speak. But we were pushed to do the unbelievable. The Nazis called us Jews subhuman, but we did what was in no uncertain terms superhuman, functioning against all odds and operating only on instinct. Just another day, hour, or minute until the end. When would the end come? We couldn't even pray for that moment. Physically and mentally we, as prisoners who never committed a crime, were transformed into something not human. Tens of thousands of people were murdered, in one way or another in Mauthausen, but even those of us who survived lost our souls.

About a year passed. I was barely animate. My legs moved one in front of the other as I walked, but I don't know how. People ask me what I did in Mauthausen. Did I work? What is this word "work?" Real work has a purpose, a goal. The notion of labor in Mauthausen was meaningless. It was just another form of torture. It is a thing that the dead do in hell. We had bodies barely strong enough to move, always on the verge of giving up life for the release

promised in death. People ask me what I used to think about. They may never understand. When your brain and body are starved for food, when you have no hope, when you are alone in the world—a world with endless suffering, death, and despair—then you do not think about things. Time passes and your brain just moves you until your body declines the invitation. A starving mind thinks of nothing. What can a mind wonder about in such conditions? Even dreams cannot move beyond the barbed wire fences and ovens and ruined bodies. Birds fly away from the camp but you do not comprehend what you are looking at. Soup is poured into your bowl but you put it in your mouth without thinking. A man falls dead in front of you and you are not fazed.

There was no longer a "me." I did not think most of the time. I merely moved.

We were lined up in the cold, barely able to stand. In a foot of snow under an icy blue-black sky, as German soldiers shivered in long woolen coats, gloves, and leather boots, we wore pajama-thin clothing with holes and tears. The German soldiers slung their rifles over their shoulders and rubbed their hands together. They blew into their gloved hands and shifted back and forth on their feet, commenting to each other that it was cold. Our feet were bloody and wrapped in rags. We stood in the cold as a means of torture. Around me men swayed, trying to keep on their feet, trying to rob Death. One, two, or more fell to the earth. They would no longer arise. The horror was gone for these lucky few.

After hours went by and evening approached, the commandant had his German guards bring out their vicious dogs—Alsatians. Our bellies and throats screamed silently for food, for just a crumb.

We cried for the thought of a morsel of food on our lips. I stuck out my tongue to catch a flake of snow. My eyes began to close and my back cramped and ached. The man beside me fell onto me then down to the ground. His eyes rolled up into his head and he died. The soldiers released their dogs on some unfortunate soul made to stand in front of us as the Germans laughed and pointed. The dogs tore into the living corpse, tearing him to shreds and gnawing at his body. God forgive us, for we were jealous of these dogs; we were jealous that they were feasting. Vicariously, our mouths moved and chewed at the air.

The things that make people human were not to be found in this vacuous world—charity, love, compassion, kindness. From time to time I would look out over the barbed wire fence and see blue-black crows take flight into the air. The birds teased us, effortlessly flying away, leaving Mauthausen and all our suffering behind. Spring was approaching, but I was long past hope. Eventually, there was no imagining that the war would end. There was no outside world. Death would come here. It would take me away over the fence with the crows. Hope had died for all of us. Our bodies and minds were sure to follow.

Spring

"The things I saw beggar description. The visual evidence and the verbal testimony of starvation, cruelty and bestiality were overpowering. I made the visit deliberately in order to be in a position to give first-hand evidence of these things if ever, in the future, there develops a tendency to charge these allegations merely to 'propaganda.'"

—Memo from General Dwight D. Eisenhower to United States Army General George C. Marshall after visiting the Nazi Death Camps, 1945

In the outside world—a world that I could no longer fathom—the Americans were advancing. American soldiers. God bless these men. God bless them all. I cannot hold back my tears as I think of these words, these thoughts I still have for the American soldiers. God bless them.

Brave, strong, well trained, and determined, the Americans were on their way. The only ones in the world who could stand up to the German army. The only force more powerful than that which had destroyed my life was fighting its way toward a victory over Hitler's forces. I had no way of knowing at the time, but the American Army 65th Infantry Division, part of General Patton's Third Army, had fought from France to Germany and across Austria, cutting a path through the snowy forests, chasing the German Wehrmacht as it retreated until it finally began to lose its footing. Then, following the liberation of Paris, one more terrible battle had to be fought—the Battle of the Bulge; Hitler's last stand.

The Americans were not to be defeated; they had come too far. But on the inside, in the lost world of Mauthausen, death continued to claim everyone around me. There was no news of the Americans. For our German tormentors, it was business as usual. More killings, more torture, more death. Bodies piled up faster than they could be burned. The crematoria operated day and night. The sky was raining ashes; rooftops were covered in thin, white, human flakes of dust.

By the spring of 1945, I had no more energy. My life was coming to an end. I could sense myself drifting away. Gradually, my ability to forge ahead was gone. All around me skeletons were slipping into the other world. A year before I had wondered: Where is the Moshiach? When is God going to reach out His hand and send His Messiah? I no longer asked such questions. Here in the hell of Mauthausen, in a barren world of stench and torment alongside a granite quarry near a dense, lush forest in Austria, I was crumbling into nothingness. My body and mind had failed me. Only fragments moved in and out of my thoughts. Food, bread, water, death. No more. Save me. Someone save me. Save us. God save us.

In the last days of Mauthausen, life came to a close. The floor beneath me rose up. It was dead, and on it, the dead. In the barracks, bunks held the weightless dead. Free. My feet, my hands, things. The ugly, bitter pill of German, guttural German, outside of my cloudy ears, gone. I could rest; I would rest. No more. There was no more to me. My eyes, against my will, were falling. Closing, closing, my life drawing to an end. My mind without thoughts or the ability to differentiate things or people. Not even thoughts of hunger. Beyond hunger. My eyes, so heavy. My self, falling closer to

the edge. Slipping, slowly, slowly into nothingness. I had become a shadow. A shadow of what? A shadow of life; a shadow of myself; a poor, dull reflection. No, I was not myself, for I had disintegrated. My back—broken. My right arm—useless. So lost, the pain too had been erased; unkindly. Legs—sticks—buckling, not even able to hold up a skeleton of bones crying silently beneath paper flesh. Crying, but with no tears. God, Momma, Papa, Zayde, myself, water, a puddle, a crumb. Darkness shut out the sun over this no-place. An unknown spring with no more sky. My mouth open, empty. My eyes, my breath—no longer mine. And I no longer myself. Gone. At last, all of this no-world, poisoned sea returned to grains of dust, and I lost my will and fell. The lids of my eyes fell. Darkness. A dark, hollow loss.

On May 5, 1945, the Americans, traveling through Austria, happened upon Gusen, one of several subcamps of Mauthausen. I was unconscious and weighing less than seventy pounds, among the thousands and thousands of dead.

The American arrival has been referred to as a chance discovery. They weren't looking for a concentration camp; they didn't even know of its existence. What they found when they came to Mauthausen has most certainly haunted every soldier since that spring day. These were hardened soldiers. They had fought to the death across Europe, their friends and comrades dying and shattered in their arms. They had seen war; atrocious, hideous war, and all of its sights and sounds. They knew what blood and death smelled like. They understood the numbness and senselessness of tragic death. They had witnessed death and suffering as they

marched across battlefield after battlefield. Yet they were unprepared for Mauthausen.

While the Americans roamed the camp looking for signs of life among the broken bodies, my own decaying body lay sunken, down by the foot of my bunk, on a razor's edge between two worlds. Wholly unconscious. A powerful young soldier from the 65th Infantry Division took notice of me. He was scanning the floor for any sign of life—the flicker of an eyelid, a blink, a moan. He lifted me like a child in his arms and carried me to an army ambulance as an American soldier watched from the guard tower across from the barracks. My life, my future, and my past were in his hands as he stepped over the dead along his way to the truck. This man, whoever he was, had come across the world—had risked his own life—to be my Moshiach.

I was not aware of the day of liberation, but those around me who were still conscious and clinging to their own sanity grabbed hold of the Americans and sobbed at their feet. Unable to speak, they thanked our liberators and miraculously lived to see the end of the Nazi regime. I was robbed of the experience, unconscious, unable, in the least, to thank my personal Moshiach whose one last act of sacrifice and duty to humankind was to make his way among the dead to my bunk at the back of the barracks and lift my body from the floor and save my life. God bless the American soldiers. May history never forget them or what they went through. And when they die of old age, as they are as of this writing, may each one have erased from his memory what he saw, smelled, and heard the day he set foot in Mauthausen concentration camp, so he can rest in peace.

The Awakening

The Zohar, the great work of Jewish mysticism that is also called The Book of Radiance, in the Kabbalah, says all things visible will be born again invisible. And so my life in the Holocaust was over. My life was about to start anew.

For weeks, maybe a month even, I do not recall, I hovered between life and death in a hospital bed in the Austrian town of Linz. The city was now in the hands of both the American and Russian militaries.

When at last I opened my eyes, I was no longer a functioning human being. There were hundreds of others in the hospital in a similar condition. Many were dying. Others were laying on an army hospital cot as living corpses. Each day of life was a miracle unto itself. So close to death were we that it was unpredictable whether we would survive even with food and medical attention. We were in limbo.

With enough food and nourishment, eventually I came to my senses and was transported to another facility. This one was in Salzburg, Austria, where I was sent to learn how to be human again. At first I was completely unaware of who I was and what had

happened to me since the liberation. Every day I was taught how to walk. I had lost nearly all my ability to speak and communicate.

The nurses and doctors would sit in front of me and ask, "How many fingers? Which is the thumb? Which finger is this? Remember who you are? What is your name? How are you today? Did you see out the window? Do you know who you are?"

They waited until I could see again. Every day I was spoken to as if I was a little child; slowly and patiently the nurses would prod me with simple questions. I drifted in and out of sleep. My attention span was short and sporadic. I was disoriented. Like an infant, the Austrian doctors and nurses would hold me. They wiped my mouth after they fed me; they held a cup to my lips so that I could drink. The nurses walked me with their arms tucked under mine, step by step, as my slippers shuffled painfully across clean, squeaky tiles down ten feet of a gleaming white corridor. Exhausted, I returned to bed and stared into space.

I knew a little German, and being able to speak Yiddish, I was able to understand a little more each day. I was just like a newborn. I came to the hospital 99 percent dead and was being introduced to the world again—the world of eating, sleeping in a bed, having a roof over my head, going to the bathroom, awakening to peace. Each day the staff members all seemed surprised that I was still alive. They constantly monitored me for signs that I might recover. The process was a long one, and it was a long time before I could try to piece together where I was and where I had come from. I was in a state of traumatic shock in the hands of German-speaking therapists. By the time I fully understood that I was alive, some of the first thoughts I had were: How did I survive? How did this happen? Who saved

me? What kind of God could take away everything I had in such a horrible way, yet find a way to save me? Why me? I hoped that it had all been a terrible dream, that I still had my family.

Still in Salzburg, a thin young man approached me in the halls of the convalescent hospital. I was now walking on my own and exploring the wing of our hospital. This, the smallest of jaunts, exhausted me, and I turned around to return to my cot. I didn't recognize the man, but he lit up when he looked at me. He approached me as if I was an apparition, holding out his thin hands, feeling for the air around my body.

When he was convinced that I was in the flesh, he smiled and said softly, "Is that really you?" He clasped his hands together in an inaudible clap and said, "I'm glad you are alive—so glad. You are alive. My God. Remember me?"

He was thin but with a round, kind, clean-shaven face and dark circles under his eyes. Teeth were missing from his mouth. He lifted his fingers to his lips, stared into my eyes, then rubbed his face.

"It's me," he said.

It was nice that he was glad to see me, I thought, but I honestly didn't recognize the man. I searched my memory, but there was nothing. Maybe he was mistaking me for somebody else.

"I'm sorry," I said. I smiled at him then turned to walk away.

He gently, but firmly, grabbed my arm and stared into my eyes. He held me with both hands on my shoulders and said, "I was with you in the same barrack—yours was the third bunk on the left from the back of the barracks. Remember? Ours was the one across from the guard tower. We left you to die among the dead. You were dead. You couldn't walk; you couldn't talk. I'm glad you are alive."

"How do you know this was me?" I asked.

He answered, "I'll tell you how I know you. We used to call you the rabbi. You said the prayers. And we saw a young American soldier carry you out. It was you. Sure, you were the rabbi."

What could I say but "Thank you?" I was "the rabbi," but I wished that I could give the man something in return. He was genuinely delighted that I had survived. We walked away from each other, but we both kept turning around, each of us a bit confused. He was surprised I was alive, and I was searching my mind for lost bits of memory. You see, those who know me well know that I remember people and faces. Here I am at age ninety-one and I remember children from Maitchet as well as the faces of their parents. But when that man stopped me in the corridor, he made me wonder what else I had forgotten.

There was a lot of time to think while convalescing in Salzburg. As I grew stronger and was finally able to walk and talk like a normal person, I spent more and more time just thinking. I thought about my family and all that I had lost. I would begin to cry at my returning memories. I thought about the insanity and the inhumanity that marked the last five years of my life. I wondered whether what happened to me was real and whether my family could really be gone. I couldn't comprehend the immensity of all that had taken place from Maitchet to Mauthausen. And I thought about those who were brave enough to help the Jews even at the penalty of death.

I wondered whether I had a heart left after all that had happened. I wondered whether I would, like the Glatkis or Tamara Ulashik, have had the ability to save a family from death and victimization if

the shoe were on the other foot. Could I overlook all the hate and prejudice and find any humanity within me to risk my own neck for a stranger? Would God give me the courage to save the life of a fellow human being trying to escape his hunter? What if someone in Maitchet had helped my mother and two little sisters, saving them from a horrible end? Who could answer such questions? I began to think more and more about the few people who risked their lives to try to save us—Tamara Ulashik, the Glatki family, and, of course, the American soldiers. It wasn't long before I realized that sitting around thinking was the worst thing I could do to myself. All I could think about was Momma, Papa, Peshia, and Elka. My thoughts were driving me crazy, and I needed to occupy my mind and body if I was to keep my sanity.

In Salzburg there was very little to do but to rest, so I became restless. Each day, as I grew stronger in mind and body, I explored the city. I walked for miles to rebuild my legs and lungs. It was summertime and the sun's heat baking on my back and shoulders was therapeutic. My wounded arm still ached, as did my back, but I walked for miles at a time throughout a city that just a year before would have swallowed me up. I looked at the windows. The Russians and Americans had ripped down all the Nazi flags and pried Nazi emblems, with their eagles and swastikas, off doorways and building facades. American jeeps were driving up and down the road. Russian and American soldiers whizzing by waved at me and I waved back.

At this time, Salzburg, like most other places in Western Europe, was in a state of turmoil. Thousands of people were homeless, including former concentration camp inmates. Now we were

called "displaced persons," or DPs. Civilians, too, hailing from every European nation wandered to and from their bombed-out cities and homes. Former Nazi SS officers, concentration camp kapos, and Nazi collaborators were trying to hide among the DPs to avoid prosecution and to collect benefits being handed out to survivors. Once in a while they were spotted in the street and then a small riot would break out. Russian soldiers would most often turn the other way.

Many of Hitler's soldiers stood in line to receive rations amid noncombatants. Killers were intermixed with victims. American and Russian servicemen, with pistols in holsters and rifles over their shoulders, roamed the streets, depending on which district you were in. Military vehicles churned up the dust on the roads and roared on for miles at a stretch as MPs directed traffic at the busier intersections. Army officers controlled government offices. The families of German soldiers were looking for some place to go; they had lost either their homes or husbands or fathers. Their former providers were dead, lost, in hiding, still in Russian POW camps, or taken away by the Soviets to labor camps.

For the Russians, the war was not over; their appetite for vengeance against the city's Germans could not be quelled. Out of control and with no law to intervene, Russian soldiers throughout Austria and Germany were hunting down SS officers and killing them on the streets and in their homes. They were butchering men, women, and children and raping females of all ages. Their own military leaders just ignored their underlings and let the violence continue as a matter of course. The Germans deserve what they get, they said. A German's biggest fear was the Russian soldier.

One afternoon, while wandering up and down the blocks of Salzburg, I came upon a train station. The trains at that time were running day and night, transporting supplies, prisoners returning home, DPs, military personnel, businessmen, and civilians of many nationalities. Trains loaded with Italian POWs returning from the eastern front were crisscrossing with trains taking Russians back to Moscow and Kiev. Stockpiles of weapons, jeeps, trucks, and artillery were passing through Salzburg as a part of a massive effort to clean up and restore normalcy to war-torn Western Europe. The Russian command was in charge of this particular station where I watched a train screech to a stop. Hanging out the window were Italian soldiers returning from the east—former prisoners of war held by the Soviets. The Russians were sending the train ahead, back to Italy.

While standing on the platform, staring at the train, looking at faces through the windows, watching bored, disinterested Russian guards stroll back and forth, I took no notice that three women had approached me. They wore long skirts and scarves over their heads. As they got closer, I saw that they were a grandmother, a mother, and a daughter in her teens. I turned my attention back to the train. When I glanced at the three women again, they were standing a couple of feet away. As our eyes met, the mother began to speak to me in German. She was very nervous and frightened and constantly cast her eyes toward the Russian soldiers milling around the station. She tried to speak slowly and clearly, but her expression was desperate and she moved to within a few inches of me so she wouldn't be overheard.

The mother asked me, "Are you from the concentration camp, Mauthausen?"

I said, "Yes."

She looked down at her feet and said, "So you wouldn't talk to me."

I answered, "Why wouldn't I talk to you? You came to me; I don't know who you are."

At that moment the woman took out a pouch from under her coat. It was a big cloth sack tied shut with a string. She told me, "I want to give this to you."

I said, "I don't want it."

She said, "This is Jewish gold, silver, and diamonds. My husband gave this to me. My husband, an SS officer, was killed by the Americans, and now they're looking for us. I want you to keep this and do me a favor."

I was shivering. She told me the name of her husband, but I don't remember. He was a big shot at the concentration camp. She grabbed her daughter by the sleeve and pulled her closer, as if afraid of losing her.

The woman told me, "I want you to take this so you'll do me a favor. I want you to save my daughter. My mother and I will go back and they will kill us, but save my daughter."

I didn't know what to think. But when she told me to save her daughter, I saw my own mother and two sisters at that moment. I knew they were dead, but maybe a miracle happened and it was them. I was looking at Momma, Peshia, and Elka. Their faces were in front of me. They had come back to be with me. I stared at them in disbelief. How did they get here? My head was swimming. My

eyes were lost in the past, my mind caught between two worlds. "Save my daughter," the woman had said to me. I was faced with a test of my own humanity. After all I had been through, after all I had lost, after all I had suffered, now I was face-to-face with the family of one of those monsters who was responsible for destroying my life. And his wife and daughter and mother were asking me, of all people, to help them. What was I to do? It seemed what I did next took place without any thought. I asked the woman, "Do you have liquor at your house? Go ahead and bring me the liquor."

She looked at me confused, "Liquor?"

I said, "Yes, go home and get the liquor and bring it back."

They left and I just stood there thinking I was with my mother and sisters. I was there by the train for more than an hour. There was a Russian officer close by. He was keeping his eye on the cargo of tanks and Italian POWs. I waited and waited as people came and went.

At last the three women came back, and I said to them, "Follow me."

I went to the Russian captain and asked him, "Where are you going with this train?" He looked at me suspiciously. I told him, "I have a present for you," and then I showed him the bottle of liquor.

The officer grabbed it, his eyes popping out of his head. "What do you want me to do?" he asked.

I said, "These three women are my mother, my grandmother, and my sister. They are from the concentration camp."

The Russian took them to the train and put them on. Tears were running down the mother's face as she boarded and looked

my way. I told the lady to take the diamonds and other valuables in the pouch with her. I would have no part of these things. And I stood there staring at her. I was frozen. After the train rolled out, I was lost in thought. What just happened? What did I just do? Out of the ethers an idea struck me. "Oh, God, thank you, you answered my question. I could do for others the same thing Mrs. Glatki did for us." I kept thinking this one thought over and over and over as the train picked up speed. It was a sobering experience that I never let go of.

Going to the Salzburg train station was a regular part of my schedule. For some reason, I was drawn to the area. Maybe it was a metaphor; maybe somewhere inside me was an urge to move on. As my body continued to heal and my energy returned, I wanted to get away from this German-speaking country. But I had nowhere to go. I thought of my Aunt Frieda in New York, but at that time it was impossible to leave Europe. There were a million people trying to get out and millions more who needed to be processed by the occupation forces. The bureaucracy of everything was stifling. All I could do for now was to wander the streets and visit the train station. I had food, drink, and a place to sleep, bathe, and rest, but I had no sense of purpose or direction.

A couple of months had passed since I put the three women on the train to Italy. Once again I was standing at the station. The Russians had stopped a long train for inspection. It was filled with the last of the Italian POWs coming back from the Russian front. They were a boisterous group who spoke like they were singing. This was a beautiful language that I had never heard before. Words rattled off the tongue and hands seemed to be extended parts of

speech. One of the soldiers, a captain in the Italian army with jet-black hair and a friendly smile, spotted me staring at the train. He called out to me, wildly waving his hands. His buddies were straining to position their heads out the window to look at me.

"Hey, you! You understand me?" the captain yelled. I shrugged.

Then the Italian officer spoke to me in broken Russian. Now I was thoroughly confused. What kind of Russian was this? Maybe I had forgotten how to speak it. I could barely understand him. He pointed to a couple of his friends hanging out of the train. They were showing me their guitar, then they started to play it and I enjoyed listening. Since Tamara Ulashik taught me to play guitar in Maitchet, I'd been enchanted by the instrument, and the thought of a bunch of Italians playing Russian folk songs was something too strangely attractive to ignore. The Russian tunes they sang and strummed were songs they learned while in a Soviet POW camp, waiting out the duration of the war.

"You!" the captain yelled, "Do you play guitar?" I was still staring at him from the platform.

I nodded yes.

"You want to go to Italy?"

I didn't think about it twice.

I had with me everything I owned and everything I had in the world—nothing. Just me. A second later the captain and his friends were pulling me onto the train. With hand signals and a lot of shouting, the Italian officer introduced himself to me as Giovanni Onofre.

"Come in, don't worry," he told me. "The Russians won't mind." And in the next breath, with the Russian guard walking past

their train car, Giovanni started to shoo me and said, "Hurry up, under the cot!"

He told me to hide underneath one of the military cots on the train so the Russian soldiers wouldn't see me and throw me off. The Italians strummed away on their guitar and sang at the top of their voices in a ridiculous attempt to act nonchalant while I hid by their feet until we pulled away from the station.

Within an hour I was bound for Modena, Italy.

Viva Italia!

In a few days, our train of Italian ex–prisoners of war arrived in Modena, in north-central Italy. Modena is between two big rivers, and at that time the city was overflowing with throngs of Italian soldiers trying to find their way back home with one of the worst train schedules in history. Modena also hosted a camp for displaced persons, but I chose to stay with my new Italian friends who treated me like their long-lost pal.

When we passed into Italy, the men on board the train were ecstatic. They waved their hats, stuck their heads out of the windows, and screamed, "*Viva Italia!*" and toasted with whatever drink they had with them. They forgot all about their Russian folk songs and, with their hats off and hands clutched to their hearts, began to sing in Italian with every ounce of their souls.

After rocking over the rails for days, at last our train came to a stop in a small, busy station. We were all immediately marched off to a military camp for questioning. The Italians and Allied military authorities were very concerned about communist spies infiltrating the west from Russia, so our stop in Modena was for debriefing and background investigations. Once cleared—a process guaranteed to

crawl along at a snail's pace—the Italians were free to continue home.

Since I had nowhere else to go, and Giovanni treated me like his closest friend, he insisted I stay with him and his army buddies in the Italian military compound. The officials running things didn't seem to care that I stayed as a visitor. The Italians treated me to food, lodging, and entertainment. We played soccer, arguing about the rules, and played chess and the guitar at night. In no time I learned a little Italian. It was a new and interesting language—my fifth or sixth by now—which I quickly grew to love. My Italian was good enough to get by but was by no means perfect yet.

For the next eight months, I stayed with Giovanni in Modena. Being in a military compound, with not much else to do, I sat in on hours and hours of training sessions. Like an Italian soldier, I sat in a bare, cold classroom as an officer lectured us about everything we'd ever want to know about Matilda tanks. I learned what the Matildas looked like, how valuable they were, and what they were capable of. I learned how to drive one, fire the huge guns, and navigate it over all types of terrain. I was soon dreaming about Matilda tanks and making sketches of them. There was almost nothing else to do during the day but attend Captain Onofre's army training sessions.

Three quarters of a year went by before the government authorities gave Giovanni permission to leave for home. After years of being away, out of touch with his worried family, Giovanni was going to be reunited with his mother, father, and sister. He couldn't wait to see them again, and he wanted me to go with him to Rome.

"I want you to meet everybody," he told me. "You're gonna love them."

I didn't hesitate to tell him I was ready to leave with him right away. As soon as we could, we hopped on the next train and headed south. Then we walked for a few miles, sat and rested, hitched a ride in a couple of American army jeeps, then walked some more. Eventually, we made it home. Giovanni stood for a moment and stared at his house as his eyes welled up with tears. I still remember Giovanni's address: Via Muzio Clemente #27.

The meeting between Giovanni and his family was incredible. They were overcome with emotion. He was squeezed and kissed black-and-blue. I was very happy for him and he was proud to introduce me to his parents. His father was a *carbonere*; he sold carbon for cooking and heating. The Onofre family lived in a modest house with a nice little garden and a traditional Italian kitchen. The house was not very big, maybe a couple of rooms, so Giovanni said, "You can share my room, if you want." Not having anywhere else to go, or knowing exactly where I was, I eagerly accepted. Plus, there was a dividend: Giovanni had a beautiful sister named Olivetta. We became close friends, but I was in no condition to be married off, so we remained only good friends.

Giovanni had friends who owned a *ristorante* not far from his house in Rome. I spent a lot of time there and loved to help out in the kitchen cleaning dishes, setting tables, carrying food, and dumping out the trash—whatever was needed. I was glad to help out. I didn't work for the money. By this time in my life, I had realized that money had no meaning. This is the way my grandfather and my father felt, and I've always felt the same way, especially since

my family was taken from me. People are valuable; money means very little. I have seen people spend an entire fortune for a piece of bread. I've seen people murdered for their possessions. And I've seen people lose their minds with so much lust for money that they willingly murdered their neighbors.

The owners of the restaurant loved to feed me; that was payment enough. Plus, I was able to regain much of the weight I had lost through the Holocaust years. There's nothing like pasta and Italian bread to put meat back on your bones. And there's nobody who enjoys eating more than the Italians. Eating with friends and family is a religious experience. I fit right in. Every Italian I met was more welcoming than the next. Their food was my food. There was no such thing as a stranger.

With a lot of time on my hands, I explored Rome every day. It was, in a way, a Roman holiday. I was taken with this ancient city, its old buildings, historical sites, and expressive people. I walked the alleyways, shopping districts, and neighborhoods. Being that the war had only recently ended, every family was now trying to live life to the fullest. Red wine was flowing freely on everyone's dinner table, and entire families were gathering outdoors in their gardens for supper every single evening. They started eating in the late afternoon and were still sitting with a bottle of Frascati long after the sun went down.

On one warm but breezy evening, I found myself strolling along in a nice neighborhood when I came upon a big, boisterous family having dinner in their garden. They were drinking, laughing, and breaking bread over bowl after bowl of pasta. There were old people, mothers and fathers, and little bambinos running around

the table and in front of the house. My heart sunk just a little bit
as I stopped to watch the colorful scene. I instantly thought of the
Shabbos dinners at Bubbie's house with my family. I didn't realize
I was staring, but one of the men looked back at me and stood up.
His napkin was still tucked into his shirt and half a glass of red wine
was in his right hand. He put his wine on the table and started
waving his hand in a very Italian manner. His palm was facing me
and he was waving as he spoke. Now his whole family was looking
at me. I started to slowly back away until I was across the street.
Where I came from, when somebody waved at you like this, he was
telling you to go away. I turned to leave and the man started after
me. I quickened my pace. I was almost running at this point. But he
followed me, yelling, "*Venaccà! Venaccà!*" With his dialect I didn't yet
fully understand what the man was yelling. He was saying, "Come
here! Come here!" But to me, his gesture was saying, "Go away!
Go away!"

"Where are you running?" the man called out to me. "*Venaccà!*"
Eventually, a block away, I realized the man wasn't mad at me; he
was trying to tell me something. So, cautiously, I stopped and let him
catch up. We were both a little short of breath from the excitement
and now I could see that he was friendly. He walked right up to
me, smiled, and put his arm around my shoulder. In Italian, he said,
"Come with me, come on, why are you running away?" I tried to
explain in my fledgling Italian that I thought he was trying to chase
me away, but I don't think he understood. The man shrugged his
shoulders then ushered me back to his house. "You come with me,"
he said. He took me right to the dinner table in the garden and
made shooing motions to his family. They parted like the Red Sea

and I was plopped down right between the mother and the father—matriarch and patriarch. This was the seat of honor in every Italian family. I felt a bit embarrassed at the attention. Out of nowhere, with lightning speed, like a magic trick, came forks, a knife, a big spoon, a glass of wine, a napkin, and a heaping plate of spaghetti. Then somebody shoved a big, warm piece of bread at me. Almost like a chorus they shouted, "*Si! Mangia!*" This I understood very well. I picked up my fork and swirled a gigantic ball of spaghetti on the end of it. I took my first bite and moaned in delight. This must have been the perfect thing to do because the Momma clapped her hands together and smiled with pride at her daughter. Then everybody went back to eating and carrying on at this wonderful table lit by the moon and a dozen candles in the middle of the garden.

Whenever I hear the expression *viva Italiano!* I think of how wonderful the Italians were to me. I can't say that I was happy in those days in Rome after the Holocaust, but living among these people provided an incalculable amount of spiritual comfort.

I was in Rome for a couple of months before I discovered the United Nations Relief and Rehabilitation Administration (UNRRA). I didn't fully realize that there were tens of thousands of Jewish DPs in Italy and that the UN had a facility nearby to help people make contacts with lost relatives and friends not only in Europe but all over the world. I returned time and time again to look for information about my own family members but came away disappointed. I checked the UNRRA registry for Shmulek Bachrach, but again, no luck. With the help of a few people I met from UNRRA, though, I was able to establish communication with

my Aunt Frieda—my mother's sister—whom I knew lived in New York. My aunt responded quickly by sending me a hundred dollars. Given the depressed and collapsed state of the Italian economy, this was a lot of money. In subsequent letters, I told my aunt of the tragic fate of my family and that I was alone in the world. I made up my mind that I wanted to move to New York. Aunt Frieda was my only connection to the past. She wrote back to me immediately saying that not only would she love for me to come be with her but that she would work on bringing me to New York. "Don't worry about anything," she wrote. "There's a place for you with me."

With the help of some Italian and U.S. state officials, I filled out the paperwork for a visa. I was told that this process might take a long time, so until then I would hang around Rome with my new friends.

With the Onofre home as my base throughout the summer, and making friends among a small group of DPs from the UNRRA organization, I learned that there was a strong and active camp close by at the site of Cinecittá, a former movie studio compound founded by Mussolini in the late 1930s. The name literally means "cinema city." During the war, when the Germans occupied Italy, they looted and destroyed Cinecittá with all of its equipment and novelties used in the motion picture business. The movie industry was forced to move to temporary facilities in Venice. Now that the war was over, Cinecittá was taken over by the occupying Allied forces and converted into a displaced persons camp. I was immediately given a home in Cinecittá and moved into a makeshift apartment right away. There was no reason to continue to impose on the Onofre family and wear out my welcome. Housing and

meals in this DP camp were free, and I enjoyed a private bedroom. Mingling with thousands of other Holocaust survivors, I began to make friends, a few who were fellow survivors of Mauthausen.

It was in Cinecittá that Dr. Yakobovich found me. He was working at a nearby hospital where many of the DPs were being treated for maladies that required medical attention after years of neglect. And so, I too became a patient. Dr. Yakobovich now was able to take a look at my injured arm in a proper medical environment. Still sincere, soft-spoken, and likable, the doctor scheduled me for surgery. In a procedure that took several hours, Dr. Yakobovich surgically straightened my damaged right arm then sent me off to a British sanitarium called Villa Sansoni, on Via Cassia, to recuperate. I spent the next several months there until my arm had healed from the delicate surgery. For the first time since I was shot while escaping the labor camp at Koldichevo, I was able to fully straighten my arm. Before leaving Villa Sansoni, I once again bade farewell to Dr. Yakobovich and returned to Cinecittá.

I came to realize that Cinecittá's Jewish organization was one of the best-organized DP groups in Europe, under the auspices of UNRRA. Care packages came from America filled with sardines, chocolate, soap, and all kinds of other supplies—from shaving kits to clothing. The main purpose of our organization was to inventory and process these goods and to distribute them fairly to all the refugees in the camp as soon as possible. In those days, there was a tremendous black market and we had to make sure that none of the care packages ended up in the wrong hands. When I was elected secretary of our distribution organization for refugees, I took my position quite seriously. I realized how important it was to keep

an eye on our inventory and make sure it made its way to the
people who needed it the most. But there was more to our DP
organization than meeting the day-to-day needs of Jewish refugees
in Rome. We had long-term goals as well. We knew we couldn't
live in Italy forever and that there was no returning to our homes
that no longer existed. So, naturally, a strong Zionist movement
arose among the camp's homeless who were itching to start a new
life without further delay. Night after night, for hours and hours,
we had lively discussions on how to emigrate to Palestine, how
we would live, and what our lives would be like. All of this talk
rekindled a bevy of ideas that I hadn't thought about since I was
a young man listening to Zev Jabotinsky in Maitchet. Most of us
agreed that Palestine was not just a logical solution but the *only*
solution to our lost state of affairs.

Not only the Jews but the entire world, like it or not, would
soon discover that there was no returning to our former homes in
Poland or anywhere else in Eastern Europe. This became painfully
obvious when, only a year after the war ended—as Jews were trying
to reclaim their homes and property—they were met, beaten, and
murdered by local Poles, Ukrainians, and White Russians. The most
notable of these instances happened in Kielce, Poland, where, in July
1946, close to forty Jews—Holocaust survivors—were killed when
they tried to re-establish themselves in their old neighborhoods.
The Kielce massacre proved to all of us that the world of the shtetl
was gone forever. There was no going back. The death of Hitler, the
end of the war, the discovery by the American and Russian troops
of the concentration camps, and the destruction in Europe would
not put an end to the killing of Jews in Poland by their former

neighbors. We did not survive the Holocaust just to return home and be murdered by the same anti-Semites who butchered our families. The remaining Jews of Europe needed somewhere to go.

What place would be safe for us after all that we had been through? So many countries closed their doors to refugees. Other nations were indifferent or obstinate, playing political games and making up quotas on immigration in emergency sessions. How long could the remaining Jews of Europe sit around, day after day, living in tents and abandoned concentration camps waiting for some government or the military to find us a new, safe home?

Even with a few family members living in America, I could do nothing but sit and wait for my emigration papers to be processed, while news of Jewish persecution made all of us survivors uneasy. Anti-Semitism, Nazism, and barbarism continued to be a very real threat. The war may have been declared over, but the hate continued to flourish. There were even Nazis in Rome at this time. There were former SS officers and German officials trying to hide from their crimes by blending in with the population. Polish, Ukrainian, Lithuanian, Hungarian, Romanian, and Yugoslavian murderers hid among Holocaust survivors, receiving welfare and medical care and hoping to emigrate to America along with the rest of us. Once in a while, one of these persons would be discovered or recognized by a concentration camp survivor then taken away by military police for questioning. Most were just set free on the other side of town.

One of the pastimes—maybe you could even call it an obsession— of the DPs was to go to bulletin boards and check the notices. We used to stand for hours pouring over thousands of notes. Husbands looked for wives, children for parents, brothers for sisters, aunts for

nephews, mothers for daughters. We read the boards for friends, neighbors, and any recognizable name or place. We searched in vain even for what we knew was lost. There were so many names, you couldn't possibly read them all. They were in all different handwritings and languages—Russian, Yiddish, Hebrew, Hungarian, Polish, German, Italian. We returned to the messages day after day, month after month, looking for a link to our past. To search the notice board, I frequented a Jewish-owned, popular café off the main street, Via Nazionale. People came to the establishment from all over to meet friends over a cup of coffee or a dish of ice cream. But most of us came to search.

One Saturday afternoon I walked to the café and ordered an espresso. As I waited for my order, I started scanning the pages hanging up on the wall. There were so many familiar names—Shmulek, Motel, Yossel, Esther, Itzhak, Abraham, Faigel, Rifka, Chaim, Sarah, Jakov, Leb—but no one I knew.

I picked up my espresso and sipped it while still standing at the wall. I slowly moved along, studying the letters from floor to ceiling. There were others around me doing the same thing. I must have been completely lost in thought because I didn't take notice of a young woman beside me in the café. The restaurant was busy and noisy with people always coming and going. By now, I was accustomed to the clatter of different voices in different accents and languages filling the air. There were so many conversations that they all just blended into one vibrant hum. Then I heard a voice speaking in German. I took little notice and just kept reading the notes. Then the voice became a little more insistent. I felt a small

but firm hand on my shoulder gently turning me around. There was a pretty, well-dressed woman speaking to me in German.

With a warm, glowing face, she asked, "Do you remember me?"

I didn't know who she was. Why would I know a German? I stared at her blankly, but she pressed me, "You don't remember me?"

"No, I don't know who you are," I answered. I thought maybe the young woman had me mixed up with somebody else. Maybe she was hoping I was somebody else.

"Remember the train station?" she said. Train station?

Her face was kind and sweet and her blue eyes were searching mine, trying to help me remember her. I was at a loss.

"The train station," she repeated. "Remember the train station with me, my daughter, and my mother?"

That's when I remembered.

The lady said, "I've been coming here for an entire year looking for you. I've been here every day hoping you would come through the door. I would never give up looking for you."

At last there must have been a sign of recognition in my eyes, because a broad smile came to the young woman's face and her eyes began to tear. "You saved our lives. I've been looking for you. I've been trying to find you to thank you for what you did." Then she hugged me as if I were her own son. When she released me, she looked me over and seemed pleased that I was getting along.

"Please," she said, "you must come to dinner with us."

She invited me to her house to reunite with her mother and daughter. It was a bit awkward for me, but I felt I needed to do this for her, and I accepted. The next week I found myself sitting with these three women, a guest of the wife, daughter, and mother of

an SS officer. They couldn't do enough for me, feeding me ham, cheese, bread, and vodka. They wouldn't let my plate go empty. For dessert they put an assortment of homemade baked dishes in front of me. We talked and drank for hours. To this day I think to myself, what kind of crazy world can this be where such a thing can happen? I was both a rescuer and a victim, sharing an evening with these strangers who once represented the worst of my nightmares.

When the evening ended, I was invited over again.

"We must see you again," said the lady. Her daughter and mother grasped my hands and pleaded with me to come back. "Please."

I accepted and returned a couple of weeks later. The three women were just as excited and accommodating on that visit as my first. They never stopped talking. At one point the woman said to me, "My God, here I am, a wife of an SS concentration camp officer—and a Jew saved my life." She couldn't get over it. She shook her head, put her hands over her face, and wept. She was so overcome with a mixture of guilt, shame, happiness, and gratitude that her mother had to console her. I found this impossible to understand myself. But eventually our conversation ran its course and we amicably parted ways. That evening was the last time I saw her and her mother and daughter, and a brief chapter of both of our lives came to an end.

Although this story seems a bit strange, it really isn't in context. I cannot begin to describe the state of affairs in Italy at this time. The country, like most others in Europe, was in a state of extreme flux. Homeless people were wandering the cities, occupying military forces were patrolling the neighborhoods, bureaucracy was worse than ever, refugees from all sides of the war were looking for

government assistance, schools had been turned into offices and boarding houses, communists re-emerged on the political scene, the military was always shipping out its soldiers, streets were clogged with people and trucks carrying supplies, political parties were rising up to represent all extremes, money was scarce, black marketers were prospering, and we, the Holocaust survivors, were getting restless. We all wanted to move ahead with our lives. We weren't drifters and we needed desperately to settle down.

I was anxious about the progress on my visa to America, but every time I checked with the consulate I got the runaround. "It's in process!" I was told. "Move out of the way; there's somebody else in line." Sometimes you had to wait in line for hours just to ask a question. Tempers were wearing thin on both sides of the desk, but it seemed that nobody was getting what they wanted.

For the time being, I wasn't going anywhere. Aunt Frieda in America would have to wait; I wrote to her and said I couldn't get my visa. There was no getting past the red tape. Rome has always been a busy city, so at least I was never in want of something to do and people to be with. Every Italian I met seemed to have a sister or a cousin to introduce me to. In this respect, I was very busy. I started seeing one girl in particular, Maria DiTota, a beautiful blonde beauty queen. The only problem was that she lived about eight miles away and I had to be resourceful to get to her house. Petrol was at a premium and nobody I knew had a car. Even the off-duty American servicemen had to get around on foot. But I was determined to visit Maria and eight miles wasn't really that far. Besides, what else did I have to do with my time?

I found a bicycle and decided I would make a day of it. It would take me quite a while to ride to Maria's house, given the poor state of the roads and the hilly terrain. I called her on the telephone and told her I was coming, but Maria warned me to cancel my plans. She said she wanted to see me as much as I wanted to see her, but there was a big *sciopero*—a strike—by communist workers and I shouldn't be on the road.

"Nobody should be on the roads," Maria told me. "The police put up roadblocks everywhere. You'll get yourself killed. Stay where you are; we'll see each other next week."

The Italian police were trying to avoid a clash between the communists and their opposition. These were volatile times and people had strong feelings about politics after the war. Strikes usually culminated in violent outbursts. Just before I was to head out for her house, Maria warned me again that it wasn't safe to be riding into the communist stronghold all by myself, let alone on a bicycle and during a curfew.

"Maybe come here next week," Maria repeated.

"Next week? No. Today," I said. I was very confident. The war had removed my fear of anything trivial. And to me this was no big deal. "Let them kill me," I said, "but I'm coming to your house to see you." What could anyone do to me at this point in my life?

I didn't give the threat a further thought and hopped on my borrowed bicycle. For the first couple of miles everything was fine, like any other day, some hills, some weeds, bumps in the road, and a Cyprus tree here and there. The sky was a bit cloudy and a late afternoon breeze cooled me off as I rode along. The bicycle rattled and clanged as my tires bounced over rocks and into little pits, but

not a soul was on the road. The curfew actually made the ride easy. Over the next couple of miles, I rolled through two villages of farmhouses and little cottages and wide-open spaces. At the second village, I stopped and found a telephone and placed a call. Maria answered and I told her I was on my way to visit her. She was excited—not because I was four miles closer but because it was too dangerous.

"Have you gone crazy?" she said, "Don't you listen to the news on the radio? The communists have guns and knives and are going to start a riot," she told me. "Michele,"—my Italian friends called me Michele—"don't come. Turn around and go back. Do you hear me, Michele? The police said the communists are beating people up and killing them. I'll see you next weekend."

I laughed, told Maria not to worry, and then said I was on my way. She didn't want to hear another word from me on this matter.

"Ciao, Michele. Next week."

I jumped back on my bicycle and started peddling. Being a big smoker in the postwar years, a half a mile later I started to crave a cigarette and reached into my pocket with one hand holding tight to the handlebar. I was now going downhill at a fast speed when a pile of rocks rose up to meet me. Quickly steering the bike around the obstacle, I ran off the road and almost took a nasty spill. If the communists didn't kill me, the road might. I switched hands and checked my other pocket. No cigarettes. Where were my cigarettes? It occurred to me that I smoked my last one before I ever got on the bike. I was all out, so I decided to stop at the next place I came to. Maybe there was a store nearby where I could buy a pack. My

trip to Maria's was slower going than I predicted. The terrain was now going uphill and peddling was exhausting. Also, I took a slight detour, knowing that there would be a police barricade up ahead in keeping with the curfew. It was now just before dusk as I wheeled around a bend and spotted an inn in the distance. As I got closer I could hear quite a commotion coming from inside. I pulled up to the building and brought my bicycle around the side near some bushes and hid it there before entering the bar. When I opened the door, the place was packed with big, tough laborers. The drinks never stopped flowing, and half of the patrons were drunk off their feet. They didn't even notice me walk in. But the other half did. None of them stopped singing their Russian songs even as they stared at me. Russian singing? In the middle of Italy? That's when it dawned on me: I had walked right into a bar full of communists— striking laborers singing songs that I hadn't heard since long before the war. I listened intently as they got more and more riled up. I stood by the door and stared at the men and listened to the words. Their pronunciation was pretty good. They probably learned these songs as POWs in Russia during the war.

That's when a burly man stood up and took notice of me. "Oh! You like communist songs?" he asked me.

His large fists were holding two glasses of vodka and he was yelling to me from across the room. These were the characters Maria warned me about. This was the group that the police were looking for and telling people to steer clear of—communist agitators looking for a fight.

I couldn't pass up a good Russian song; it had been years since I had last heard one. I walked across the room to where the men

were singing and drinking, put my hands on their shoulders, and climbed up onto a table. It got quiet for a second. I was the center of attention, dressed in a suit and tie and standing in shiny black dress shoes. You could hear a pin drop as all eyes looked me up and down. Then somebody shoved a glass into my hand and another guy poured vodka into it until it ran over the sides. I took a swig of the drink, wiped my mouth with my sleeve, and started singing in Russian. The place went wild. Everybody began to clap with the music. They were overjoyed and wouldn't let me go. They sang with me one song after another. I even taught them some songs they had never heard before. They thought I was the second Stalin. One song led to another, and all the while my vodka glass was kept full to the brim. In no time, especially since I hadn't had anything to eat since breakfast, I was so drunk I could hardly see straight. The walls were spinning and the scores of faces around me were melding into a collage of scraggly black beards, drenched mustaches, red eyeballs, sweaty bandanas, and shiny noses. They lifted me up on their shoulders and paraded me around the room as we sang at the top of our lungs.

I had a ball; all the singing and drinking brought back wonderful memories, in a language that filled me with warmth. I was treated like a best friend as they toasted me and coaxed me on to sing and drink "just one more for the road." This went on for four or five more rounds. At last, somehow, I pulled myself away. I was given a pack of cigarettes then showed the door to a standing ovation. I don't even know how I was able to stand up when I walked out; I was so drunk. To the waving and cheering of a hundred drunken communists, I started to walk away from the bar then remembered I

had hidden the bicycle in the bushes. It took me a while, on wobbly legs, to pull it free from the branches. I held onto the handlebars and wondered why the bike wouldn't stay still and why the trees were bending and the building was spinning around. With great concentration, I climbed back on the bike and rode sideways all the way to Maria's house.

Nowhere but Palestine

Still waiting in Rome for my visa to clear so I could leave for America, I heard that there was a big displaced persons camp in Turino, up north. I decided to catch a train and pay a visit. Like Rome, Turino was bursting with refugees, and one of the biggest DP camps was called Grugliasco. It was situated near the Alps and along train tracks that brought survivors into Italy mainly from Western Europe.

Having been in Italy for two years, the DPs were quite restless. Although Jewish organizations were well established in the DP camps, with schools, a synagogue, entertainment, and vocational training, nobody seemed to have an answer as to what would come next. Or when they would be allowed to get on with their lives, settle down somewhere, start a family, and pick up the pieces. Where would all of these people go and how would they get there? All the countries had quotas; they weren't accepting more than a certain allotment of refugees. But above all, the Zionists among us realized that, after being through the hell of the Holocaust, we Jews needed a place of security. The world had proven to us over and over again that we were, at best, guests in a foreign world. With or without the

consent of the rest of the world, the Zionists were making plans to create a Jewish homeland to accept Europe's scattered refugees.

It was in Turino that I first met up with the Jewish Brigade, a division of the British army out of Palestine. To see Jewish fighting men in uniform was inspiring to us Holocaust survivors in a way that nobody else can fully appreciate. The Jewish Brigade, made up of trained, armed, healthy soldiers, was empowering. Now that the war had ended, and the Brigade had seen action fighting the Germans in northern Italy, the division's focus had changed. The Brigade took on the monumental task of catering to the needs of displaced persons, including setting up a few DP camps and then bringing to Palestine all who wanted to go to form a Jewish state from the remnants of the Holocaust. To accomplish this, they were given the covert task of locating military equipment, weapons, and vehicles throughout Europe and finding a way to smuggle these things into Palestine under the noses of the British occupying forces. The time for this mission could never have been riper. Displaced persons—Holocaust survivors from the death camps—were largely being ignored by world politics although they needed to begin anew. No productive life could be found for us where we came from in Eastern Europe, so our Zionist dreams were being fashioned into reality out of desperation and the most basic psychological needs of a deeply traumatized people. The Jewish Brigade was our new source of strength in finding dignity, purpose, and peace. I decided to do whatever was needed of me to bring my people home.

Within days of my stay in Turino, I made friends with a few of the Brigade officers. I told them that I wanted to be part of their movement to create a Jewish state. I was willing to do whatever it

took to help; and I was not alone. I was told that the British did not want any more Jews to enter Palestine and that they were continuing to refuse entry in through the ports. The British had promised us settlement prior to the war, with the Balfour Declaration, then shut off immigration with their 1939 White Paper. Then, after the war, they continued to stall. They were virtually without compassion for the hundreds of thousands of concentration camp survivors who needed a safe place to start a new life. Any rational, intelligent person who could see how people were living in postwar Europe would understand that life could not continue this way. The Jewish Brigade, Zionist organizations, and even politically neutral Jews joined a massive exodus movement.

Now I, along with thousands of others, was brought up on the prayers and pledge of "Next year in Jerusalem." It was our obligation to return to Eretz Yisroel. Finally, but under the worst conditions, the remnants of Europe's Jews were the people to make this two-thousand-year-old promise come to realization. We wanted this not for ourselves but for the future generations; our lives were already lost, our families taken from us forever. All we had to live for was the future and we had no fear of death to make this happen. We wanted the Zionist dream to come true to honor the memories of our mothers and fathers, our sisters and brothers, and families and friends who were murdered for no other reason than the fact that they were Jews. Palestine would be our gift to the world of our children and grandchildren yet to be born. We understood very well that the world was proving unwilling to give Jews refuge, as each nation, one by one, turned us away or limited our entry.

I was then reminded of the words of the Zionist Zev Jabotinsky when I saw him speak in Baranowicze in my former life: "You will not build Israel with money but with blood." This was all we refugees had to give; and we would give it freely, to the last man, woman, and child.

I began meeting with the Jewish Brigade regularly. My knowledge of so many languages, they told me, was useful. I was friendly with the Italians, I could communicate with the Brigade in Hebrew, and I could organize people who spoke Polish, Yiddish, and Russian.

The officers told me that there was a lot of ammunition in Italy, especially in Rome. It was leftover from the war. The Allies had weapons, bullets, guns, rifles, and explosives all over the place—in Germany, Austria, Russia, Poland, and France as well. Too costly to recover, this materiel was just sitting idle.

"We need this ammunition," one of the officers said to me. "Find out how we can get hold of it."

Now I had my mission. I headed back to Rome in search of abandoned military supplies, thinking that the best way to find what I was looking for was to make contact with somebody "in the know." Who did I know who knew influential people? There was only one person I could think of—one of the most popular people in Rome. As soon as I stepped off the train, the first thing I did was pay a visit to a friend, the son of a wonderful and wildly successful bakery owner named Mosca.

Mosca owned one of the biggest bakeries around. Everybody knew who he was. He was a well-to-do man whose three sons worked closely with him in the family business. Starting at close

to three in the morning and finishing late in the day, the Moscas worked in a frenzy to meet the needs of their customers by loading up their drivers so they could head out on their routes.

The Mosca's youngest son, Mario, was a close friend of mine; we used to run around together in Rome, chasing girls and finding things to do at night. Mario was a good-looking young man in his twenties who was always dressed to impress. He wore tailored jackets, freshly pressed white shirts, and shiny, soft leather shoes. His jet black hair was combed straight back and he walked with a bounce, as if he didn't have a trouble in the world.

With their colossal bakery enterprise, Mario and his family supplied food stores, cafés, and small shops all over Rome. There were trucks coming and going all day long—in for loading and out for delivery. The Moscas had big contracts with an array of government agencies, one of which was the Reparto Celere ("quick-action unit") police of Rome. If the upper echelon of the Reparto Celere had known about what I'm about to tell you, they would have thrown somebody in jail without a doubt. But fate was on my side, and all is now history.

The Reparto Celere had their hands full responding to communist uprisings and labor strikes and trying to quell riots before they got out of hand. At this time in the late 1940s, the fear of the spread of Communism was at the forefront of every government rebounding from the war. A little protest here or there would break out like a fire; then the Reparto Celere came rushing to the scene to break it up. This police unit was quick, mobile, and very well supplied.

Mr. Mosca was a favorite with the Reparto Celere because he allowed the police to use his gigantic ovens to bake potatoes for their troops. After baking thousands of loaves of bread and countless rolls, Mr. Mosca would truck them out to his customers then get to work for the Reparto Celere. Day after day, the police drove their trucks full of potatoes up to the docks of the Mosca bakery. As police drivers sat parked outside the bakery, Mr. Mosca, Mario, and his brothers loaded a ton of potatoes into the ovens on tremendous metal trays, baked them for an hour or so, and then put them back onto the trucks for distribution to the Reparto Celere all over Rome, hot and ready for the mess halls. You can just imagine how popular the Mosca family was with Rome's special police. He not only baked their potatoes but also happily gave them bread and other baked goods to take home to their families. Mr. Mosca was the bread angel; the wives of the police were the envy of all their neighbors. I knew that the Mosca family, with such a close relationship with all the police drivers, was our best link to the Jewish Brigade's success. As the potatoes baked, day after day, the police would stand around chatting by the hot ovens. All the while, covered with a dusty layer of flour from his feet to his eyebrows, Mr. Mosca ran around his bakery kneading, mixing, blending, cleaning, clanging, and shouting out orders. He was a ball of energy. "You hungry?" he'd ask the police. "Here." He'd shove a tray of fresh, hot rolls in front of them with a pan of olive oil over strong garlic. "*Mangia!*" He'd tell them. "*Di mangiare bene e' una cosa sacra*"—to eat well is a sacred thing. No wonder he had so many friends.

In ovens so big you could drive a car into them, the Moscas held the secret to happiness, and their generosity knew no bounds.

But when you do so many favors, people feel they owe you. And Mario Mosca wasn't afraid to call in a few of these favors.

On a Friday morning, after the police had gone, I came into the Mosca bakery for a talk with Mario. There was a lull in the morning rush, and I brought him a pack of cigarettes. As usual, we were happy to see each other.

"Michele, what are you doing tonight?" Mario asked me. "I can borrow a car and we can go drive around town—maybe to see a movie. Maybe we can get some girls to come along. What do you say?"

"Sure," I told him. I thought that this would be a good time to see what Mario Mosca could do for the plight of the Holocaust Jews. Little did he know what I was about to ask him.

In the early evening, I met Mario in front of a café. He shrugged his shoulders and smiled apologetically. "I couldn't get a car," he said. "Walking is good for us, don't you think?" As we began to walk, he told me, "One day I'm going to have my own car. A black beauty—shiny for the nighttime. Girls love a sports car. Then we'll have a great time. You'll see, Michele." So we walked a few blocks to a movie theater, watched a picture, then found a nearby restaurant where we sat watching people come and go along the busy street. While Mario was shoving forkfuls of pasta into his mouth, washed down by a glass of red wine, I took the opportunity to make my proposal. I asked him if he would be willing to talk to the Reparto Celere and ask them if they had any ammunition leftover by the Allies after the war. Mario wiped his mouth then stared at me for a moment. I could see the wheels spinning in his head. He squinted at me and jutted out his chin.

"Ammunition?" he repeated.

"Just make conversation," I told him. "See what you can see."

"What are you going to do with ammunition—rob a bank?"

"There's Allied equipment lying around Rome," I said. "The Jewish Brigade would like to make a deal. Don't tell them this at first," I said. "Find out if we have anything to talk about."

Mario's expression was controlled, but I could see that he was interested. I don't know how he felt about the plight of the Jews, but I knew he loved money. He said, "I'll see what's going on."

A week went by and I walked into the Mosca bakery. Mario told me that I was right. There was a lot of ammunition sitting around Rome—bullets, TNT, explosive devices, hand grenades, detonators, rifles, and guns. "The police say there's more than they know what to do with," Mario said. "So, now what?"

I was ready with the answer. "Make some arrangements." Another day went by. Mario did some more talking. I came back at around noon and brought Mario a pack of cigarettes. He took one out, lit it, and jumped up on a table, sending a small cloud of flour into the air. "Well," he said, "they're interested in talking to your Jewish Brigade."

"Good," I said. "Let's do it." I made the arrangements for the meeting, and the very next morning I found myself sitting in a chair in the middle of Rome's Piazza Etcetera.

It was late morning and the sun was casting short shadows on the cobble-stoned plaza. There were a number of people milling about and I strained my eyes looking for the representatives of the Jewish Brigade. I didn't know what they looked like or from which direction they were coming. There was not much more I

could do but sit and wait. A half hour went by and then an hour. A grandmother and small boy were across the way, feeding pigeons crumbs of bread until at last they had no more to give. The child ran at the birds and sent them flying. Then he ran off giggling and his grandmother slowly shuffled after him.

Here and there somebody would stroll along then disappear into a doorway. I was told by my contacts in the Brigade to just be patient and stay put, so I remained in my seat and scanned the whole area as more and more people poured into the plaza. I thought of getting a cup of coffee but worried that my contacts might miss me. I rubbed my arm out of habit, feeling the spot where I had been shot a few years earlier. A reminder of why I was here raced through my head. Several more minutes passed by and a policeman sauntered into the plaza. He stopped to talk to a group of young ladies seated several feet away then glanced over at me and winked. I smiled and he tipped his hat to the girls, turned on his heels, and walked off whistling.

What was once a cool morning was now turning into a warm day. I stood up, took off my jacket, and folded it over the back of my chair. When I turned around, standing in front of me was a man of medium height and build with a pencil-thin mustache and a serious, dark complexion. He asked me my name and I told him. Then he walked off. I sat down and rested my good arm on the table in front of me. I checked my watch. Two minutes slowly passed.

Then I noticed a smartly dressed man and woman walking toward me. The man was carrying a suitcase, and the woman cautiously glanced in all directions as they approached me. Introductions were short and I doubt that they used their real names. When the man

reached out to shake my hand, the sleeve of his jacket hiked up to reveal a serial number tattooed on his forearm. We waited for the woman to sit; then we got down to business.

"Is everything arranged?" the man asked me. I nodded.

"Good," he said.

We stared into each other's eyes in a moment of anxious silence and then, with his foot, the man pushed the suitcase to me under the table. I felt it bump up against my leg. Without another word, they both arose to their feet, turned around, and quickly walked away. Nobody smiled. They did their job and now it was my turn.

I kept my leg against the suitcase and stood up to put my jacket on. Then I picked up the suitcase by the handle. It was much heavier than I imagined. Inside there was enough money to fund a war. Literally. I found the shortest route out of the piazza and walked at a steady pace along the streets of Rome. These were familiar streets but now they looked so much different. The buildings were ominous. I found my head swimming with thoughts, stirring up emotions and words planted long ago. I heard my grandfather uttering the words Eretz Yisroel and my fellow inmates in Mauthausen praying to God on their way to the ovens. I saw the face of Zeb Jabotinsky as he pleaded for a Jewish state to a small crowd in my hometown of Maitchet—a state paid for not with money, but with blood. Zayde spoke to me, reminding me that the exodus out of Egypt did not mean freedom but the beginning of a long journey fraught with danger. I had taken that journey and emerged without my family. And now I was on a new journey.

With only a few blocks to go, the aroma of the Mosca bakery wafted through the air, somehow reawakening feelings from the

darkness of my soul. My mouth watered. My stomach growled as it did when I was scavenging for food in the forest with Shmulek Bachrach and as it did when I lay starving in my cold bunk in Mauthausen while listening to weak, desperate prayers to God coming from a man dying on the floor.

And then I paused and stared at the back door to the Mosca bakery. My shirt was soaked with perspiration and my arm was fatigued and aching. I stood alone, realizing that I was now part of a great mission of worldwide proportions—historical proportions. It's hard to explain exactly what I mean when I say this, but here I was, a Holocaust survivor who only a few years ago sat in my grandfather's house listening to him recount ancient dreams of setting foot in the Promised Land. For thousands of years, Jews had kept this dream alive. And now these survivors would make this dream a reality. Survivors like me.

I had survived to witness hundreds of thousands of Jewish refugees wandering without purpose and turned away at every door. Rejected; discarded; cast off. But things were about to change.

I became a link between my struggling people and the forging of a new nation in Palestine. My Zayde stood with me as I stood staring at the open door to Mosca's bakery. This moment was a dream come true. Not just my dream but the dream of millions who had come and gone over the centuries. I was given, in my hands, the opportunity to build a homeland from the ashes of the concentration camps. I was filled with more pride than I can describe.

I left the busy streets of Rome, with its patrol cars, military personnel, and refugees, and stepped inside Mosca's bakery. It took

a few moments for my eyes to adjust from the bright sunlight as I made my way to Mario Mosca, who was kneading dough on a long, old wooden table against the far wall. He looked over at me and greeted me like he hadn't seen me for years. He patted me on the back and left a big white handprint on my jacket. Then he picked up the suitcase and exclaimed, "My God! This weighs a ton! Did you count it?"

I shook my head. I can't imagine how much money was entrusted to my care; I never looked inside to see. When I tell this story, people still ask me whether I was ever tempted to take a peek to see how much I was carrying. I tell them that money meant nothing to me. I had lost everything. I had seen whole villages of people murdered for greed, hate, and money. I had seen how money, in the end, could not save a single life from the ovens.

I was glad to hand over the suitcase—glad to be rid of it.

The wheels turned quickly and, within days, the Reparto Celere potato trucks arrived at the Mosca bakery as usual. But there were no potatoes inside. This time a fleet of six trucks came to Mario Mosca loaded to capacity with arms. Then, within minutes, another fleet of trucks arrived at Mosca's bakery. These trucks were driven by members of the Jewish Brigade who pulled up to the loading dock. They jumped out of their vehicles then back into the Reparto Celere trucks. The police drove off to pick up potatoes, business as usual, while, in the other direction, the Brigade drivers disappeared without suspicion.

When I saw Mario the next week, I was sitting at a café having an espresso. I heard the sound of a car horn honking and looked up to see him waving from a brand-new Fiat. There were two pretty

girls in the car and he was yelling to me, "Hey, Michele! You like my new car? Hop in, let's go for a ride." Within a week, military supplies from all over Italy—and beyond—were pouring into Anzio to be taken to Cyprus. In Cyprus, materiel was transferred to other ships headed for Palestine. This was the beginning of a long supply line coming into the Jewish homeland right beneath the noses of the British occupation forces. Thousands of trucks bearing weapons from the stockpiles of Europe formed the groundbreaking of Eretz Yisroel. And the wheels of motion were greased by a well-loved son of an Italian baker and a one-time Yeshiva bocher with plenty of time on his hands.

A War We Would Not Lose

The arms and supplies were now pouring into Palestine, thanks to an underground army of dedicated Holocaust refugees. We were committed to the idea that we would no longer allow the world to determine the fate of the Jewish people. No more stalling; no more political games. This last war had sobered us to certain realities. The Holocaust, if nothing else, taught us that we could never again allow others to define for us who we are. The Jewish people would at long last create an image built on strength, resolve, respect, and self-determination. For as long as we stayed in Europe, living in DP camps, refused entrance to nations all over the world, and living without dignity, we would remain Hitler's victims. We were tired of being victims and survivors. We wanted to be creators and contributors, fathers and mothers.

I was now a part of the Jewish Brigade's unprecedented Brikah program, whose mission was to move Jewish refugees into Palestine, to give them a home and allow them to build their lives. We were resolved to move out of our makeshift tents, barracks, and compounds under military guard. We were tired of knocking on the doors of countries that refused to accept us. We were tired

of being told there was no room for "our kind." We were tired of the British, who were occupying Palestine, telling us to be patient as they stalled. And we had more than just willpower on our side. There was also legal precedent.

In 1917, statesman and Zionist world leader Chaim Weizmann persuaded the British government to issue the Balfour Declaration to establish a Jewish national home in Palestine. The declaration was, in part, payment to the Jews for supporting the British against the Turks during World War I. After the war, the League of Nations ratified the declaration and in 1922 appointed Britain to rule in Palestine. They promised to create a Jewish state, but when World War II broke out, the British were afraid to upset the Arab nations that were already on the side of the Nazis and aiding Hitler's war effort. The British needed to hold onto whatever Arab relations they had to ensure a free flow of oil for their own war machine. The politics of World War II, once again, was deciding the fate of Jewish lives.

Now that the war was over and the Arab states had lost their ties with Nazi Germany, it was time for the British to make good on their promise. Hundreds of thousands of people were living in cities and sites of former concentration camps as well as in DP camps, waiting for some resolution by some government or world court to decide where they should go. The sites of some of the worst Nazi atrocities, like Bergen-Belsen, were still serving as the living quarters for victims of the Holocaust. The concentration camps were liberated but the Jews inside were forced to stay there under a new army's strict control. We were a people in limbo. Tortured

minds and bodies were subjected to a prolonged incarceration out of nothing more than a political agenda.

With the Jewish Brigade and growing military forces inside Palestine, we were taking matters into our own hands and getting our people out of this depressing, miserable predicament. All able-bodied men and women were called into action, including me.

I escorted ships out of Italy carrying supplies and people to Cyprus, a small island nation in the Mediterranean about fifty miles south of the Turkish coast that served as a detention center for refugees trying to get into Palestine. People on Cyprus were living in squalid, decrepit conditions. The world was willing to forget the refugee plight, but we were not. This was only the first step. We would not stop at Cyprus. We would not give up until we found a place for all of our people in Palestine. The British actively turned our ships away, but we kept coming, bringing more than two hundred refugees to Palestine. More than fifty thousand Jews had been refused entry and redirected to Cyprus where Holocaust survivors spent boring, endless days in tent cities without running water, electricity, or cooking facilities under the scorching sun.

In 1948, three years after the liberation of Mauthausen concentration camp, I took a small boat from Cyprus to Palestine. Although I crossed the Mediterranean several times to Palestine, I had never disembarked. I had never actually set foot in Eretz Yisroel. Now I wanted to go ashore. I was ready—or at least I thought I was.

Along with five hundred other Jewish refugees, our boat was rocking in the waters off of Palestine when we spotted land. A gasp could be heard on the ship, a collective sigh. Then there was silence. It was as if we were all, as a group, suddenly struck for words. We

were all staring at the most magnificent sight: a dream, gazing at the land once found only in our prayers. We few survivors, who had once stood beside frozen bodies, shivering and falling from starvation, and cruelty in the concentration camps—we few devoid of hope or help, now stood shoulder-to-shoulder, warmed by the sun, staring at a dream.

And yet, who was I to share this joy with? Zayde's voice was in my head along with images of sharply inked letters in the Torah spelling out the words Eretz Yisroel, the land of Israel. Maybe I uttered these two words, Eretz Yisroel, trying to somehow, maybe impossibly, connect the past and the present. Was this the same Eretz Yisroel of which generations dreamed and spoke in steamy clouds on frigid days in the synagogues and shtiebls of Eastern Europe? It didn't seem real that I could be going ashore, that I could actually embrace this vision. Who was I to deserve such a thing? I was a representative of my entire family and my people, going back generation after generation—all the way back to the exodus out of Egypt—returning home to Eretz Yisroel. I, without a home, had come home. I was about to complete a two-thousand-year-old circle. I was part of the new exodus. With my own two feet, I would touch the land of our hopes. This was the Eretz Yisroel that I thought about as a young man in Poland as I trudged through snow up to my knees to get to the kalte shul. "Zayde," I thought, "Zayde, here I am. I have come to Eretz Yisroel. You would be so proud of me. Zayde," I began to cry without shame, "look at me. I am here by the sands of the Promised Land."

Our ship came closer and the land grew taller and wider, and then someone started singing Hatikvah, choked with tears and

grief. And then another and another joined in until we were one big chorus. Hatikvah. The words stuck in my throat and my own tears melded with the salt of the sea and we were one again.

The singing voices rose into the heavens. Hatikvah. There is no more appropriate song for any nation on earth. Hatikvah means "the hope." Hatikvah was to become the national anthem of Israel. Unlike any other, Hatikvah is not a song of conquest, of kings and queens, of war, or of nationalism. It is a song of hope—the longing of my people.

When our boat pulled into the harbor, I walked onto the land of Israel. It took two thousand years to cross this gangplank. I couldn't believe what I was doing. My head went numb and my knees gave way. I fell to the ground all alone amidst hundreds of refugees and I cried. I could not stop. I could not see through the wall of my tears, and my face sunk lower and lower until, at last, my lips kissed the earth. I kissed this land and all it represented. I kissed Eretz Yisroel for Zayde and Momma and Papa and Elka and Peshia and everyone in my village of Maitchet. My fingers grabbed for grains of dirt to hold. I rubbed the sand on my face. I fulfilled my promise never to forget this land. I had returned. I was an *aliyah* and I was willing to die to make this place, this tiny place on earth, the land of the Jews. I had already paid with one life, and I had one more I was willing to give.

To this day, when I talk to students about my Holocaust experiences, I am always asked what the expression means, "Never again." I didn't invent this phrase that is now associated with the post-Holocaust experience. It means so many different things to different people, but above all, to me, as I realized kissing the ground

of Palestine, it means that never again will we be separated from our roots. Never again will we lose our connection with our land. We who wandered through the centuries as outcasts, victims, and enemies in Europe realized that, by never forgetting our homeland, we would make our own future. We would turn the desert green and fill the soil with lushness. We would not look back into the fire.

Thousands of Holocaust refugees were streaming into Palestine, our only hope on earth. There was nothing we could not accomplish. Kibbutzim had already sprung up all over, with Jewish farmers making life out of desolation in the most literal and metaphorical terms.

With world opinion turning to our side, and the British getting tired of fighting a losing battle, they left Palestine in 1948. Shortly thereafter, the new state of Israel was granted admission into the United Nations. This was the first and only time in history that a nation had to get permission from the rest of the world for admission. When the Soviet Union cast their "yes" vote among the others in the United Nations, Jews were at last offered a public declaration of legitimacy. Following Israel's statehood there was dancing and music in every corner of our new country. But it was not even to last the night.

Soon after the last British ship set sail out of Israel, I traveled to a kibbutz called Negba on the frontier bordering Egypt. Polish Jews who fled Europe founded Negba in 1939. It was a reunion of sorts, because a lot of the residents were members of the Hashomer Hatsair, a Zionist youth movement I remember well from my childhood. By the time I arrived at the kibbutz, it was May 14, 1948,

on the eve of our declared statehood. The War of Independence was about to begin. People were still dancing wildly in the streets of Tel Aviv, but I knew the celebration would be short-lived. Our leaders, as well as survivors like me who had lost their families, did not need to be reminded that we were about to face a fight to the death. Celebrations would quickly give way to preparations for war. I saw the mood of Israel change in a heartbeat. By the time I found myself standing in Negba, every Arab nation surrounding us vowed to destroy us. I was about to enter into the second war of my life. But this time things would be different. Although we were still outnumbered, this time we went in with our eyes wide open. We had already been through the nightmare of having our neighbors try to kill us, but now we had a warning. Most of all, now we were armed, united, and had no fear. What more could the world or any other enemy take from us? Nothing. The Arab world said they would finish the job that Hitler started, and we, remnants of the Holocaust, said, "Never again."

We had nothing to lose. And we would not lose. We could not. To lose meant to be defeated. In broadcasts that reached the bigger cities as well as kibbutzim on the frontier, we listened to General Moshe Dayan tell us that war would break out any minute. David Ben Gurion said that we would be attacked and be tested to our limits. The Arabs would come to massacre us. How can I explain what this meant to us, when just four years prior we faced the same predicament? Another people in another land, coming to murder all the Jews in their path? What would we do this time? What could we learn from our very recent past? Somehow we were imbued with the feeling that here, in our own land, God would be on our

side. We were victims who would not be victims again. We had already faced death and were survivors—an implication that our Arab neighbors knew nothing about.

Our preparations for war began hours after sunset. Trucks and jeeps rolled up to the kibbutz and parents tearfully loaded their children into the vehicles. It was a heart-rending scene, but at least the parents of Negba were sending their children away from the impending war instead of having them torn from their arms by a ruthless enemy. So we sent the children further into the interior of the country. Then we took inventory of our ammunition and arms. Some of us knew how to use weapons, and others did not. But we were all willing and ready to fight. There was no doubt about this. Crash courses were taught on how to fire a rifle, throw a hand grenade, and use a bayonet. We knew that there would be no one to rescue us. Although the Palmach—the new army—was on its way they would not reach us in time. Like most of the other kibbutzim, we were too far to be saved by reinforcements. We would have to make our stand in the desert with whatever we had to use as weapons and resources.

Late at night our kibbutz leaders held a meeting. Their faces were serious and filled with foreboding. "We are on the frontier," they told us. "This means that the road that passes by Negba is the road to the heart of Israel. When the Egyptian army comes, we must do everything to keep them from advancing. If we can hold them just one extra day then perhaps our army will come."

The Egyptian army was under the leadership of their president, Abdul Nasser, a dedicated Nazi sympathizer and collaborator, who bragged about how Israel was born on one day and would be dead

the next. He and the other bordering Arab states would finish Hitler's work and drive every last Jew into the sea.

And then it began. The first thing the Egyptians did was cut off our water supply. I was walking through the kibbutz when one or two Egyptian-piloted, World War II British-built airplanes grew louder and louder until they were upon us. We all ran for cover, which was sparse at best, trying to disappear from view. The planes began firing, with bullets digging into the sand on the first pass. Then they came back around and we fired on them with rifles, pistols, and whatever else we had, but they hit our water towers, sending water gushing onto the ground out of the giant concrete containers. We had no anti-aircraft weapons, so our attempt at defense was futile. Somehow, though, the strafing planes failed to hit our loud speakers, so we were able to maintain communication and organization within the kibbutz. Once they hit our water towers, we didn't see the planes again. But the Egyptian army was nevertheless on the way.

Radio broadcasts from Tel Aviv, carrying the voice of Prime Minister David Ben Gurion, told us to prepare for an Egyptian invasion of more than a thousand soldiers, and we, a hundred and fifty men and women, braced ourselves. Our kibbutz was situated on a ridge overlooking the northern Egyptian desert. Now all we could do was wait. For as much time as we had, we busied ourselves building barriers with sandbags and any metal objects we could find. Every so often we would hear a test come over the public address system. All was in working order, loud and clear.

We sat and waited for hours. Most other activity of the day came to a halt. There was no planting, harvesting, or production. All

our efforts were focused on the impending battle. Our plowshares were being converted into swords.

A couple of days or so passed. Word was given that the Palmach was sending weapons, tanks, and soldiers to Negba. But nobody celebrated this fact, for we were told that they would not make it in time to meet the first wave. The Egyptians were only thirty miles away. This would be our last day of rest; the last day to get ready.

In the late afternoon, I lay on my back and stared at the sky as the sun beat down on me. The quiet before the storm. I had come through hell to be here in Palestine, and on the eve of an impending, terrific battle, in my heart I was at peace in my homeland. The warmth of the sun bathed my face and body, baking me with therapeutic rays. I half-opened my eyes against the brightness when a faint sound grew in the distance. I sat up and looked around in all directions. Up in the water tower was a man scanning the skies with a pair of binoculars. He started to shout and wave his hands. Other people, too, were straining to see what was going on. The sound grew louder and louder. And then it appeared in the sky—a single fighter plane of the new Israeli air force ripped through the heavens in one pass. With every ounce of my being I was invigorated and electrified with the power of my own people and my history. I cannot explain this feeling—it was a sign from heaven. News began to spread throughout the kibbutz that our new Israeli air force was flying across Palestine to attack the airports of the neighboring Arab States that declared war against us. The lone plane in the sky disappeared somewhere to the north and all was quiet again. This did not last for long.

From the southern desert grew a different sound—the rumbling of Egyptian army vehicles For hours I listened to them as they came streaming toward us in a metallic caravan. I walked along the sandy ridge watching dust clouds wind through the desert down below. With a rifle in my hand, I laid down on my belly among dozens of fellow Holocaust survivors as the sun set and the cool evening ushered in our visitors. We waited in our little outpost of a kibbutz, alone on the frontier, and the Egyptians finally arrived. It was now night.

The darkness of the desert made it impossible for the Egyptians to tell exactly how many of us there were, so when their forces arrived, they nonchalantly settled down below us. They would stay the night and wait patiently for the light of dawn before launching an all-out attack. But we knew that if we waited for the morning to come, the Egyptians would roll right over us with their tanks, killing us all. We could not wait for the Egyptians to make the first move, so an emergency meeting was convened and a plan was devised. What could we do? We were facing tanks and heavy artillery. We were outnumbered ten to one.

To our credit in Negba, we had two very gifted and experienced leaders in our kibbutz. They were expert organizers and had been trained to mount a defense. They spoke with great authority while the rest of us listened intently and received their orders. In the middle of the night, the entire kibbutz, down to every man and woman, was set into motion. I was among a team of people told to gather empty oil drums and quietly bring them to the ridge. We were told to fill the drums with rocks. "But," one of our leaders whispered to us, "we cannot afford to make the slightest clang in

the process. Does everybody understand this?" We all nodded our heads and went to work like a swarm of bees.

It was dark and we could hardly see what we were doing. We slung our rifles over our shoulders and paired off to retrieve the oil drums. Quickly, but carefully, we laid one stone at a time down at the bottom of the drums without making a bit of noise. When we finished loading up one drum we moved on to the next and then the next. There were hundreds of these drums and each one was handled as if it were packed with dynamite. When the last steel container was filled a little more than halfway, we slowly carried the drums to the edge of the hillside facing the Egyptians. We were instructed to wait for a signal.

Someone came running along the ridge whispering, "Quiet. Turn the drums on their sides facing the valley." We did as we were told. It was a clear night but dark except for the fires burning down below where the Egyptian soldiers were settled in. Several guards marched back and forth in their compound and a number of men were sleeping in their vehicles. One brave soul stood at the top of our bullet-ridden water tower with a pair of binoculars. We relayed a minute-by-minute update to somebody down below.

A couple of hours had passed since we filled the oil drums with rocks. Then the kibbutz leaders turned up the loud speakers to their maximum volume and we were ordered not to utter a word. I crawled on my stomach right to the edge of the ridge between two oil drums and looked out over the desert. I heard the static of the public announcement system as the volume was raised. This dead air, this static, was all you could hear. No human voices, no clicking

of weapons, no milling around, and no talking. From time to time the wind whipped through the speakers.

Those of us with weapons checked again to make sure they were loaded as we took positions on our stomachs, creating a long row of riflemen. We kept our eyes on the Egyptians down below. Those among them who were not asleep were shadows casually loafing about on guard duty in the dim moonlight. Here and there a cigarette was lit and a puff of smoke carried away in the breeze. The whole Egyptian division was extremely confident that they would take our kibbutz in the morning then drive further into Palestine to meet up with their other armies.

When we were all in position and ready, a hand signal went up, followed by another and then another, and in less than a minute the action began. The entire kibbutz went from complete silence to a storm of deafening proportions. All of a sudden the still night was aflame with shouts, orders, and gunfire. Our leaders screamed out: "Now! Push!" One after another we shoved our oil drums full of rocks so that they rolled out of control down the hill on the other side of the kibbutz. Hundreds of oil drums tumbling and bouncing in the darkness and broadcast over our PA system. At the same time, without cessation, we fired our weapons and screamed at the tops of our lungs. The whole commotion was so deafening over the loud speakers that the Egyptians were convinced that a full-scale offensive was being launched at them. The rocks clattering in the drums and echoing in the night sounded like volleys of rifle fire and machine-gun reports coming from every direction. The Egyptians panicked, with only a fraction firing back at us. Their whole camp, now wide awake, was in a state of confusion and fear.

They were running in every direction, looking for their weapons, trying to take cover, and fleeing from their vehicles. The element of surprise was on our side. Those of us on the ridge seemed like an insurmountable force. To the Egyptians it seemed like an entire army was raining down toward the valley floor. They fired back with rifles and canons but never mounted a serious counterattack. Some of our people were shot and killed and others were wounded. But the Egyptians, in their confusion, hastily retreated, leaving their tanks and all sorts of other weapons behind.

Tanks. The abandoned tanks were all Matildas, the same kind that I studied while staying as a guest of Captain Onofre three years earlier in the Italian military compound in Modena. With the Egyptians in retreat, we overtook their position and I hopped in a tank and turned it around. I was ordered to fire into the air before moving to the next tank and doing the same. We wanted to keep the Egyptians on the run and the sound of shells exploding in the desert kept them in retreat.

For several days we fired all the weapons in our possession and held the Egyptians at bay. But we knew we could not hold out forever. The Egyptians decided to hold their ground and prepared to launch a new assault. This time we had nothing left to give but our will. It seemed at last that the end had come for us and our kibbutz. We were nearly out of ammunition, and it was clear that the Egyptians planned to come at us again.

Then fate dealt us another reprieve. From the north we saw clouds. The Palmach had at last arrived. Armed to the teeth and led by a general, a host of military officers, and soldiers, the Israeli

army swept through Negba, assessed our damages then chased the Egyptians far into the desert.

It wasn't until much later that I learned that our outpost—our kibbutz in Negba—was instrumental in keeping the Egyptian army from pushing into the Israeli interior and creating a wedge that may have resulted in defeat. We had good cause for celebration when we learned of what we had done. Against all odds, in what I can only call a miracle, we had held back the mighty Egyptian army.

At last, when the War for Independence was over, my mission in Palestine also came to an end. Now I was eager to move ahead with my life.

Where's My Visa?

fter Israel's War of Independence, I said farewell to the kibbutz
and all my friends and went back to Italy to check on the
condition of my visa. Something deep within me was yearning for
a connection to my past, and as much as I loved Israel, I knew it
was time to move on. I was overcome with a strong urge to reunite
with relatives; to reconnect and salvage what was left of my former
life. I wanted to be with my Aunt Frieda, my mother's sister, in New
York. By being close to Aunt Frieda, in some small way I could find
a part of my mother.

But getting to America, as it turned out, wasn't such an easy
venture. For some reason, my visa was being held up. I couldn't
get to the bottom of it; I couldn't wade through the bureaucracy.
I spoke no English, so there was no way of pleading my case with
the American embassy in Naples to see whether I'd ever be able
to emigrate.

Europe was still reeling from refuge problems. There had been
no change in my status over the past three and a half years. I was all
but forgotten in the Italian bureaucracy. I needed help if I was to
ever get to New York.

That's when Uncle Harry arrived like a hero from an American Western movie. Uncle Harry Berman, the biggest little man I ever met, was an in-law relative of my Aunt Frieda. She called him and asked him if he would travel to Italy and find out why my visa wouldn't be issued. After all, the Italians were paid the necessary fees, all the paperwork was filled out years ago, yet nobody was being responsive. Sensitive to the plight of the Jews of Europe, Uncle Harry readily took the challenge and promised Aunt Frieda he would get to the bottom of it. And when Uncle Harry was on a case, he was like a pit bull. He wouldn't let go until he got what he came for. He was a brilliant businessman with a track record for taking charge.

Harry Berman was an accountant—not just any accountant, but a very intelligent, powerful, and wealthy one whose list of clients included the top movie stars, directors, and producers in Hollywood. He commanded as much respect as any producer at MGM. Everyone in the motion picture business called Uncle Harry "HB." Harry Berman was a no-nonsense guy who immigrated to America in the late 1800s, grew up in poverty in the Jewish district of New York, went to college, and then became a self-made millionaire. He was the embodiment of the American dream and thought everyone should have the same opportunity. When a great deal of his employees left his office to fight overseas, Harry supported their wives by supplying them with a weekly paycheck until their husbands came home from war. If the men did not return, Harry Berman continued to pay the widows until he retired and closed his business many years later.

The fact that I, a member of his family, was being held back from a future in America didn't sit well with Uncle Harry. By the time he came to see me in Italy, he had his mind set on getting me passage to America. He was a big shot and would let everyone know who he was and that to say no to Harry Berman was to invite more trouble than you bargained for. So it would be a showdown between HB and the entire Italian state department.

I first met Uncle Harry in 1949. When I returned to Cinecittá, following my stay in Israel, the old movie studio was being resurrected. The United Nations organization told us all that the DP camp was to be closed to make way for a new era of Italian cinema production. We were all to be moved to new quarters. I, along with hundreds of others, was moved to Ostia, a little seaside town bordering Ostia Antica, an ancient Roman city. Ostia was a resort town a short train ride away from Rome where people came during the summer to escape the heat. During the day the beaches were crammed with sun worshippers and swimmers and loungers, and at night there was always something going on in the restaurants and bars. It was a good place for a young single man, like myself, to live.

When I first came to Ostia, I found the address of the apartment house I was supposed to move into. There were about twenty families or so living on five floors and I, a young single guy, wasn't sure I wanted to be crammed in with a bunch of families. So I looked around, trying to find some place in the building that might suit me. I visited floor after floor and made my way to the penthouse. Some penthouse! The entire top floor had been used as a live chicken coop for years. I stared at it for a while, looking

at cages, chicken wire, beat-up old boards, and punctured walls. Then I got an idea. Over the next month I cleaned out the whole place and built myself a perfect flat. I put up walls, a bedroom, and a bathroom. I scrubbed, sanded, and painted day and night. When I had finished, the old chicken coop was a thing of the past, and I had a custom-made penthouse apartment that became the envy of my friends. Now I had all kinds of room and had a bird's-eye view of the ocean and the street below.

I had everything I could want—except a family and a sense of permanence. And this was eating away at me. The only way I could keep from falling into a state of despair was to stay busy. Fortunately, the beach was always full of lively, chattering people and the roads were streaming with tourists. I met a lot of friends and stayed out all day and night until I had to drag myself home to bed.

One summer night I did as I had so often done—I went with a friend to the beach. We put on our bathing suits in the early evening, took a dip in the water, and then came out to dry ourselves on the sand. I was lying on the beach, just down the road near my house, watching the waves roll in and the girls walk by. It was fairly dark outside and, unless your eyes were adjusted, you couldn't see twenty feet in front of you. Between the black sand and the overcast sky, looking out to sea was like staring at the bottom of a well. The streets weren't very well lit, so whenever a car came along, which was a rare event, all the buildings would light up from the headlights. And in the ocean you could see flickering lights from little fishing boats anchored offshore.

My friend, whose name I have long forgotten, lit up his cigarette and blew out a cloud of smoke that was carried away by the ocean

breeze. Staring up into the sky, we started talking about politics or some such thing, when out of nowhere a couple of guys came trudging over the sand calling out my name, "Michele! Michele!"

I answered, "Here! I'm over here!"

Out of breath, a young man, about my age, said, "There's a man looking for you. He says he's your uncle and he's looking for you. Come on!"

My uncle? What uncle? I walked to the side of the road and saw a huge, black, highly polished late-model car parked in the street. There was a gathering crowd of people who had come to look at the unusual sight of a limousine parked in the middle of the road in Ostia. Maybe they expected a movie star to jump out. Instead, out of the driver's side stepped an Italian chauffeur well over six feet tall. He adjusted his tie and his hat and scanned the crowd. He cleared his throat. A group of twenty or so people was now hovering around the limousine, with more than half of them pushing one another to get a better view. The chauffeur started to call out to the crowd, "Motek Shmulewicz! Motek Shmulewicz! I'm looking for Motek Shmulewicz!"

It had been a while since I had heard my own name. It sounded strange coming from the Italian chauffeur. In Italy I was known as Michele. So who was this calling me by my real name? I stepped forward and answered, "That's me." The chauffeur motioned me to approach, and the crowd parted like the Red Sea. Curiously, I walked over to the car and around to the passenger door.

The window was rolled down and the man inside leaned toward me and asked in Yiddish, "*Du redst Iddish?*" (Do you speak Yiddish?) I nodded yes.

Then the man asked, "*Du bist Motel?*"

Again, I answered yes. "I am Motel."

The man asked, "Where do you live?"

I pointed to a five-story building down the block and said, "Over there, just up the block."

"Let's go to where you live," he said. "Hop in the car."

"Who are you, anyway?" I asked.

The man held out his hand and said, "I'm Harry Berman. Your Aunt Frieda sent me to help you."

We shook hands and Uncle Harry invited me, bathing suit and all, to climb into the back seat as the chauffeur drove slowly up the road with an entourage trailing behind. The high beams shone on every building and pedestrian like a searchlight. It took all of a minute to get to my building. Uncle Harry got out, and for the first time I saw that he was only about five feet tall. He was immaculately dressed in a made-to-order brown woolen suit and a well-starched white dress shirt and striped necktie. His fingernails were manicured and his hair neatly combed back away from his high forehead. Uncle Harry was a stout man but looked strong and hardy. He didn't smile much; he had a rather serious demeanor but somehow I felt a great deal of warmth from him, like he was taking me under his wing. Maybe it was the way he told me that he was sent to bring me to my Aunt Frieda. After years of trying to get out of Italy, I was now starting to feel that it was possible. An important man like Harry Berman doesn't travel across the ocean on a mission unless he's confident he'll be successful. I felt good about him.

"Well?" Uncle Harry said, jutting his chin toward the building. "Lead the way."

"I don't mind showing you where I live," I told him, "but I'm sorry to say that we have to climb up five flights of stairs."

"Don't worry," he said. And he followed me all the way up to my apartment.

I told Uncle Harry that I had to take a shower. I was still sandy from the beach.

"You do what you have to do," he said. He took a handkerchief out of his back pocket and wiped his brow. "I'll be right here when you get back."

I realized later that while I was in the shower, Uncle Harry was taking the liberty of going through my things. It was nothing malicious or nosy; he just wanted to see how I lived and what I had—which was practically nothing. When I came out of the shower and got dressed, Uncle Harry took a few minutes to find out who I was. Maybe he was concerned about bringing a greenhorn to America. Maybe he was worried that I would be a burden to the family. He had to check me out. He heard Aunt Frieda's description of her nephew, but now it was my turn to speak for myself. Little did he know that I had already experienced two lifetimes' worth of hardships, trials, and tribulation.

"Have a seat," said Uncle Harry. He sat on the edge of my bed and I pulled up a chair. For the next hour or so I told Uncle Harry everything he wanted to know about me, and maybe more. He was interested in learning about Maitchet and my family and any of the details I cared to share about the slaughter in my shtetl. Then he asked me about my experience in Mauthausen, how I survived, and how I came to Italy.

"How did you live?" he asked.

"I don't know that myself," I answered.

"And the Americans rescued you?"

"Yes. They liberated the concentration camp."

"Then you were taken to Salzburg?" asked Uncle Harry.

"Yes, but I wasn't conscious," I answered. "I was little better than dead. The next thing I remember is waking up in a hospital."

Uncle Harry shook his head sympathetically and laced his thick fingers together. He leaned forward, forearms resting on his knees. "Tell me," he said, "tell me how you've been spending your time here."

Uncle Harry wanted to know how long I had been in Italy and what I did in Palestine. All the while he continued to listen intently, rarely interrupting except to ask me to elaborate here and there. He let me get it all off my chest, to share my sacred memories, and to choke on my recollections of the atrocities. I told him about my nightmares and my sleeplessness. I told him things I don't think I had mentioned to anyone up to that point. And when I had finished talking, Uncle Harry waited. If there was more to say, he didn't want to interrupt. So we stared at each other. I studied his round face, beady eyes, and square jaw. Finally, a trace of a smile appeared on his thin lips.

Uncle Harry asked me, "Are you all right?" I nodded.

"Good," said Uncle Harry. Then he slapped me on the knee with his heavy hand. "Let's go to dinner. You hungry?"

"Sure," I said.

When we went downstairs, there was still a crowd milling around Uncle Harry's car. When we decided to walk, they followed

us all the way to the restaurant. I thought Uncle Harry was going to shoo them all away, but he didn't.

As soon as we stepped inside the restaurant, Uncle Harry, with me as his interpreter, asked to meet the owner. A friendly little man emerged from the kitchen wearing a thin white shirt and an apron stained with pasta sauce. He was wiping his hands on a white towel and his arms were dusted with baking powder. Uncle Harry asked me to ask the owner whether he had enough food to feed a hundred people. The owner nearly fell over. He took his apron in his hands and wiped the sweat off his face. "You mean tonight?" he asked.

Uncle Harry said to me, "Tell him, yes, tonight."

The man nodded his head and kept repeating the word "*Si.*"

So Uncle Harry invited everybody within earshot to dinner at this little restaurant. "Tell them, Motel," he said to me, "that I'm paying, but this man," he pointed to the restaurant owner, "this man is your host. *Rispetto*? Okay? *Capisce*?"

Every table, chair, and bench was taken, indoors and out. Some people were sitting on planters, and girls were sitting on the laps of boys. You would have sworn it was a scene from a wedding reception. Wine was poured bottle after bottle and people were raising their glasses in toasts to who knows what. It was the biggest party I had ever seen since Purim in Maitchet. By the end of the second hour, the restaurant owner had cooked up everything in his kitchen and used up most of his wine, and I became the most popular friend to a hundred people in Ostia. When we were finished with dinner, Uncle Harry made an announcement. He stood up and said to everybody, "I hope you all enjoyed your dinner. Let's toast a final

drink to our host." Then a big cheer burst out followed by applause and whistling. Uncle Harry raised his glass to the restaurant owner who by then looked like he had been through a tornado. Somebody poured the man a glass of Chianti and he drank it in two gulps.

"Now," said Uncle Harry, "I want everyone to join in and clean up this place."

This made the owner more than thrilled. He grabbed Uncle Harry's hand and shook it vigorously. And, without a complaint or excuse, everyone eagerly went to work. They cleared the tables, washed the dishes, mopped the floor, and straightened out every table and chair. By the time they were finished, you couldn't tell that such a wild party had ever taken place.

When Uncle Harry came to Rome, he treated me like I was a son he never had. To me, Uncle Harry was an icon in a short, stout body with the face of a serious businessman who always knew what to do and how to get it done. He dressed in the most expensive suits, smelled of expensive cologne, wore gold rings on his thick fingers and traveled in limos and taxis.

Over the next couple of days, Uncle Harry bought me a new suit and gave me a wad of cash. He invited me to his hotel where he introduced me to a beautiful actress, his wife. Then he took me to the movie studio that was just being resurrected in Cinecittá and introduced me to a young movie producer named Dino De Laurentis, who was making a movie called *The Captain's Daughter* (*La Figlia de Capitano*). De Laurentis winked at Uncle Harry and asked me if I wanted to be in his picture. Of course I said yes and a month later found myself on a movie set as an extra dressed up as an Italian peasant. Being in the movie and meeting all the gorgeous

actresses, including the producer's wife, the star Silvano Mangano, was a great diversion from my problems of getting a visa. Days on the set helped pass the time.

But the sad fact was that my life was going nowhere. I was no closer to leaving for New York than when I first set foot in the American embassy to file for my paperwork years earlier. But Uncle Harry had a plan. He told me to pack a small suitcase and meet him downstairs in the morning. That's when I jumped in the limousine and we hit the road. We were headed to Naples where the American consulate was. Uncle Harry was about to barge into the Italian visa offices and lay down the law.

The first person Uncle Harry came to tried to put him off and give him the runaround, but HB wouldn't have it. He was hollering in English, a language that nearly everyone within earshot was trying to understand when spoken so fast and boisterously. HB punched the desk in front of him and made a pencil jump out of its holder as he screamed, "We paid you, for God's sake! We filled out all the forms. Where the hell is his visa? I'm not leaving this damn office without that visa, do you understand?"

Uncle Harry was intimidating. He wasn't afraid of yelling at people. If he was just putting on a show, then he was better than any of his actor clients because I found him quite convincing. Apparently so did everybody else. The bureaucrats were wondering what kind of man would come all the way to Italy, dressed in the finest suit they'd ever seen, barge into their offices, and make demands like an army general. All sorts of officials were called in to deal with this irate American big shot. They tried to calm him down. Calm down? HB wouldn't even *sit* down. He paced, he sighed, he grumbled, and

he stomped. The bureaucrats were running around like chickens. They put aside their other cases and started a massive search for the records of Mordechai Leib Shmulewicz: me. They were speaking a mixture of Italian and English that I couldn't understand at all except for my own name, which was now being used as a curse word. All the files were turned upside-down until at last somebody discovered my file at the bottom of one of six stacks on the desk of a scrawny bureaucrat up to his elbows in paperwork.

"Well?" said Uncle Harry. "You found it, didn't you, you incompetent idiots?"

With a red face and a ring of perspiration soaking his collar and underarms, one of the secretaries cleared his throat then made an admission. "It appears that the visa for Mordechai Leib Shmulewicz has been issued. He has gone to America already."

Uncle Harry stared at the man with fire coming out of his eyes. "Either you are out of your mind, or I am out of mine. What the hell are you talking about?" Uncle Harry demanded. "He's sitting right next to me." Uncle Harry pointed at me in the chair beside him. "What do you think this is—a ghost? Can you see him? There he is. Take a good look! Mordechai Leib Shmulewicz."

They could see me, but they shook their heads as if I didn't really exist. "No," one of the secretaries said while looking at my file. The consulate workers stared at one another for over a minute. Then it became painfully obvious. My visa, the one I had been waiting years to be issued, was sold to somebody under the table. "Somebody else has it," someone said, barely above a whisper.

"Somebody else?" Uncle Harry repeated. "And whose fault is that?"

So that's what happened. I was the victim of the black market. My visa was gone, along with an imposter using my name and now living somewhere in America. Uncle Harry stood there like a stone. His arms were crossed in front of him and beads of sweat materialized on his forehead. The veins were pulsating in his neck and he began to tap his fingers on his forearm. There was a momentary staring contest. Uncle Harry pointed his finger at the man in charge and said, "Are you going to do something about this or is there going to be an even bigger problem?"

The bureaucrats got the message and said that a visa would be issued to me within a few weeks. HB put his hat back on his head and stormed out of the building with me in tow. Harry called his son Milton in New York and told him, "Tell Aunt Frieda I'm bringing her nephew to America. Make a big party for him. I like him; he's a nice guy. When he gets there, we all need to make him feel welcomed."

With hardly enough time to kiss my friends good-bye, I packed up my bags in Ostia, traveled to Bagnoli near Naples, and waited for my ship to arrive. At last, I was soon saying *arrivederci* to Italy.

America the Beautiful

The last time I had been aboard a ship was on the way back to Anzio, Italy, leaving a new nation called Israel. Now I was heading out over open waters to the port of Bremerhaven, Germany, on the north coast of General Eisenhower's American occupation zone. In Bremerhaven I boarded a huge U.S. Army transport ship called the General J. H. McRae and shoved off from Europe. Disappearing behind me as the ship cut through the harbor was the country where the whole nightmare had begun. I watched Germany fade to nothingness along with a thousand of my fellow passengers who were refugees like me, looking for a new life.

The trip across the Atlantic was rough, with people fighting seasickness the whole way. I had no problems, though, and found myself taking care of a man who was sick from the day we left until the day we entered U.S. territorial waters. And at that point, everybody went up on deck to soak in the sun. We were quite literally among the tired, poor, and huddled masses as our ship steamed passed the Statue of Liberty in the New York Harbor. She was looking right at me, filling me with hope and relief. The year was 1950. It was January 26th.

It took over an hour to disembark. There were thousands of people clamoring and searching the crowd for faces to match photographs held in gloved hands. I, too, was surveying the faces as I was carried along by a river of people. It was a strange scene. The air was filled with uncontrollable sobbing and tears ran down cheeks and onto trembling lips. There was hugging and kissing and hands were squeezed until they hurt. A woman held her soft hand to a young man's face as she said over and over in Yiddish, "Remember me?" Another woman grabbed hold of a lady and cried out, "We thought you were dead. We thought you were dead."

I pushed my way along until I saw a middle-aged lady standing before me in a long, dark woolen coat and matching hat. At first I thought it was my mother. She had Momma's eyes. Momentarily confused, we looked at each other. I needed no picture to know it was her. "Aunt Frieda?" I asked. An expression grew on her face that was hard to interpret. It was a smile and a frown. Tears began to flow. We cried as she pulled me to her. "Motel," she said. That's all she could say.

My reunion with Aunt Frieda and Frieda Watskin (my cousin) in New York Harbor was a bittersweet meeting. I could not help but see my mother every time I looked at her. And I was speechless. Even as I arrived at her home, I couldn't come close to telling her what happened to our family. The pain gripped me. More than the pain of my loss and the suffering of my family, now I knew the pain of trying to tell Aunt Frieda what had happened to her baby sister. Too terrible. I couldn't breathe; I couldn't bring myself to speak about it. Not yet. Maybe over time.

In the next few weeks, I became acquainted with relatives I had never known, including cousins, aunts, and uncles. We understood one another by speaking in Yiddish until I could learn English. When I had settled into a routine, I regularly joined my relatives on Sundays in the Bronx, as we all met up at the home of my aunt and uncle with the last name of Watskin. I was once again part of a big family gathered around a dinner table. But amidst the laughing, arguing, kvelling, and lively conversation, the greater part of me was alone. These people who were so nice to me didn't know me at all. How could they? How could they ever see into me and all that my eyes had seen? For them, there was no real war, no real loss. I did not begrudge them for their innocence, but neither could I find a bridge over our differences. I was a stranger in the midst of family. Yet as we sat together to eat and enjoy one another's company, no one could understand how much this meant to me as I silently stared at their faces while they rambled on and on about the *mishagoss* going on in their lives.

Aunt Frieda and I immediately became very close. She wanted to give whatever she had to me—love, support, happiness. "If it's mine, it's yours too," she told me. We shared a link to a world of people found only in our memories. With our shared sentiments, I wanted to take care of her as well. Although she had invited me to stay with her, she lived in a furnished little apartment that was too small for the both of us; so, I found a place to stay nearby with a friend. Uncle Harry, too, invited me to live with him, but being on my own was the best I could imagine for myself.

Like many other refugees from Europe, including several friends I had already made in New York—fellow Holocaust survivors—

my most immediate goal was to become a citizen of the United States of America. I shed my "old world" name, Mordechai Leib Shmulewicz, for a new one: Martin Small. I came to be known as Martin Small soon after I moved to New York. Martin was easy for me and everybody else to pronounce. I kept my same initials. Then a friend of mine said, "Shmulewicz is too hard to pronounce. This is America. You need a last name that's not so big." My answer was, "Small is not big." And that's how I changed my name to Martin Small.

So I had a new name; now it was time for a new life. It was also time for me to start a family, and the best way to do this, my cousins insisted, was to find the perfect woman. "We'll take care of it," they said. At about this time, I became acquainted with a distant cousin named Bernie whom everyone called Sonny. He was attending New York University. Sonny knew all sorts of girls—college girls. One day he called my Aunt Frieda and said, "I found a nice Jewish girl from Brooklyn. She speaks Yiddish. Her father is a furniture manufacturer."

My aunt was excited. She told me, "Martin, Bernie made a blind date for you—a nice Jewish girl who speaks Yiddish."

My English was not so good. When she told me this, I said to her, "I'm not going."

Aunt Frieda's face dropped with disappointment. Sonny had gone through all sorts of trouble to line someone up for me and I dismissed the whole thing right away. I wouldn't give it a chance.

Aunt Frieda asked me, "Why don't you want to go?"

I said, "Bernie's a nice guy, but I don't want to meet a blind girl."

Almost in disbelief, and kind enough not to laugh at me, Aunt Frieda explained what a blind date was.

Once that was ironed out, I said, "Okay then, I'll go."

The next day Sonny came by in his car and picked me up. He was all dressed up and ready to impress the girls we were off to meet. He told me to get in quick. He said, "I've got a great double date lined up," and he didn't want to be late. I hopped in the front seat and off we went to meet the girls.

While driving, I stared out the window and started thinking about a friend of mine, Yossel Abrams, a Holocaust survivor I knew from Italy. He was living in Washington Heights—on the way to our date. When we got close to Yossel's house, I told Sonny, "Stop the car; I want to visit my friend." I felt uncomfortable about being set up and I wanted out.

Sonny was in disbelief. He ignored me at first, but I persisted. Then he turned to me and said, "Are you crazy? I have a girl waiting for you. I made a date for me and you." He was speaking as if I may not have understood where we were going. But I understood very well.

I told him, "I don't want to go. Pull over the car and drop me off at Yossel Abrams's house." I grew more and more adamant. "Pull over now."

After a minute of arguing, Sonny steered his car off to the side of the road and came to a screeching halt. He screamed at me, red in the face, "Get out of here!" He was so mad that he wouldn't even look at me anymore. As soon as I stepped out of the car and closed the door, Sonny mashed his foot on the gas pedal and took off.

I went to Yossel's house, rang the bell, and he invited me in. His wife, Esther, and their baby daughter were inside and I kissed them all hello. They weren't sure why I decided to drop by just then, but, as always, they seemed happy to see me. When I stepped into Yossel's living room I noticed there were two young ladies—sisters named Doris and Ida—waiting patiently for their friend, another girl who was renting a room from Yossel and Esther. The three girls were about to go out on the town for the evening. I could see that Doris and Ida's friend was ironing her blouse in the other room. We all looked at one another and smiled.

Yossel clapped his hands to break the awkward silence. He said to Doris and Ida, "I've got an idea. While you girls are waiting, let's all sit down and play cards." Then he looked at me and I said, "Okay." I wasn't especially in the mood for cards, but what else was there to do?

Yossel brought out a card table and four chairs. He sat down, removed a deck of cards from their box, and started to shuffle. Then he said to me, "I'll play partners with Doris, and you play partners with her sister Ida."

I looked at Yossel and said, "Joe, no. You play partners with Ida." Then I pointed to Doris and said, "I'll play with Doris, because she'll be my partner for the rest of my life."

Everybody stared at me. Their jaws dropped. Doris smiled and Ida looked at her sister to gauge her reaction. Yossel dealt the cards and Doris became my partner.

It's a good thing Yossel's renter had a wrinkled shirt, because just a few months after this chance meeting, Doris and I were married

in Manhattan—two Holocaust survivors without parents, in a new world eager to forge a new life together.

Doris and her sister Ida were in Germany during the fateful event that history calls Kristallnacht—the night of broken glass in 1938— when Nazi storm troopers started a frenzy of hate that culminated in looting Jewish businesses, smashing in shop windows, terrorizing and beating Jews on the streets, burning synagogues, and lighting the fuse that set off the Holocaust. Barely escaping Kristallnacht and its aftermath of killings and deportations to concentration camps, Ida and Doris took the Kindertransport from Berlin to England. As the war began, they were present during the blitz on London, with bombs falling all around them day and night.

Doris and I were married in the spring and settled down in the Washington Heights area of New York. In 1952 we had our first child, our wonderful daughter Miriam. We gave her the middle name of Esther, after my mother. Five years later we had a son, Stuart Michael whom we named after my father and Doris's father.

My cousin Larvey found work for me in H&H Butler, one of the largest clothing stores with 4,800 outlets. I went to work in the shipping department but soon after realized that there was very little hope of advancement. However, for the time being at least I was earning a living and had settled down in New York.

Next, my cousin Morris gave me an opportunity. Morris worked in a factory that made women's hats, and I learned the business very quickly. I ran all parts of the enterprise, from operating the equipment to sales. I was earning a good salary and had enough money to meet my expenses. But making money wasn't enough; I saw bigger opportunities in the business world on my own. After

five years had passed, I got together with a friend and we decided to start a company. We put up two thousand dollars each and grew a thriving company with salesmen working for us all over the country. We did quite well for several years until fashion began to change and hats for women were no longer en vogue.

And that's when I came upon another means of earning a living. Doris had an uncle who was quite well-to-do. He owned a number of apartment buildings from the Bronx to Staten Island and needed someone to manage them. I was his first choice. Because there were so many people in these upscale residences, I came to know hundreds of them, from prominent entertainers to underworld figures. It was quite a colorful scene, and my work schedule had me coming and going all hours of the day and night.

By the time Miriam was able to speak, she begged me for a puppy, so I bought a beautiful, well-trained Doberman pinscher that we named Daisy. Three times a day I took Daisy to Central Park not far from my office on 58th Street. Daisy loved to run, but with the command of my voice she would come sprinting back to me and sit at my side like a statue. The city of New York's Central Park mounted police officers came to know me quite well. They'd sit in their blue uniforms and white hats, watching as I brought Daisy to the park. They admired how well behaved she was, like the best of their police dogs. Then one day I walked Daisy to the park bench where I was going to take a seat and eat my lunchtime sandwich. We were under a tree and the park was relatively empty. The mounted police weren't anywhere in sight. In those days Central Park had a reputation for being a dangerous place, depending where you were. There were so many muggings that the comedians used to make

jokes about them. With my dog, though, I could go anywhere and not be bothered.

I sat down and Daisy sat beside me with her ears perked up as she paid attention to everything going on around us. Nothing escaped her senses—squirrels, leaves blowing on the grass, honking cars, or voices in the distance. She was a sentinel. As I unwrapped my sandwich, I noticed a woman quickly walking across the park. It was around noon, and I supposed she was heading to or from a nearby office. At about the same time, I saw a man coming up behind her. He lagged slightly behind her then started to run. The mounted police were on the far end of the park, so the man made his move and grabbed the woman's purse. She screamed as he fought with her then began to run away with her pocketbook, wallet, keys, and everything else. With one word I told my dog, "Daisy, go." I barely even spoke above a whisper and off my Doberman went at full speed. In seconds, tearing through the grass and jumping over obstacles, Daisy ran the burglar down and pinned him to the ground just as the police came to the scene to rescue him. When the police had everything under control, I gave a little whistle and Daisy came running all the way back to me and sat down at my side.

This incident gave me and the police a lot to talk about over the coming weeks. In fact, I came to know one policeman quite well. His name was Jim Curry, a tough, strong Irishman on horseback. Officer Curry and I struck up an immediate friendship. Months went by and every time I went to the park Jim Curry and I talked. We were about the same age, so we talked about family, the future, politics, and the news of the day. I found out that Jim was born and raised in New York, went off to war with a group of friends,

fought in the army, then came home to join the police force. I, too, related my life's experiences, leaving out the details that still caused too much pain to retell. But Jim was a hardened soldier, so he understood what it was like to keep some things unspoken. Jim and I became good friends. Doris and I invited him over to our home for dinner and we met his wife, Jeanette. In time, he reciprocated and Doris, Miriam, and I had dinner at the Curry's home. We shared a lot of laughs and personal stories. Doris told the Currys about how her brother in Berlin was taken away in the middle of the night, never to be seen again, leaving her and Ida to fend for themselves. The Currys listened with great interest about the days Doris spent in air-raid shelters listening to German bombs falling all around her in London. Jim, in turn, told us of the day he landed in Normandy and, afterward, fought through all of France and into Germany, losing his closest friends along the way. I related what my Polish neighbors did to my family, but, again, I spared everyone the details. When conversation grew too heavy, we changed the subject to lighter topics, with Jim asking Miriam what she was learning in school. Or we'd talk about the motion pictures or how the Yankees were faring.

Within a couple of years Doris and I bought a summer home on Long Island and we'd have Jim Curry and his wife over for barbecues. We had a great relationship that continued to grow. When we came to Central Park, sometimes Jim would pick Miriam up and take her for a ride on his horse around the park. When Jim and his wife had children, we all got together for family festivities. Our get-togethers continued for many years, even after Doris and I left the city and moved permanently into our Long Island summer

home. The Currys used to come out for an entire day to visit, and our discussions eventually drifted away from the past and all its ugliness.

Like all other ex-GIs, as well as the Holocaust survivors, with all that we had experienced left far behind, we chose to look ahead, raising families and building lives. More than anyone, we focused on the present and the future. This was something to toast when we got together. Our experiences during the war years were still a very painful and fresh subject that we chose to avoid, except among ourselves in very small circles. Even then, the memories were too terrible to discuss. Little do people know, but we Holocaust survivors are all plagued with nightmares and visions that never leave us. So, if we speak about what we have been through, we can never escape the pain. While we couldn't control our disturbed sleep, the least we could do was avoid revisiting our past during our waking hours.

While "normal" people slept soundly in their beds at night at the end of a long day of work, I could find no rest. Over and over and over again, I would be tortured by the memory of my family and what was done to them. Faces from the past—Polish neighbors—would terrify me in my dreams and nighttime thoughts. I would toss and turn in mental anguish over the atrocities that replayed in my mind until I screamed out in the darkness and drowned myself in tears and sweat. In the recesses of my mind dwelt a living hell that would not leave me. Other than a friend here and there who was also a Holocaust survivor, there was nobody to talk to about this. It was driving me insane. I didn't know what to do. I could not control these nightmares that visited me every night and several times a day. I thought at times that I was mad; I couldn't predict

when my mind would go blank, America would disappear, and I would be in Maitchet watching the most horrible things. I would be walking down the street or standing in my kitchen and my mind would be in another world, back in Baranowicze, then running through the woods, then imagining my family buried over in dirt and choking on the prayer, Sh'ma Yisroel. Why? Why? Why? No answers came to mind; there was no reason and no rest. It was so hard to bear that I found a psychiatrist in Long Island who gave me a prescription for strong pills to help me sleep. And sleep I did.

The sad fact is that my mind became more and more numb the longer I was on these pills. They were ruining my life. I was forgetting not only my past but much of the present as well. My mind grew less sharp and I was losing my sense of self. I was unable to remember my mother's and father's faces. They were disappearing and we were drifting permanently apart. My memory was dissolving. I was even forgetting the things I had done in just the recent past; I was finding it hard to remember the names of my friends in Palestine and Italy. The pills that were restoring my sleep were also disintegrating my very being.

One day I sat on the edge of my bed and tried to remember what my mother looked like. I called out to her and concentrated but to no avail. Now she and the rest of my family had not only died in Maitchet but they were almost dead to my memory. This was too much for me to bear. It put me into a panic. I worried that part of my mind was gone, and what would I be if I could not see my mother's eyes? What if I could not remember holding Zayde's hands or sitting in Bubbie's kitchen on Shabbos evenings? What if my father and my little sisters were torn from the recesses

of my mind? I feared that this kind of loneliness would put an end to me.

I told Doris that I would no longer take the pills. I decided on the spot that I would rather live with the horrible memories if the alternative was to forget the good ones of my family. I told Doris that I was going to flush the bottle of pills down the toilet, which I did without thinking any further about it. I resigned myself to live with the painful memories, that I would take the bad with the good. Without my past, I did not exist.

So, to this day I still suffer from nightmares and a mind that wanders into the past. I sweat and cry and become lost in despair as my memories come to haunt me. Doris and I go to the grocery store, and while she is putting food in the basket and I am beside her, suddenly I am standing at the edge of the forest in Maitchet beside Shmulek Bachrach, looking into a bottomless pit of souls. When Shabbos comes around, I stand in the synagogue next to the Torah, and while the entire congregation sees the rabbi, I am seeing Zayde, in the kalte shul, running his fingers over his beard and changing the pages of his prayer book. As the ark is opened, with my eyes wide open, I am in Maitchet hearing the screams of my sisters Peshia and Elka. I close my eyes to shut out the thoughts, but even with my eyes closed tight, they stay with me. I have to wait until the visions pass. When my eyes open, I do not know where I am, as if waking up from a deep sleep. I stand in the shul, but each of my feet is in another world.

Today I remember Maitchet, Mauthausen, Polish neighbors who turned into murderers, starvation, beatings, torture, Bubbie's baking, Shabbos at Zayde's, and my little sisters cooking with

Momma. Good and bad. I embrace it all. Each memory is a double-edged sword that I cannot bear to let go of.

To cope with my past, I continued to stay in touch with fellow Holocaust survivors who were as determined as I was to preserve the memories of all those we lost. Some time in the 1950s, my cousins Charlie (formerly Chonyeh) and Morris (formerly Moishe) Samuels, from Maitchet, helped form a survivors' group with several others and me. With the help of Myrna Siegel in Chicago, whose family owned the flour mills in Maitchet, we New York–based survivors, as well as some who were now living in Israel and Argentina, eventually pieced together a Yitzkor (remembrance) book of our shtetl, which was published at Yad Vashem, the Holocaust memorial organization in Israel. Our goal was to try to keep the memories of our families, friends, and shtetl alive for posterity. Like this book you are now reading, our Yitzkor book is a bridge to another time and place, whose pages are glued together with the most disparate substances—our troubled memories as well as our best wishes for a better tomorrow.

Years later, in 1995, Myrna Siegel and her husband, Shael, traveled to Maitchet and visited our lost world. At the edge of the forest, in the midst of the underbrush and beneath a canopy of trees, she found and videotaped the gravesite where nearly my entire family was buried—most of them alive—among the 3,600 other Jews in the summer of 1942, the majority of whom were refugees fleeing from other towns. There is a plaque covering the mass grave, but there is no longer a single Jew living in Maitchet. When Myrna sent me her videotape of my shtetl, I immediately popped it in my video player and sat on the edge of my living room chair in stunned

silence. A flood of memories came to me as I saw familiar streets and buildings, including the Greek Orthodox Church where the kind priest and his family were murdered across from my house. When the Siegels came upon the site of the mass grave in the forest, Shael began to read the kaddish prayer for the dead. In my living room I stood up and recited the kaddish along with him with tears rolling down my face and my heart burning in my chest. I sobbed and sobbed until I couldn't utter another syllable. Maitchet, once one of the most vibrant shtetls, was now the resting place for the dead. May my family, friends, and neighbors forever rest in peace.

Like in other shtetls throughout Eastern Europe, the townspeople with whom Myrna spoke continue to deny their role in the murder of the Jews in the early 1940s. They readily blame the Germans or are quick to point fingers at others, but those of us who were eyewitnesses know who the murderers were. We remain on their consciences even as they use our Jewish gravestones as slabs for their kitchen porches and as sidewalk stones around their churches. The good Poles of Maitchet reluctantly allowed a Jewish commission to erect a small memorial, but you must search through the woods to find any trace of the town's rich Jewish past. By chance you might bump into the two plaques that stand as the only evidence that Jews ever existed in the shtetl. And to this day, the biggest fear shared by the Poles is that the Jews might return to reclaim their homes and property.

Time for Reflection

Doris and I permanently moved our family to our summer home in Long Island right around the time that Aunt Frieda was mugged in an elevator in Queens on her way home from the bank. She was badly injured and I decided it was no longer safe for her to live by herself, so Doris and I built a cottage next to our house just for my aunt. After all she had done for me, I was glad I could provide for her. My goal was to keep her safe, happy, and cared for. Aunt Frieda lived out her retirement with us until she passed away in 1989.

Doris and I lived in our Long Island home for close to twenty-one years. The most tragic portion of our married lives was when our son, Stuart Michael, died at age eleven. We continue to visit his gravesite in New Jersey to this day.

In the years that we made Long Island our permanent home, Doris and I sought out the Jewish community, joined a synagogue, and took an active role in all of its programs. I was honored many times by teaching children Judaism, training bar and bat mitzvah boys and girls to sing their Haftorah portions, giving lessons of the Holocaust and the birth of Israel, passing along wonderful stories I had learned as a Yeshiva bocher in Maitchet, and helping our

synagogue grow and prosper with a variety of enriching programs. The cantor of our Long Island shul, coincidentally, was the son of a Holocaust survivor whom I knew from Poland.

During the time we were living in Long Island, I was asked to speak at a local synagogue about the Holocaust. After my speech, at the end of the evening, a man named Max, about my age, came down the aisle as I was gathering my papers. Max stopped me and was crying. He said, "I'm so happy to see you're alive."

I felt like I was back in Salzburg, Austria, in the convalescent hospital. I remembered that I was approached by another man who gave me the same introduction: "I'm so happy to see you're alive." But this was a different man now, yet he had the same message and same look of astonishment on his face.

"How do I know you?" I asked.

Max answered, "We used to call you the rabbi in Mauthausen and we saw an American soldier carry you out. You don't remember me? I remember you."

Max went on to describe where our barracks were and what bunk I was made to sleep in—the bunk in the back on the left, in the barracks across from the guard tower, he said. I could see in this kind man's eyes that he was amazed that I was still living and breathing; he wondered how I ever recovered among the skeletons of the concentration camp. Although I did not remember him, he accurately described our Mauthausen experience. In no time, Max and I became friends. Sadly though, Max died only a few years after this reunion. Still, his words haunted me as years went by—"I'm so happy to see you're alive."

By the time our daughter Miriam was married, Aunt Frieda sprung the greatest of surprises. She was cleaning out her things one day and remembered that she had a lot of photographs packed away. She gave the pictures to Miriam who then showed them to me. I had to sit down and catch my breath. The photographs were of my family. There were images of my mother, my father, all of my grandparents, friends from Maitchet, townspeople, and portraits of my sisters and myself. There were group pictures of Maitcheters all dressed up in costumes during Purim and photos of friends who joined the Zionist groups and left for Palestine before the war. And there was a letter in my Zayde's handwriting still inside his original envelope with stamps bearing the name Molczadz, the Russian name for our shtetl, Maitchet. My mother, Aunt Frieda told us, sent these photographs to New York before the war. This little act of foresight preserved at least some of my past for me, and in them Momma came back to me.

Where most Holocaust survivors have lost all connections with their families and their possessions, including old photographs, at least I have these clear, beautiful images to remind me where I have come from.

Before Miriam graduated from Hunter College, she decided to take a year off to travel west across the United States. She and a girlfriend packed their car and off they went, California bound. But on the way to the Pacific Coast, Miriam stopped in Colorado and told her friend to go on without her. Without a lot of money to spend, Miriam found a room in a trailer for rent and lived with a roommate. Later on, her roommate's brother, Bill, paid a visit. Miriam was smitten, and my daughter began dating Bill until

eventually they married and settled in Colorado. It wasn't long before Miriam gave birth to my granddaughter, Jenniffer Rachel— and my grandson, Jacob Michael.

Now a new world opened up to Doris and me. We traveled west to visit our growing family. Each time we stayed in Colorado, we fell in love with its mountain views, high altitude, and slower pace of life. The scenery was nothing short of therapeutic. Our days in New York were numbered.

At one point we were speaking to Miriam on the telephone and she told us, "Maybe since you are getting older, we should all be together."

Doris and I sat down and discussed what Miriam was proposing. In our eighties, we decided to move to Colorado and start all over. While I stayed in New York, Doris went out west looking for houses but couldn't find what she wanted. She came back empty-handed and we thought maybe the process of moving would take longer than we guessed. But Miriam was determined to find us a home, so she set to work searching the market for houses. It was only a few weeks later that we received a call on a Sunday morning. Miriam told me she had discovered the perfect house for Doris and me in a nice neighborhood. I remembered having visited the neighborhood Miriam was telling us about and that I liked it.

"Then that's that," I told my daughter.

Doris and I sold our house and sent Miriam a check to buy our new home so that when we arrived in Colorado we could move right in. We visited the gravesite of our son, were given a send-off by the Jewish community, and said so long to New York. Just before we left Long Island, I was honored with a lifetime achievement

award during a lavish banquet sponsored by our synagogue and all the friends we had made over the decades.

This may all sound like the end of a long saga, but with me, life never stops sending me surprises. In my late eighties, you may ask what else could happen of any consequence? What would I do with my time?

I was never one to sit still for very long. In my new Colorado house, I went into my basement and created a workspace, lining all my tools against one wall under a small window. To the left of the bench I put a table where I could sit and design new pieces of artwork. And to the left of the table was where I stored scraps of wood, canvases, and crafts materials. My goal was to express myself through art. I never had any formal training as an artist but to me this was not the point. I was not out to impress anyone or sell anything. I wanted to somehow pour my soul into an expression that somebody might recognize and think about.

Over the years I had created a number of works related to Jewish themes and my experience in the Holocaust. Now, though, with even more time on my hands, I would really go to town. The senior citizens center near my new house had some great equipment— drill presses, band saws, grinders, sanders, routers, and other devices for woodworking. Inspired by a friend from Long Island, Gerson Rappaport, who showed me how to make a mezuzah out of wood, I got to work carving my own creations, with Hebrew letters in the designs and figures fashioned out of pine. A mezuzah is a small piece of paper bearing the first two paragraphs of Deuteronomy and is meant to be attached to the doorposts of a house as a reminder of the Jewish people's covenant with the Almighty. The paper is then

encased in a covering that can come in thousands of designs. My own designs are made of wood that I find wherever I go. This has a certain amount of significance for me, taking a discarded scrap and turning it into something valuable. To me, among other things, it is a metaphor for the Holocaust survivor who, as a castoff after the war, had to create himself anew. Each of my mezuzahs is a resurrection of sorts.

Also in my basement I've continued to paint pictures on canvas and wood, create varnished wooden sculptures, and glue, hammer, and sand a series of projects with Holocaust scenes. To this day, my basement is a museum of my art. When I travel to give a talk, sometimes I take one or two pieces of my art along with me. After my talk, students and their parents will come up to the dais and contemplate what I've depicted. They stare at the steps in the stone quarry of Mauthausen and at the puffs of human clouds ascending from the chimneys of the crematoria. Without me saying a word, every visitor can get a glimpse into my past. They can see where I'm from and where I've been, from Maitchet to Mauthausen to the Statue of Liberty. My expressions hang in Yad Vashem at the Holocaust memorial, synagogues, churches, schools, living room walls, and museums. Many have told me that my artwork is a type of therapy for me. Maybe it is. They say I survived to tell the story of what happened. But what am I trying to say? At the very least, people should know what happened and what was lost. I want them to pause to think, not about me, but about themselves, their own character, and their own families. Without such reflective thoughts, there can be no change for the future and no appreciation for the suffering of others.

Over the years I've had a steady stream of visitors coming to my house asking to see my artwork. Members of my newly adopted synagogue, mayors, lawyers, judges, doctors, statesmen, writers, professors, students, children, war veterans, fellow Holocaust survivors, television crews, filmmakers, artists, rabbis, and priests have all taken the tour in the quiet of my Colorado basement.

A little more than a year ago, I received a call from a professor, Victoria McCabe, PhD. A long-standing faculty member of Regis University in Denver, Dr. McCabe called me to say that she saw an article written about me and my Holocaust years. She said she wanted to pay me a visit. I told her to come over whenever she'd like and I would show her my art collection. She told me it would be an honor if I would share my time. But it was me who was honored.

You may wonder why the professor of a Catholic university would want to visit me. Well, I've come to know that this is a strange world and that people have their reasons. Eventually, those reasons come to the surface, into the light after years of suppression. Dr. McCabe sent me a very nice letter as a follow-up to her phone call. With her letter was an article that had been written about her. It said that she is one of the daughters of a former American soldier who fought in World War II. The article said that her father kept a letter-sized box tucked away in his closet in his home in Iowa. As a young girl, Victoria McCabe noticed that once in a while her father would have a drink or two before revisiting the contents of the box in his closet. He was lost in his thoughts, quiet and melancholy. He would walk into his closet and remove the wooden box and study the contents. This is the only way he could look at the things he

kept hidden. Yet for some reason he was drawn to take them out and review them time and again over the years. What kinds of contents must have been in Mr. McCabe's storage box that required him to get drunk before he would dare to look inside? Why would he keep such things if they affected him so deeply? Such are the workings of the mind and memory—they do not even make sense to those of us who continue to be haunted by images and recollections.

On one occasion, Mr. McCabe allowed his daughter to look inside the box. She found gruesome photographs, as well as letters and documents relating to her father's discovery of Dachau concentration camp. From that moment on, Dr. McCabe's life was permanently changed, sending her on a life-long journey to explore the Holocaust and, in her words, "read everything I could get my hands on concerning that part of history." These artifacts, sealed away in Mr. McCabe's closet, hidden in a wooden box, were his darkest secrets. The box held the horrible memories of what her father, as an eighteen-year-old soldier, had seen with his own eyes: the skeleton figures, piles of dead bodies, inhumanity, ruin, and carnage upon the discovery and liberation of Dachau. "He didn't talk about it unless he was drunk, and he would not only talk but sob and weep about what he saw," Dr. McCabe remembered. All of these things were too horrible to remember, but at the same time, too horrible to want to forget. I know just how he felt. The box was a powerful metaphor for the minds of every one of us who has survived the Holocaust, whether inmates, soldiers, doctors, nurses, or partisans. The mind, damned until our last breath, is filled with memories of experiences that defy human understanding. We suppress these memories—we try to lock them away, out of sight—but they haunt

us and beg us to revisit them over and over again throughout our lives.

In the face of today's movement of Holocaust denial, we must ask ourselves how many thousands of these boxes exist all over the world? What secrets are your father or grandfather keeping from the light of day? Believe me, there are hundreds of thousands, if not more, of these wooden boxes filled with traumatic images. I meet people every week who relate their stories to me—American soldiers, army doctors, and liberators. Recently I met with a former army officer who came upon a concentration camp when he was twenty-one years old in Austria at the close of the war. His sentiments mirror those of so many others. "I was there," he said. "I was there and anyone who says these things never happened is filled with an evil lie that they themselves cannot even realize. I was there. Not only did these events happen, but they were even far worse than words and photographs can begin to express."

The horrors of the Holocaust are burned not only into the minds of us Jews, but we must understand that there are many, many other victims as well. When you watch television or see an event where World War II veterans are gathered, you must try to imagine what is in their minds. You would be very surprised. We are all victims of an unspeakable, unresolved trauma.

Over the telephone Dr. McCabe told me that she teaches an intensive course on the Holocaust at her university. When she arrived at my door, I was greeted with a warm, sincere smile. We chatted for a moment or so, Doris offered the professor something to drink and eat, then I led her downstairs into my basement. I didn't say a word. I wanted her to roam freely and look at my

art on the walls. I sat down and told her, "Take your time and look around."

As if in a museum, Dr. McCabe's eyes carefully studied every piece of artwork in the room. She looked at my sketches of Mauthausen and the framed carvings mounted onto wood, depicting images of chimneys bellowing out smoke in the shape of prayers. Her eyes fell upon hands carved like flames reaching up to heaven, the only escape from the hell of the concentration camp. Dr. McCabe, as a professor of Holocaust history, understands what happened. But nothing seemed to prepare her for what so many people have experienced alone with their thoughts, staring at my art in my basement. She stood like a stone in the middle of the room and tears began to run down her cheeks. She was speechless.

Then we talked. The professor was in my house for hours. It was a solemn occasion. Before leaving she asked if I would like to come speak to her students. I said I would be honored. When I gave my presentation in her classroom at the university, Dr. McCabe's students were exceptionally intent to listen to what I had to say, and they were loaded with intelligent questions. It warmed my heart to know that they were truly interested. A bridge had not only been forged across generations but also across religious boundaries. Before I left, Dr. McCabe expressed to me that she would like to bring her students to my house for the full "tour."

I said, "You can all come at once at any time." Well, to my surprise, a week later I got a call that everybody was coming over and that they were bringing food, a barbecue, and drinks. When they got to my house, we had a feast for thirty people, and they wouldn't let me or Doris lift a finger to help. I was a guest in my own house!

Dr. McCabe's students treated us like royalty. And, of course, in small groups they toured my basement museum. In the following weeks I received letters from students expressing their appreciation and concern. I was told that I made the Holocaust real to them. Their visit was mutually rewarding. Like never before, I discovered the therapy that came from sharing my Holocaust experiences in art and in talks to student groups. Students from age ten to twenty have interviewed me for their school projects. Groups of fifty to five hundred have gathered to listen to Doris and me. Some of these wonderful youngsters are grandchildren of American GIs who liberated the death camps and fought to save people like me. Such is the case with Annalise and Christa, daughters of Beth Eberhard and the granddaughters of U.S. Captain Elmore K. Fabrick who was with the 11th Armored Division—one of the forces that liberated Mauthausen in the spring of 1945. Captain Fabrick, who passed away in June 2007, took pictures of the atrocities of the camp, and his letters home to his wife about the military campaign and what he saw in Europe are all documented in sobering detail. Annalise and her two friends, Kari Mahannah and Rachael Perkins, created a documentary called *Voices of Mauthausen*, which took third place in the nation in the National History Day Competition, June 2007.

Inspired by the realities of the Holocaust and Captain Fabrick's experiences, the Eberhard family, including Christa, Annalise, Beth, and her sister, Marie Bainbridge, took a vacation to Europe and visited Mauthausen. Beth Eberhard wrote to me: "It was chilling to visit the place we had heard so much about, with the reality of its evil for all to see. We picked a flower from the quarry for you. I

pray that God's goodness and blessings be with you to the end of your days."

I thank God that I have been able to give the families of the U.S. servicemen at least a little something in return.

The Circle Comes to a Close

I have to tell you that God is a powerful force in my life. We have a unique relationship. I don't understand Him and He probably doesn't understand me. But on this one day, thirty-six years after I had set foot in New York to start a new life, God decided to give me a gift that made my legs fall out from under me.

Two weeks after coming to Colorado, I was called by a student at the Hillel Center at Colorado State University in Fort Collins—about two hours north of where I live. I was asked if I would like to come speak to the students and visitors of the school in a panel of Holocaust survivors and tell of my experiences. Naturally, I said I would be honored to share my story. When the event took place, I gave the highlights of my life, and, as usual, when I had finished, a great part of the audience was lost in thought. I was glad that I had given this talk, but I came home late at night, very tired. You see, each time I give one of these talks, a whole flood of memories comes back to me. These memories never stop breaking my heart. Many times, although I have repeated my story over and over, I must pause in the middle of my talk to allow my own tears to subside. Then, with a patient audience ever in front of me, I collect

my thoughts and move on. So after my talk, I arrived home and was getting ready to go to sleep when the telephone rang. Jim Curry had called me. He said he was trying to call me for a long time but nobody was picking up the phone.

Jim said, "Martin, you sound tired. How come?"

I said I was speaking at the university in Fort Collins. "I just got home after a very long day, Jim."

"You were speaking?" he asked.

"Yes," I said, "I was talking about my Holocaust experience to a group of students. I told them about what happened to my family and the time I spent in the concentration camp."

I told Jim that as of late I was spending a lot of my time speaking to groups of children, students, and anyone else who would listen. I told him about how the students were so interested in what I had to say and how I had more invitations than I had time to accept. Jim thought this was curious. Of course he knew I was a Holocaust survivor, but now he wanted to talk about it in more detail. After all of the years between us, and now that I moved away across the country and was ready to go to sleep, Jim wanted to talk.

Jim asked, "Where were you?"

I never discussed this with him in detail before, but for some strange reason, now seemed to be the best time. More than thirty-six years since the date we met in Central Park, after years of close friendship, I said, "I was in the concentration camp Mauthausen, the worst one of them all."

When I said the word "Mauthausen," it was like a shock. There was a very long pause. He didn't speak right away. The silence lasted for at least a minute—this is a very long time if you watch the

seconds tick by on a clock. I didn't know what was going on, but I heard him on the other end. I could hear his breathing. I waited for Jim to speak. As if trying to process the information, Jim asked me two or three times, "Martin, you were in Mauthausen?"

Patiently, I said, "Yes" each time he asked.

He asked, "How did you survive?" Then he paused and said, "How come you never told me?"

I said I didn't ever want to talk about it. I never wanted to get into the details.

Now it was my time to be confused.

My friend, Jim Curry, a retired New York police officer, a tough ex-soldier who survived the invasion of Normandy on D-Day and the Battle of the Bulge, and fought his way through the deadliest battles of the war, just sat in stunned silence on the other end of the phone. He could not bring himself to speak. Again I waited for him to collect himself.

"I was in Mauthausen too," Jim said. He could hardly get the words out.

I didn't understand him. Did I hear him correctly? I asked, "Jim, how could you be in Mauthausen? You're not Jewish."

Jim said, "I was in the 65th Infantry Division. We are still sick over what we saw. What we saw over there was horrible; piles of skeletons lying in ditches. There were bodies everywhere. Bones. I can't even describe it. We were walking around completely in disbelief. . . . "

Now Jim Curry's entire past was opening up. We were sharing a part of our lives that we both held secret from each other for nearly

four decades. We were friends who never spoke of this, the most impressionable experience of our lives—but no more.

Jim went on, "Then we went in to see the barracks. I went in with my army buddies. The smell was beyond terrible. The stench is something you don't forget. There were skeletons in there and we were on our way to get out. We had to get out of there. All of a sudden I heard something; I turned around and there was a skeleton with an open mouth and eyes barely open, like he was trying to tell me something. He was seventy, maybe seventy-five pounds. I picked him up and took him to the ambulance."

The hair on the back of my neck stood on end. I broke out into a cold sweat and sat down. My eyes began to well up with tears as if I knew what Jim would say next. I couldn't believe this. I was afraid to hear what he would tell me, but at the same time I wanted to hear.

Jim told me that the man he carried to the ambulance was lying on the floor next to the third bunk on the left from the back of the barracks across from the guard tower. He had precisely described the barracks I was in. He told me that he lifted this human skeleton in his arms like a child, his legs and arms just dangling, his head cradled in the crook of Jim's elbow. "I could see he was still breathing," Jim said. He told me that he quickly carried this body to the ambulance, hoping that he would live. He wanted to save this poor man.

"Jim," I said almost too softly for him to hear, "that skeleton you saved . . . that was me."

More silence.

God had answered my prayers. He sent my best friend, Jim Curry, to be my Moshiach.

I Remember

Perhaps by now you will begin to understand how unbelievable life can be. A few months ago Doris and I were out to dinner with our family to celebrate our wedding anniversary. I sat with my wife and looked out over all the happy faces smiling back at us.

In the midst of all the lively conversation going on, I put my little great-grandson on the table in front of me and my mind, as it so often does, drifted far away. My entire past came over me, then I returned to the busy restaurant. I posed an impossible question to God: "What kind of life is this where everything that was ever important to me—everyone I loved with all of my heart—was taken away in the most terrible way, and yet here I am blessed with a family sitting around me now so filled with love?" I looked at the baby I held in my hands, and I cried. I realized at that moment more than ever that I was a man who truly lived with my feet in two worlds.

We may never discover the "why" of the Holocaust, perhaps because there can never be an excuse that would explain how neighbors and friends can turn into heartless killers overnight. All we can do now is remember. For the sake of all that was lost,

all that used to be, and all that could have been, all we can do is remember.

Maitchet is no more but lives in detail in my mind. In my memory, there exists a world that pains me to revisit. But I must look at it; I must remember. I do remember. I remember as I speak to university students and church groups. I remember as I carve out images of the past in my artwork. I remember as I look into the faces of my new family. And I remember with an indescribable mixture of reluctance and readiness as I write my poetry and relive an anguish and sorrow inside of me that will never pass:

> In my mind's eye I freeze.
> I freeze in time only to see a little hill;
> A hill of memories and so much pain;
> A place where I was born and raised.
> I see the houses. I see the trees.
> I see the streets where I was playing.
> Now the streets are full of naked people;
> Men, women, children, young and old;
> Friends, relatives.
> I also see my Momma, my Papa and my two little sisters.
> Naked.
> Holding on to each other, screaming, crying, praying for their
> last walk on this earth.
> To their graves.
> They walk to their own funeral.
> They walk to a place where no one comes back.
> I scream out in pain:

Oh, God in heaven, how can you watch this horror?

Do you hear their cries?

Now I wake up, but this is not a dream.

It is all real; very real;

The slaughter of my town, the slaughter of my people, my dear
ones, my very dear ones.

Gone forever.

Just memories.

What is left now?

Pain in our hearts;

A pain in my heart that grows with time, calling so loudly in
silence: "Remember us."

It has been said time heals all wounds. But for a Holocaust survivor, time just makes things worse. The pain grows. The mind is tormented as it tries to make sense of the senseless. We cannot comprehend the magnitude of the loss; thinking and remembering brings us no closer to peace. The cry of "Never again" takes on the most personal of meanings. Never again will the mind rest in peace; never again will we share our lives with those who were taken from us. Never again shall the world be the same.

There is a part of my life that will not be forgotten. I don't want to forget, though I am haunted by my own memory every waking and sleeping moment. But I am saddled with a responsibility to remember. I want to remember. I want the pain and yet I do not want it. I dare not forget. I have nothing else to give to my family but my will to remember.

With all the goodness and yearning of my heart, I am here to say kaddish. I am here to answer the pleading, voiceless voices who live on through my memories as they simply beg of me, "Remember us."

Epilogue

by *Miriam Small Saunders,*
Martin Small's daughter

I still remember the commotion. . . . The sound of the police car rounded the corner. Then the siren wailed. We had just walked into our Washington Heights apartment in New York City—both of my parents fell to the floor. It was only a police car. I must have been about six years old. Seeing my parents on the floor, one under the coffee table and one between the end table and the couch looked very funny. I started to laugh. A few minutes later they got up and sternly ordered me to go to the bedroom. I sat on the edge of the bed and listened to my mother and father talking loudly to each other—some parts in English, but mostly in Yiddish. As I sat on the edge of the bed, I knew not to ask any questions. I knew there would be no explanation. I just knew it would be a long time until I got to come out of the bedroom.

Another time, my mother and I were walking to the park. The park was on 173th Street in Washington Heights, across the street from the elementary school. There was a lot of construction in the park that day, so my mother decided we should go to the other park

because my brother wouldn't be able to sleep with all that noise. The other park was quite a walk. Once we got there, my mother sat on the bench with the carriage and I looked for someone to play with. I saw two girls sitting on the swings looking at us. In the old park, all the families with kids knew one another. I went over to the girls on the swings and asked, "Can I play with you?" The girl with the longer blonde hair said, "Go back to your Jew park." I went back to my mother and innocently asked her, "What is a Jew park?" My mother jumped, grabbed my hand, held it to the carriage, and we walked as fast as we could home. Once inside our apartment, my brother, Stuart, was put in his crib and I sat on my bed in our shared bedroom. The Venetian blinds were closed; the door was closed. I could hear the shades in the living room being pulled down. There was no explanation.

In the middle of many nights, I would awaken to the sound of my father's screams. He would be crying, sobbing. I could hear my mother trying to calm him down. "It's only a dream," she would say. Nobody explained to me what was happening and what troubled my father so.

Like many kids in other neighborhoods, we didn't have two winter coats or two pairs of play shoes. But these were minor similarities. However, living in Washington Heights in the 1950s, I knew we were different. I had no grandparents. And my parents weren't born in the United States. Europe was not spoken of as a vacation place. And no one in my family ever talked about "the good old days."

My mother told me stories about her father, mother, brother, my Aunt Ida (her sister), and herself. I loved listening to her stories, but

they were somehow incomplete. Pieces were missing. My Auntie (great aunt) Frieda told me stories about her sister (my father's mother) and how they used to trap pigeons outside the window for dinner. My father never told me stories. The only thing I remember, later in my teenage years, was overhearing my father and Izzy (a Romanian Jew) in our kitchen. They would be discussing the war, camps, my father being in a ghetto, and Hitler. By this time we had moved to 58th Street in Manhattan. Where were the details of my parents' earlier days? There was no explanation. After I moved to Colorado and started my own life, my father began to speak—not with words at first but through his art. His rich, expressive paintings and his skillfully carved and painted wooden pieces revealed stories of his past; stories you could see, giving you a glimpse of his pain and the people of his past. My father started to express himself in poetry as well. And in this poetry I first understood the screams of his nightmares. In these extraordinary wooden art pieces, he told chapters of the demented, brutally evil regime of the Nazis and the suffering and bravery of common people.

My father went on to speak at universities and other places as one of the last living Jewish Holocaust survivors standing before them. Gradually, he began to speak more and more, allowing his story to unfold. His pain, his loss, and his suffering were forever entwined with a family and life he was forced to leave behind. He spoke publicly about bits and pieces of a period of time for which there is still no explanation.

Now, at long last, this has been my father's story.

Afterword

by Vic Shayne

As we all know, the number of Holocaust survivors is dwindling, year by year. As a student of this tragic history for the past thirty-five years, I recognize the importance of publishing all that we can to not only remember what has happened to all the victims of the Holocaust but also to validate their experiences. Why? Because, as fellow human beings, we should care. This is true especially in light of the fact that there are always forces trying to rewrite history, diminish the scope and breadth of atrocities, purvey anti-Semitism, and find excuses for the inexcusable.

Martin Small, born Mordechai Leib Shmulewicz, was a Yeshiva scholar fluent in ten languages who bravely spoke about his experiences during the Holocaust, though it pained him to no end to do so. Past the age of ninety, Martin refused to succumb to defeat, as he not only spoke out about the past but also expressed his trauma through unique artwork that remains on display in his home in Colorado, in New York, in Israel, and in the Holocaust memorial in Yad Vashem, Jerusalem.

The story of Martin Small is one of three lives, like a play of three distinct acts. First there was his life of relative peace, happiness, security, and love—a life immersed in rich Yiddish culture steeped in centuries of tradition and practice. This chapter of Martin's life spanned from his birth through his upbringing, and includes his studies as a Yeshiva student under the tutelage of his loving grandfather, and as a productive member of a great, extended family and community. The second act was a period of great darkness, of loss and suffering and of unending cruelty and pain; a chapter that seemed to have no end, one in which everything was taken from him. It was a time when Martin Small's world of the shtetl, of family and friends, of long hours of study and all things familiar and enriching went up in smoke. This was a period of the unimaginable and the unthinkable. It was an era that witnessed an unprecedented, unforeseen volcanic eruption of horror, hate, and torture on a scale that the world never knew prior to the Holocaust and has not known since. Martin's was a world of day-to-day survival marked by human slavery and degradation, at times spent on the run in the forests of Poland and eventually in a hell called Mauthausen concentration camp. Martin Small found himself in a hopeless nightmare constructed and managed by a regime whose leaders were no less than sociopathic in their every action. Martin's loss is often too heavy for the average person to consider, yet he lived with it day and night.

The second act of Martin Small's life at long last gave way to the third, bringing him from Liberation in 1945, when the Allied forces freed the survivors of Mauthausen, to life as a displaced person and eventually through to the present. This was a proactive period

wherein Martin Small fought for the rights of displaced persons, struggled to create a Jewish homeland, and settled down to live the American dream.

Martin Small was one of millions who experienced untold suffering and loss in the years of the Holocaust. In all of its breadth and width, it was a very personal event that should never be reduced to mere statistics and military strategies as the study of history is wont to do. Martin Small's journey is that of a single person caught up in a time of unspeakable tumult and state-sanctioned criminality. He was an individual whose story is unique, especially when we think of the few in number who managed to survive the Holocaust.

Martin Small spent the Holocaust years trying to survive just one more day, one more hour, in the hopes—in the remotest of hopes—that somehow he would at last be rescued from the fate of millions of others, including all members of his immediate family, at the hands of mass murderers. To Martin Small, the hope for a Messiah—the Moshiach—that he came to understand in his years of Jewish study would be the most personal of dreams.

When you looked into the eyes of Martin Small, you could see the ocean, the sky, and distant lands. He was often lost in thought over who he was, where he had come from, what had happened to his loved ones, and why he survived. He could find no answers to any of his questions. He would be sitting with you, but you probably would not realize that he was, in his own words, "a million miles away."

"I am in two worlds," Martin would tell me. One world was a place that no longer existed except in his heart and mind. His entire family dwelled there, and though it pained him, he would not

allow himself to forget even a single detail of that world. The other world was that which began after the liberation of Mauthausen concentration camp by personal Messiahs dressed in the uniforms of the United States Army.

In his advanced years, acquaintances and friends came to know a reflective Martin Small, traumatized by all the indelible images burned unwillingly into his mind. And out of this, we knew him as an artist whose sculptures, paintings, and artwork were expressions of what he had suffered. He carried his trauma with him, both because he would not, dared not, forget. And because he could not forget. In my estimation, Martin Small was a hero. He was the embodiment of the mythical icon in "the hero's journey," having faced the crucibles of fire and water, having lost all, and having arisen like the Phoenix. He bore witness to that to which even his fellow Jews are apt to turn a deaf ear because the pain of his story is too great of a burden for the psyche to absorb. Martin Small was a silent witness by his own definition. He had witnessed that which cannot be described. He was silenced by a failure of words or images to communicate all that he had seen and experienced. He was unable to fully tell his story, for the emotional aspect—which is the most impressive and burdensome—could not be put into any tangible form of communication. This, for Martin Small—one of the most intelligent, insightful, witty, communicative, and exuberant people I've ever met—must have been one of the most frustrating realities of all.

In the preceding pages, to paraphrase the words of Auschwitz survivor, writer, and Nobel Prize recipient Elie Wiesel, we share

Martin Small's personal journey not so that you will understand but so that you will know you can never understand.

Appendix

Gentle Snowflakes Falling

E vidence of the Holocaust can be found in hundreds of thousands of places, with the most obvious being in museums and the least obvious in private collections stashed in dark corners of closets. Most of the testimonials have never been written and remain in traumatized memories. Many have been passed along to close friends, wives, daughters, sons, grandchildren, and, occasionally, therapists. The trauma of the Holocaust is a worldwide phenomenon, not just a Jewish one. To think otherwise is to invalidate the suffering of others and to be ignorant of the enormity of the war and all of its victims, from soldiers to partisans and from concentration camp inmates to resistance fighters and from rescuers to civilians who lived through hell on earth.

Some of the most awe-inspiring testimonials were recorded by the American soldiers who came upon the Nazi death camps across Europe. There were privates, sergeants, lieutenants, captains, colonels, majors, and generals (Eisenhower and Patton are most notable), as well as military medical personnel.

George S. Maxwell, MD, a retired orthopedic surgeon, wrote the following when he was with the 131 Evac Hospital and came to Mauthausen in May, just days after the liberation:

Upon approaching, we were met by MPs who had preceded us by some hours. We were told to enter on foot, no vehicles in the camp. The forbidding iron entry gate, now propped open, led to a complex of large ugly brick buildings two to three stories high surrounding the central open area. There was an eerie silence, no talking or commotion of any kind, just the buzzing of millions of flies. The ground was covered with liquid feces which we learned was the ubiquitous starvation diarrhea. The smell was powerful. I recall battle hardened GIs vomiting. I too was sick.

The few individuals who were standing moved very slowly and appeared dazed. As we got further in we saw the hundreds upon hundreds of prisoners seated side by side against the building walls. Most were naked and looked like skeletons with tightly drawn skin. They seemed lifeless and it turned out many were. . . . We all felt helpless and stunned by the magnitude of this tragedy. An effort was made to get water to those who could swallow. From the onset it was obvious that the priorities were getting nourishment to the living and removing the dead.

. . . Getting rid of the dead was urgent and seemed never ending. Separating the living from the dead was a challenge because of the sheer number. It turned out the huge fly population was a help. In going down the line of seated inmates, those who blinked from the flies about their eyes were judged not yet dead and were bypassed.

Partly to expose the local population to the horrors of the camp, horse drawn carts were commandeered with local peasants doing the loading. The emaciated bodies were so light that two old men could sling them onto the small wooden carts. . . . By the second and third days there was a steady stream of carts coming and going. To the best of my knowledge using locals to transport the dead was a local decision. However, early on General Eisenhower ordered it as a general rule. This order was based on the persistent denial by the Germans and Austrians of what went on in the camps. A local gravel pit was the disposal site with burial by bulldozer when one became available. To illustrate the magnitude of the problem, even at the second week, I recall the daily removal of three hundred bodies. I have no figures for the earlier days but it was surely much higher. Our unit chaplain was at the burial site daily doing what he could to administer to the dead. I remember his estimate of the total bodies brought to the pit to be fifteen thousand. . . .

Closer Look at the Camp: Not long after our arrival we got a better view of the compound layout. Around the entire camp was an elevated walkway over an impenetrable barb wire fence. We were told that the twelve-year-old son of the camp commandant considered it sport to take pot shots at the prisoners from this vantage point.

Incinerator Ovens: Gruesome by any standard was the building housing the two incinerator ovens. Bones were still visible inside and nearby. Still present when we arrived were bodies neatly piled five high and twenty long waiting for disposal. Close by was a windowless concrete room apparently for gassing. We were told they were facilities for death by hypothermia: naked starving prisoners were huddled together in a confined space and sprayed with cold water until dead. This method was out of favor as too slow. . . . A feature of this camp, and I am sure others, was that it was highly organized for slave labor while at the same time useful for extermination. Most, if not all, the inmates were required to work in what we came to know as the tunnel factory. . . . The inmates worked twelve hour shifts, seven days a week. Rations were one kilogram of black bread and one kilo of ersatz coffee per five men per day. . . . The German mindset needed a rationale to murder. Sickness or weakness provided that rationale. For the Germans, this system worked because of the supply of slave labor was vast and food was expensive. Their big concern was getting rid of the dead while leaving no trace.

Thoughts Coming Home: I left Germany with an uncomfortable feeling. Any country so highly developed and by most standards civilized, could foster for many years a system of slavery, mass extermination and unimaginable brutality could go this way again. Not a pleasant thought. After all, Nazism was a widely accepted national movement interrupted only by crushing military defeat.

Another eyewitness testimony of note comes from U.S. Army Colonel Edmund M. (his last name remains anonymous to protect his privacy), then a first lieutenant with the 65th Infantry Division that entered Mauthausen concentration camp in the spring of 1945. The colonel had fought through most of Germany into Austria when his unit, with the 11th Armored Division, stopped to wait for Soviet troops coming east from Vienna. Tanks of the 11th Armored Division were probing for German forces:

Two or three tanks then stumbled upon Mauthausen concentration camp. . . . There was no prior knowledge. . . . I think it was pure chance that our American tanks found these. . . . Almost immediately more and more tanks of the 11th Armored Division . . . were the first to liberate the camp. [Colonel M. arrived shortly after the tanks.]

The thing that, I think, impressed all of us immediately was the horrible physical condition of most of the inmates . . . most of them in very, very bad shape. Some of them

actually looked almost like living skeletons. . . . I would estimate their average weight might have been probably eighty-five, ninety pounds. . . . I walked then into one of the barracks, and the first thing, that almost literally startled me, was the terrific stench of the barracks. It was just unbelievable—the odor of excretions, et cetera, that were in there, that the inmates could not help over a period of time. It was just so much so that I first just wanted to grab my breath and maybe walk out immediately without going any further. But I took a deep breath, and went indeed further, and looked around, and . . . those that were in the, in the bunks in there were in very, very pitiful shape. The bunks were in a sense unbelievable. The bunks were roughly about, I'd say about six feet long, probably about three and a half or four feet wide. And they were triple-tiered, sort of like young children would be having, except one would be sleeping in them. Here we had three to four inmates sleeping in each of these bunks just squeezed together, literally like almost sardines.

Colonel M. was able to communicate with the prisoners through soldiers in his unit who spoke German and Yiddish. He was shown the quarry where many of the prisoners were slave laborers. He describes a two-hundred-foot drop from a precipice at the bottom of which were jagged stones strewn with broken and decomposing bodies:

One hundred eighty-six steps of death that led from the bottom of this quarry up to the top of this precipice.

. . . This particular work detail . . . was one of the worst tortures. . . . Inmates would carry these heavy stones up the one hundred and eighty-six steps of death. . . . Weighing only eighty, eighty-five, ninety pounds, [inmates] were carrying stones weighing perhaps thirty-five, forty, forty-five pounds, up these steps all day long. . . . If they fell or stumbled . . . or dropped the rocks, very often they were beaten to death right on these one hundred eighty-six steps . . . [or] pushed from the precipice down to the jagged rocks below, to their deaths. . . . Happened very often . . . went on constantly. The atrocity of the one hundred eight-six steps of death, which left such a vivid memory in my mind, that I have never, never forgotten these many years.

For the colonel and his men, and all the others who set foot in the concentration camp, the vision of Mauthausen would forever change their lives and the way they thought about the world. What they saw brought grown men—battle-toughened soldiers—to their knees. They entered a world of walking skeletons, piles of dead bodies, the stench of death, disease, starvation and human waste, and broken souls. Beyond this they found the remnants of the workings of a death camp—gas chambers, torture chambers, instruments of atrocities (Source: Yale University Library, 1996: http://www .library.yale.edu/tes- timonies/excerpts/edmundm.html).

Here is another account from the liberating soldiers' point of view from William J. Powers, son of a KZ Gusen [Mauthausen] liberator. He wrote:

I was going through some of my father's photos from WWII and found one labeled as St. Georgen, Aust. Since my dad spoke Russian, Polish, English, and German, he was taken from Patton's Army in Germany and sent to help liberate the camps. I assume that he was there to help the victims of the cave camp there. It was an experience that so changed him that many people failed to recognize him when he returned to the USA, he looked the same but his personality changed. He was an infantry Captain known for caring for his troops, comradeship, and courage. After a week freeing the concentration camps he was a changed man. He lost all interest in the military and any form of violence. It took years before he regained any sense of humor. Even though he was a natural leader, he was unable to step forward except in situations where he sensed an injustice. Well, his problems were small compared to the denizens of the camps, but I wanted to tell you what little I knew, and that Capt. William Poplawski was there to try to help—and add to the record of the disaster . . . "(Source: nizkor.org/hweb/camps/gusen/feedback).

The United States Holocaust Museum describes the arrival of the 11th Armored Division at Mauthausen concentration camp:

On May 5, 1945, the 11th arrived in Gusen, which had
originally been a subcamp of Mauthausen. The division's
arrival prevented the SS guards from murdering thousands
of concentration camp prisoners by dynamiting the
underground tunnels and factories where the inmates
had been forced to work. The next day, the 11th Armored
Division entered the Mauthausen concentration camp. In
the unit's "sanitary report" of May 25, 1945, the division's
Medical Inspector stated that "the situation in the camp
on the arrival of the U.S. Forces was one of indescribable
filth and human degradation." The report stated that
nineteen thousand prisoners were crammed into bunks
meant to accommodate around five thousand persons and
that the two- and three-level bunks held ten to twenty
prisoners each. The prisoners had been fed a mixture of
sugar beets and potato peelings that "looked like worms
in mud." Thousands of prisoners were naked or clothed
in rags. Some eight thousand survivors in the camp, the
report continued, were in need of immediate medical
care and more than half of the camp's inmates "were
little more than skeletons." Soon after arrival, the 11th
Armored Division began implementing measures to treat
the ill prisoners and improve conditions within the camp.

Among the memorabilia U.S. Army Captain Elmore Fabrick
brought home as part of the liberating forces of Mauthausen, was a

carbon copy of a written statement from a Belgian medical officer named G. W. Hoorickt, who wrote:

This camp, in the first period of its existence (1938), was intended for German criminals and political prisoners. Polish political prisoners arrived here in 1940. Over 200,000 prisoners passed through Mauthausen during the period of its existence. In view of the fact that the number of prisoners amounted lately to 50,000, the number of the dead is equal to about 200,000. This high mortality is explained by the circumstance that Mauthausen was a camp of the III category, that is today a camp where the most cruel methods were applied for the aim to harass and exterminate prisoners, represented in the last years, mostly by working intelligentsia of suppressed nations. According to his murderous purpose, a special staff was selected.

Standartenfuhrer Francis Zyreiss [sic], known as one of the most bloodthirsty German hangmen, was appointed commander of the camp. It is needless to say that each member of the staff, from officer to private, was especially trained in the application of the cruelest methods. It must be emphasized that the right to survive was granted only to those prisoners who were fit for work, others, exhausted from work and starvation, were considered ballast and deserved extermination.

During my stay in concentration camps since 9-4-1940 this principle, as regards treatment of the sick, was vastly applied. It should be added that certain groups of prisoners

were destroyed immediately after their arrival at camp. About 500 Poles from Warsaw were shot in Sept. and Oct. 1940. In the period since April 1940 to April 1941 about 8,000 members of the Polish intelligentsia were killed in Gusen (a branch camp of Mauthausen), in the autumn and winter 1941 and in the spring 1942 over 3,000 Dutch Jews were killed, mostly in the quarry hurled from the rocks or drowned by plunging in a stream. On the day of 2-10-1941 a group of 2,500 prisoners of war arrived to the camp; in the following months new groups arrived including a high number of Soviet army officers. The total number of Soviet prisoners amounted to 5,000 in Mauthausen and in Gusen to 5,000. It was stated in June 1942 that out of the above named number of 5,000 in Gusen only 67 survived. The majority perished of famine, flogging on prisoners, or mass slaughter, employed in the quarry. Others were poisoned with cyanide of potassium, sulphurate of magnesia or benzine injections. This exterminating action was carried out by the SS staff with collaboration of German criminal prisoners, belonging to the barrack personnel. In this way i.e., weak or half frozen naked prisoners were deposed on the floor in heaps in bathrooms and kept for the night under a cold shower. The miserable victims who tried to escape were knocked down and killed with cudgels. The average mortality in the prisoners' barracks amounted to 150 daily. In 1942 a gas chamber was installed. A number of 20 sick prisoners (barrack 20) was selected to be poisoned with gas for

experimental purposes. Forty-two superior officers and political soviet commissars were gassed in the spring 1942. In the same year about 400 soviet officers and commissars (among them were a considerable number of Jews) were gassed. They were transported to be executed immediately after their arrival to Mauthausen railway station. In October 1942 over 300 Czech prisoners were gassed, this number including families (167 women and children). In December 1942 and Jan. 1943 about 8,000 were transported from prisons to the camp. They were brought to trial and condemned for offences of military character, as listening in, reading of English pamphlets, spreading clandestine news, patriotic songs, membership in secret anti German organizations, etc. This number included 80% Poles. About 1,500 sick and feeble prisoners were grouped in barracks 19. A part of them died of hunger under indescribably unhygienic conditions, the majority were gassed in a motor van specially equipped for this purpose. This car transported 2 or 3 times daily 50 prisoners to the camp of Gusen (6 km) and the victims were gassed on the way. The car was always by the camp commander ZYREISS [sic] in person. On the day 26-1-1943 a group of 47 English, American, and Dutch persons arrived with labels attached to their chests and backs bearing the inscription "SPY." All these prisoners were murdered in a most cruel way in the quarry on the 6th and 7th of Sept. (List of persons enclosed.) In the period of time from 27-4-45 til 3-5-45 a group of 1,607 healthy

but undernourished prisoners were gassed in Mauthausen camp. The camp authorities demanded a group of 2,000 feeble prisoners to be moved to special barracks for the purpose of administering improved nourishment. A group of 1,800 men was delivered. On gaining information that these prisoners were destined to be gassed, I refused further delivery, and as a result of my interview with the lager fuhrer Bachmayer, all prisoners pertaining to west European nations, escaped death. On 27-4-45 I received an order from the camp physician Obersturmfuhrer Rychter to select a number of 1,500 grave hospital cases and to administer poison in the form of pills. He attempted thrice to induce me to commit the act in spite of my firm refusal. During the first years of the camp's existence the prisoners toiled and suffered till exhaustion refused them to bear the burden of work. When unfit for work they were killed by the SS or by barrack personnel recruited from German criminals condemned to penal servitude. After daily work when evening came, the feeble sick were picked out and killed in the barracks or in the square where the roll was called. Various methods were applied; in this report only the most commonly used will be described: 1. By smashing the brains with cudgel. 2. By knocking down the victim and threading on his thorax and abdomen. 3. By plunging the victims head in a cask of water. 4. By pouring water into the victims' pharynx by means of a rubber pipe. 5. The prisoners were knocked down, an iron pipe was introduced into his pharynx

and [pressure] was applied on his thorax (threading and stamping). 6. Some victims were torn to pieces by dogs. Others were drowned in latrines.

All the prisoners were cruelly beaten during work hours, and, frequently, at night. A primitive sanitary aid was established at the end of 1940; never the less it was strictly forbidden to employ medical men prisoners. In this period, members of the sanitary staff recruited from the criminal elements in the aim contrary to bring patients relief. It is needless to say that the feeble patients were killed. Doctors were admitted to treat prisoners of war in 1940 Oct. and other prisoners in Sept. 1942. The physician's activity was highly restricted by camp regulations, lack of medical articles, etc. This activity may be considered a constant struggle for the life of every patient—struggle against camp authorities' doctors. The Standortarzt as well as other physicians representing the German authorities, took no interest in the sick; they played on the contrary, the part of instruments in the camp commanders hand, used for the gradual destruction of prisoners. Standortarzt, Sturmbannfuhrer Krebsbach (known as "Sprintzbach") known for his utmost cruelty, introduced several murderous methods, as the gas chamber, poisonous injections etc. Bauptsturmfuhrer ENTERS and Sturmbannfuhrer WILTERS followed his example. Obersturnfuhrer LUCAS proved to be the only doctor, in the proper sense, who refused to sign death certificates of murdered victims, and was always willing to aid such and

bring them relief. His humanitarian nature did not permit a long stay at Mauthausen, and after 2 months duty was removed to the other camp.

Every year in autumn (clearing or sweeping) action was carried out. It was based on the principle that all grave hospital cases (in Mauthausen and its branch camps) work invalids, undernourished individuals and prisoners above the age of 50, were to be selected to the so called "Convalescence" or "Recovery Camp" (Genesungslager) for further treatment. All the victims were gassed on the way. This action was going on systematically since 1940 in this year 300 men were picked out in Gusen and 900 in Mauthausen camp. This number approximately equal to the number of victims transported in the following years, 1944, 2973 sick prisoners were removed from Mauthausen hospital to the Recovery camp. The sick were always selected by German physicians.

The gas chamber, as well as the crematory, was installed in Hartman Castle. All traces of these installments were removed in Feb. 1945. Constructing plans of a new gas chamber and crematory intended to cremate 10,000 corpses daily were elaborated at the Baubure. The detailed data concerning this subject could be gained from Capo Henryk Matyszkiewics. In the course of evacuation in Poland and eastern Germany all unfit march prisoners were killed. Several evacuated transports were a month on the way. Transports of 200-3,000 prisoners were coming into Mauthausen Camp at a time. These people were in

a state of complete exhaustion. The majority died in the first days or weeks of general exhaustion. The Mauthausen hospital mortality in Jan. 1945 amounted to 257 prisoners (the total number of sick 6,000) in Feb 1945—1,600 (the total sick number—7,000) and in March—3,242 (the total 8,000). Organized methodical famine should be considered as the principle cause leading to death in 90% of the cases. A transport of 4,000 sick prisoners from Cross-Rosen came in Mauthausen in March 1945, 400 men picked out, stripped and kept outdoors for 14 hours (from 8 QN till 10 BN) while standing in the cold, the victims received several times a spray of cold water. Those who survived were murdered with cudgels. The above methods of destruction are entitled to be mentioned in this brief repot, as methods most commonly applied, a detailed elaboration requires time. The veraciousness of these facts is testified with my signature. If requested, I am willing also to take oath.

Captain Fabrick not only wrote detailed descriptions of the horrors he encountered during the liberation of Mauthausen, he also took a series of photographs to document the carnage. Captain Fabrick's granddaughters, Annalise and Cristina Eberhard, more than sixty years later, would pay great tribute to their grandfather and honor the names of all who died to liberate the concentration camps. Annalise and her friends worked on a school project and won a national award for their effort in creating a DVD about

Mauthausen. The Eberhard family even visited Mauthausen in 2007. Part of the girls' project reads:

> At Mauthausen the tragedy is obvious: due to Hitler's Aryan philosophy, 200,000 innocent people were taken captive and 119,000 were killed. These numbers represent only a small percentage of the people imprisoned and killed in the hundreds of concentration camps all over the Third Reich. Prisoners were worked to death, starved, killed in gas chambers and tortured in other unimaginably horrific ways. In spite of all the horrors, there is a triumph: the triumph of the human spirit. Those who experienced Mauthausen, soldiers and inmates, have gone on to dedicate their lives to serving humanity. Politically and culturally, another triumph was the formation of Israel as a Jewish homeland.

> Had we known what was in store for us, we might not have undertaken this tremendous task. However the depth of our understanding has greatly increased in a way that would not otherwise be possible. The topic was disturbing, but the gift of personal testimony given to us by the men we interviewed will stay with us forever.

The American soldiers' experience with Mauthausen is now documented history that attests to the conditions that the GIs encountered in the spring of 1945. One such experienced has been recorded in this report from American Veterans (AMVETS), in the 2005 issue of their newsletter:

Bill Corwin, a sergeant with the 260th Infantry Regiment, 65th Infantry Division, attached to Gen. George S. Patton's Third Army, hardly knew about the camps. But he sensed something was up when his unit followed a tank that crashed through the gate at the Mauthausen Fortification Camp in Linz, Austria. They had been chasing retreating Germans all the way from the Battle of the Bulge.

As part of a frontline combat team in April of 1945, "We hardly saw a copy of STARS AND STRIPES. We just didn't know," Corwin pointed out. "But we found out damn quick. After we were dumped off into a field, what appeared to be light, gentle snowflakes began falling. They covered everything—the grass, flowers, our guns, helmets." But it wasn't a snowstorm that Corwin and his unit were in the midst of. It was a shower of ashes from the crematorium at Mauthausen.

"It was unbelievably mind-blowing," recalled Corwin from his home in Henderson, Nevada. "I remember the smell even now. I saw every degree of human being walking around in one physical condition or another," the 79-year-old said. Corpses were stacked 10 to 15 bodies high, like piles of cordwood 30 feet long." He is quick to quell any connection between liberating Mauthausen and his religion. "This was not a Jewish issue. The minute I

walked through the gate I was in hell. There was no more rhyme, reason or common sense."

For many a GI the gruesome sights that greeted the liberators were hard to accept. Silver Spring, MD, resident Colonel Louis "Chick" Cecchini, today eighty-four, from the 89th Infantry Division, Third Army, recalled the reaction of such a soldier: General George S. Patton.

"Patton, with his [tough] image, couldn't stand it. He went off and vomited," Cecchini said (Source: Yablonka, Marc Phillip; American Veterans online magazine: http://www.amvets.org/ HTML/news_you_can_use/magazine_spring2005_article2.htmt).

In April, 1945, General Dwight D. Eisenhower, Supreme Commander of the Allied Forces in Europe, made this statement following his visit to Ohrdruf concentration camp in Germany:

The visual evidence and the verbal testimony of starvation, cruelty and bestiality were so overpowering as to leave me a bit sick. In one room, where they were piled up twenty or thirty naked men, killed by starvation, George Patton would not even enter. He said that he would get sick if he did so. I made the visit deliberately, in order to be in a position to give first-hand evidence of these things if ever, in the future, there develops a tendency to charge these allegations merely to "propaganda."

As Eisenhower predicted, now that more than sixty years have passed, there are indeed groups of individuals arguing that the Holocaust never happened. This outrageous claim, motivated only by the brand of prejudice that caused the Holocaust in the first place, is in complete ignorance of the fact that the Holocaust is the most, and best, documented event in human history. To say that the horrors of the Holocaust did not occur is an insult not only to every survivor of mass murder and those who senselessly lost their lives, but also to every brave American soldier who risked his life as he fought across Europe to combat the Nazi menace. The validity of the Holocaust rests not only with the records of the victims and the perpetrators but also with the firsthand accounts of soldiers who witnessed the aftermath of the atrocities. All across America, tucked away in closets, boxes, and chests, are personal photographs, letters, and artifacts collected by GIs as proof of what they saw in the concentration camps. For good reason, retired soldiers often repeat the same sentiments in defense of history when they say, "Don't tell me the Holocaust never happened. I was there. I saw it with my own eyes. Anyone who says otherwise is selling a lie."

Acknowledgments

As you may imagine, there have been hundreds of people over the past ninety-one years who deserve credit for their positive influences in my life. But let's begin first with those most directly helpful in making this book possible.

Thank you to my writer, Vic Shayne, whose thoughts have melded with my own so that I could bring to bear this difficult account of life, love, and loss.

Thank you to my wife, Doris Small, a fellow Holocaust survivor who, with her sister Ida, barely escaped Kristallnacht and exportation when they joined the Kindertransport and fled to England at the start of World War II. And thank you to my daughter, Miriam, for her love, encouragement, and the photographs she provided for this book.

Thanks to my son-in-law, Bill; granddaughter, Jenniffer Rachel; and her husband, John; my great granddaughter, Samantha; and Jenniffer's boys, Vance David and Ezra. Also thanks to Jacob Michael, my grandson; his wife, Jennifer; and their son, Julian, and daughter, Jaden Elka (named after my sister Elka).

A special note of appreciation goes to Josh Shayne for his cover design and for assisting with all of the computer work needed to make this book a reality.

Thanks to Myrna and Shael Siegel for providing photos, background information, and support, as well as for Myrna's tireless work on the Maitchet Yitzkor book. Myrna and her husband were brave enough to return to Maitchet many years after the war to videotape the town and outlying areas. Representing all of us from this shtetl, Myrna said kaddish at the monument where my family, and hers, were murdered along with three thousand other Jews in the summer of 1942.

No amount of words can describe my appreciation for my friend Jim Curry, retired New York City policeman and, years before that, Army soldier of the 65th Infantry Division. Thanks to Beth Eberhard for contacting author Vic Shayne about her father, Captain Elmore Fabrick of the United States Army, who fought through Europe to one day be among the liberators of Mauthausen concentration camp. The world will never know how brave and great these American soldiers were as they persevered and fought to end the madness of the Holocaust era. Too many of them, albeit for the right reasons, have kept their experiences locked up in the recesses of their memory owing to the pain of revisiting the trauma that marked their lives during the war years.

Thanks to Jody Berman for her professional proofreading services and encouraging words.

I also want to thank my friend, Andrea Jaracz, who shared her thoughts about this book, saying, "This is a story quite difficult to ponder, much less to live through. So much hatred has been

poured into Martin Small's life, yet he exudes love. It is plain to see that the enemy, who has diligently tried to rob him of all human dignity, has failed miserably."

Another personal friend, Irene Calvano, wrote these supportive words: "During the reading of this book, I was privileged to be able to share the details of the wonderful childhood bestowed on a very few, and then gradually the horrors bestowed on many millions. To be able to call Martin Small a friend is one of the grandest privileges one can have in life."

I thank every family member and friend who read this book with interest and gentle guidance.

Much appreciation as well goes to veteran actors Ed Asner and Jerry Stiller for taking their time to read the manuscript for this book, as well as friends Rabbi Zalman Schachter, Irving Roth, Cynthia Nieb, Victoria McCabe, George Lichter, and George Maxwell, MD.

Last but not least, I would like to mention my family from New York who helped me feel at home when I came to America in 1950. Of course, there was Aunt Frieda, my mother's sister; and Frieda's cousin, Uncle Harry Berman, who came to find me in Italy. But there's also my extended family, who welcomed me home with open arms, beginning with my cousin, Ruby Watskin, and his wife, Frieda; and Ruby's brother, Murray. Also supporting me were my cousins, Larvey Plotkin, and his wife, Ida. All of these newfound relatives, I learned, helped put up the money to bring me to America (Ruby and Murray Watskin, along with Aunt Frieda, supplied the affidavit for me to come here). Frieda and Ida were daughters of my Aunt Frieda's brother, Schmerl Berman. I also

came to know Frieda and Ruby Watskin's daughter, Cynthia (my second cousin), and their son, Jerry. Plus, I met Ida's son, Elliot, and daughter, Joni; as well as Ruby and Morrie's brother, Larry.

Further, upon coming to America, I was connected with other relatives from my mother's side of the family. About twenty kilometers from Maitchet, in a shtetl called Zetel, lived the family of my mother's sister, Yachna Senderowski, who was from another father. Yachna had two sons, Hilka and Isroel, and a daughter named Rywka who married Baruch Silberklang. Rywka's son, Melvin, was born in Germany in a DP camp. When the Silberklangs moved to New York, they had one more addition to their family, a son named David (now professor in the Rothberg International School of the Hebrew University in Jerusalem, where he serves as editor-in-chief of Yad Vashem Studies) with whom I frequently communicate as he travels the world as an educator.

My deepest appreciation goes out to all who have uplifted my life.

About the Author

Vic Shayne has been a professional writer for more than thirty years, having published several books, hundreds of articles, and several screenplays. An avid researcher of the Holocaust period, Vic Shayne has interviewed survivors, family members, and WWII veterans to bring to life *Remember Us,* the true story of survivor Martin Small.

This book is the result of more than three years of almost-daily conversations with Martin Small in which he imparted the details of his life's experiences to Vic Shayne in the hopes of preserving, honoring, and sharing invaluable memories.